Miss Mary Cassatt

IMPRESSIONIST FROM PENNSYLVANIA

·

Miss Mary Cassatt

IMPRESSIONIST FROM PENNSYLVANIA

.

By Frederick A. Sweet

UNIVERSITY OF OKLAHOMA PRESS

NORMAN

LIBRARY OF CONGRESS CATALOG CARD NUMBER: 66–13423

© *1966 University of Oklahoma Press. Second printing, January, 1967.*

For Esther

Preface

ALTHOUGH MARY CASSATT'S STATURE as an artist is generally recognized and her counseling of the Havemeyer family on art purchases is well known, she still remains a very shadowy figure, remembered for having lived in a château in France, for having been born in Pittsburgh, or was it Philadelphia (neither of which is correct), and for being the sister, and some have said the daughter, of the president of the Pennsylvania Railroad. Probably no artist has ever had so many misstatements of fact written about her as Mary Cassatt. Her only full-scale biography was published in France in 1913 by Achille Segard, who based his information on her personal recollections recounted when she was in her late sixties. Many articles and catalogues have appeared since then, but all of them have perpetuated old errors or propounded new ones.

I have been fortunate in having the full co-operation of all of Mary Cassatt's relatives as well as of the Havemeyer heirs and other persons, both here and in France, who had known her. In addition, I have had the privilege of making use of a large number of hitherto unpublished letters written by Mary Cassatt and her parents to family and friends, and of journals, family records, and photographs. The letters, which extend from the 1860's to 1926, bring to light countless details of her life and serve to correct many errors about her activities.

This book, which is in no sense a *catalogue raisonné* of Mary Cassatt's work, has a multiple intent. While the major purpose is to follow her development as an artist, the whole progress of her career takes on a completely new aspect when we realize the difficulties under which she worked on account of the constant invalidism in her family. Her parents' letters are most revealing in this respect and have been quoted here at length in the belief that Mary Cassatt herself is more fully understood by virtue of our being given a true picture of the environment in which she lived and worked. Thus her life and her career, the two inevitably intertwined, are both projected in a dimension and scale that have never before been possible.

Second only to her creative activities was the profound influence that Mary Cassatt exerted on American collecting. She not only furthered, in fact almost created, an interest in French Impressionism, but also rediscovered El Greco and had a great interest in Italian, Dutch, and Flemish art alike. The Havemeyers, who relied on her the most, recognized the fact that she had an unfailing eye, a positive sixth sense in her judgment of quality in pictures. Furthermore, she was in advance of her time in being among the earliest admirers of Japanese prints and of painters of the baroque period.

Mary Cassatt, aside from her role of artist and collector, or adviser to collectors, is fascinating as a person, a true personality, dynamic, opinionated, as voluble on servants and dressmakers as she was on art, politics, or spiritualism.

In quoting from letters and journals capitalization, punctuation, and, in most instances, spelling have been made to conform to modern usage for the sake of clarity. In the case of a few letters oddities of spelling and an occasional grammatical slip have been left for flavor.

I should like to express here my sincere appreciation to the many persons, some of whom are no longer living, who helped me in so many ways. Among those in France who contributed so much were M. Charles Durand-Ruel, who put at my disposal the

archives of the Paris branch of Durand-Ruel, as well as giving me access to Cassatt paintings in his own household and those belonging to his sister, Mme Jacques Lefébure; M. Jean de Sailly and his sister, Mme Jean Bourdée, children of Mary Cassatt's old friend Octave de Sailly; Mme Lavergne, M. Jean Louis Vaudoyer, M. Paul André Lemoisne, and Mme Ernst Rouart, all of whom had interesting recollections of Mary Cassatt and in some cases owned examples of her work; M. Georges Salles, ancien directeur des Musées de France, and M. Jacques Dupont, inspecteur général des Monuments historiques and president des Amis du Louvre, who made a number of private collections available to me in Paris; Mme Pinault (Reine Lefèbvre), from the village near Château de Beaufresne, who recalled posing as a child for Mary Cassatt; Mlle Marthe Brune, former chambermaid, and especially M. Armand Delaporte, former chauffeur, who contributed so much to my knowledge of Mary Cassatt's day-to-day life.

Among those in this country I am grateful to Mrs. Adolph Borie, Miss Mathilda Brownell, Miss Anna Ingersoll, Mr. Homer Saint-Gaudens, Mr. George Biddle, Mr. Forbes Watson, and Mr. William Ivins for their most valuable personal recollections of Mary Cassatt; Mr. Joseph T. Fraser, Jr., director, and Mrs. Loren Eiseley, assistant director, of the Pennsylvania Academy of the Fine Arts, for bringing to light documents and letters which furnish valuable evidence about Mary Cassatt's student days at the Academy; Mr. Francis James Dallett, former librarian of The Athenaeum of Philadelphia, and Mr. Nicholas B. Wainwright, director of The Historical Society of Pennsylvania, for help in locating former Philadelphia and West Chester residences of the Cassatt family; Miss Rose Demorest, librarian, Carnegie Library, Pittsburgh; Mrs. Henry W. Howells, Jr., librarian of the Frick Art Reference Library, who helped in various research problems. I should like to thank Mr. John Walker, director of the National Gallery, Mr. Perry T. Rathbone, director of the Museum of Fine Arts, Boston, Mr. Henry S. Francis, curator of paintings, The Cleveland Museum of Art, and Mr. Henry G. Gardiner, assistant curator of paintings, The Philadelphia Museum of Art for their

courtesies; Mr. William Davidson, of M. Knoedler and Company, Mr. Norman Hirschl, of Hirschl and Adler, and Mr. Vladimir Visson, of Wildenstein and Company, for their assistance in locating many paintings and photographs.

I am particularly grateful to Mrs. Adelyn Breeskin, former director of the Baltimore Museum, for putting at my disposal her wealth of Cassatt photographs, and to Mrs. G. Page Ely, Mrs. Jane Miller, Mr. Henry Drinker, Mr. Harris Whittemore, Jr., Mr. Calvin Stillman, Mr. Donald W. Pierpont, headmaster of Avon Old Farms, and Mr. Carroll Tyson, for making available to me important letters, or for their personal reminiscences; Mrs. MacKinley Helm (Frances Hammond), for a most interesting account of Mary Cassatt's visit to Boston to paint the Hammond children; Mrs. Cameron Bradley (daughter of Mrs. J. Montgomery Sears), for letters, photographs, and delightful accounts of the pleasant relationship that she and her mother had with Mary Cassatt in Paris.

Before their deaths, Mrs. J. Watson Webb and Mrs. Peter H. B. Frelinghuysen (daughters of Mr. and Mrs. H. O. Havemeyer) were of tremendous help with letters, with their mother's memoirs, and in recalling Mary Cassatt and her close association with their family. I should like to thank Mr. J. Watson Webb, Jr., for permission to read the letters from Mary Cassatt to his grandmother.

Finally I wish to express my gratitude to the members of the Cassatt family for their great co-operation and interest; first to a distant cousin, Mrs. Lilian Casat Smith, for lending me the family genealogy; then to the group of closer cousins, descendants of Mrs. Robert Moore Riddle: Mrs. William Howard Hart, Mrs. Donald B. Barrows (Anna Newbold), Mr. Clement Newbold, Jr., and particularly Mr. Edgar Scott; and to the several grandchildren of Mary Cassatt's brother Alexander J. Cassatt: Mrs. Eric de Spoelberch, Mrs. William Potter Wear, and Mrs. Stewart Simmons, all daughters of Mrs. William Plunket Stewart (Elsie Foster Cassatt); Mr. Alexander Johnston Cassatt and Mr. Anthony

Drexel Cassatt (sons of Robert Kelso Cassatt), who lent me important letters and recalled childhood visits to Château de Beaufresne; and Mrs. John B. Thayer (Lois Cassatt, daughter of Edward Buchanan Cassatt), who put at my disposal her wealth of Cassatt family letters, documents, and photographs. This material more than any other single source has been of inestimable value in writing this book.

I owe the greatest of thanks to the three children of Mary Cassatt's younger brother, J. Gardner Cassatt: his son, J. Gardner Cassatt, who lent me Mary Cassatt's obituaries and clarified many details of her life, Mrs. Percy C. Madeira, Jr. (Eugenia Cassatt), who lent me letters and photographs and permitted me to examine the furnishings of her house, which were formerly in Mary Cassatt's apartment in Paris, and Mrs. Horace Binney Hare (Ellen Mary Cassatt), to whom I wish to express my most profound appreciation for lending me the family history, letters, and photographs and for her endless patience in answering my lists of questions either by letters, in hours of conversation at her house in Radnor, or while driving me around to see other Cassatt houses.

I wish to thank my wife, Esther Stephenson Sweet, for helping me with bibliographical problems and for careful reading and wise criticism of my manuscript. I am grateful to Mr. Anselmo Carini for advice about reproductions. Finally I offer my thanks to Miss Helen Perce for typing the first draft of the manuscript of this book, and to Miss Sandra Grung for carrying through the arduous task of typing the final revision.

I am indebted to the following publishers and private individuals for permission to quote from the publications indicated: Bruno Cassirer, Oxford, *Degas Letters*, edited by Marcel Guérin, translated by Marguerite Kay; Quatre Chemins, Editart, and Mme Ernest Rouart, Paris, *Correspondence de Berthe Morisot*; Mrs. Helen Haseltine Plowden, *William Stanley Haseltine*; Mr. John Rewald and Pantheon Books, Inc., New York, *Camille Pissarro Letters to His Son Lucien*; Mr. John Russell, *Unfor-*

gotten Years, by Logan Pearsall Smith; Mrs. Peter H. B. Freling-
huysen and Mrs. J. Watson Webb, *Sixteen to Sixty, Memoirs of a
Collector*, by Louisine W. Havemeyer.

I wish to express by appreciation to the following for generous-
ly placing at my disposal letters from Mary Cassatt, members of
her family, and others: The Baltimore Museum of Art; Mr.
George Biddle; Mrs. Cameron Bradley; Department of Prints
and Drawings, The Brooklyn Museum; Mr. Alexander J. Cassatt;
The Art Institute of Chicago; The Detroit Institute of Arts; Mr.
Henry T. Drinker; Mrs. G. Page Ely; Gilman's Old Books,
Crompond, New York; Mr. Charles Gimpel; Mrs. Horace Binney
Hare; Mrs. Jane Miller; The Print Room, The New York Public
Library; The Pennsylvania Academy of the Fine Arts; The
Archives of American Art, The Philadelphia Museum of Art;
Mrs. Abram Poole; Mrs. John B. Thayer; Mr. Carroll Tyson;
Mr. George L. Watson, Director of the Hill-Stead Museum,
Farmington, Connecticut; Mrs. J. Watson Webb; and Mr. Har-
ris Whittemore, Jr.

I wish to express my appreciation to Miss Sibyl Pantazzi for
obtaining permission from Miss Irene Cooper Willis for me to
quote from a letter from Vernon Lee to Clementina (Kit)
Anstruther-Thomson.

FREDERICK A. SWEET

Chicago, Illinois
March 22, 1966

Introduction

"FROM THE UPPER DECK I could see Miss Cassatt walking impatiently up and down the wharf," Mrs. Henry O. Havemeyer commented in her memoirs about landing in Genoa on the *Kaiserin Augusta Victoria* in February, 1901. Mrs. Havemeyer was a poor sailor despite thirty previous trans-Atlantic crossings, but the Hamburg-American's new idea of a southern cruise to reach Italy by way of Madeira, Gibraltar, and Algiers had somewhat alleviated the situation, for the stopovers at hitherto seldom-visited ports had been most fascinating. In fact these pleasant and exotic side trips and a tolerably calm sea had made Mrs. Havemeyer, her husband, and her sister, Mrs. Samuel T. Peters, all reluctant to leave the ship. However, an exciting venture lay ahead of them, for they were going on an extensive picture-buying trip with Mary Cassatt as their leader and adviser.

"Impatient" would indeed have described Miss Cassatt's manner as she walked up and down the dock, a tall, slender, erect, scrupulously well-tailored American spinster in her mid-fifties. She did not like to waste time and was obviously annoyed at the delay in docking the ship. Then, too, for one who talked incessantly, her lack of facility with the Italian language must have been highly frustrating. Despite being bilingual in French and English as well as having fluency in German, she would not have found any of these to be much help on a Genoese dock on a chilly

February morning. She was most anxious to see her closest friend, Louie, as she called Mrs. Havemeyer. This friendship was entirely mutual, for Mrs. Havemeyer regarded Mary Cassatt as her only really intimate friend. Their meetings nearly always took place in Europe, where they had first met in 1873. In fact, Miss Cassatt, who was invariably desperately seasick, had in 1898 been back to America for the first time since she took up residence in Paris in the early 1870's. Even though she spent so little time in her native country, she exercised a stronger influence on art collecting in America than any other individual of her day. This was due to a series of fortuitous circumstances. In the first place, as a woman coming from a family of fine cultural traditions and ample means, she was in a position to know people who had both the taste and the money to purchase works of art. Furthermore, as a resident of Europe she had the opportunity of visiting all the important galleries and of becoming thoroughly familiar with both old masters and her contemporaries in painting. This would have been impossible in the sparse museums of the United States in the late nineteenth century. Perhaps the most significant aspect of her role as an adviser was the fact that she herself was a serious, hard-working artist who had gained the respect of Edgar Degas and members of the Impressionist group and was accepted by them professionally as an equal and invited to exhibit with them. Thus she knew the independent artists, the more advanced painters of the last quarter of the century, and, because of her belief in them, was able to interest her American collector friends in purchasing their work. One might wonder how a young American woman of impeccable background would have had the temerity to become an artist in the Paris of the 1870's. Mary Cassatt was a person of such character and determination that she would have had the temerity to do anything that she firmly believed in.

Extensive travel in Europe in her childhood had given her and her family a familiarity with continental life and made the shortcomings of American museums and art schools all too apparent. At seventeen Mary Cassatt enrolled in the Pennsylvania Academy

Illustrations

COLOR PLATES

Miss Mary Cassatt

IMPRESSIONIST FROM PENNSYLVANIA

.

Family Background and Early Childhood

I T HAS OFTEN been said that Mary Cassatt preferred to spend the greater part of her life in France because of the fact that, being of French blood, she felt more at home in the cultivated milieu of her ancestors. A look at the family records reveals the fact that she could claim to be only one sixty-fourth-part French, for the Cossarts (as the name was originally spelled), like so many other Huguenot families, wandered far and intermarried in the course of eight generations with a succession of non-French strains. Jacques Cossart, born in Normandy in 1595, sought the greater freedom of Protestant Holland, settling in Leyden, where his son Jacques was born in 1639. In France the severe restrictions imposed on Protestants had been somewhat alleviated in 1598 when Henry IV promulgated the Edict of Nantes, but this halfway measure did not satisfy the Cossarts, who demanded complete freedom of worship.

At seventeen Jacques Cossart, the younger, married Lea Vilman and removed to Frankenthal, a German Huguenot village in the Palatinate, where their first children were born. Soon the young couple was on the move again, for on October 12, 1662, accompanied by their five-year-old daughter Lea and the infant Susanne, they boarded the *Pumerlander Kerch* in Holland and two days later set sail across the Atlantic to New Amsterdam. The ship carried about ninety passengers and charged each the sum

of thirty-nine florins for the crossing, with children at half-price and infants free. Jacques Cossart was billed by Skipper Benjamin Barentsen for 97½ florins, the equivalent of about $150 today. In New Amsterdam he established himself as a miller; his house was one of those which stood on the site of the present Produce Exchange Building near the Battery and Bowling Green; his church was the nearby Dutch Reform. In their later years Jacques and Lea moved to a forty-acre farm in Bushwick, Long Island, where they both died.

Their sixth child, David Cossart, became a prosperous builder and contractor and about 1720 moved to Bound Brook, New Jersey, where he purchased large tracts of land. His house remained standing for many years and was a notable landmark until destroyed by fire in 1881. On June 10, 1736, David, who indicated his superior social status by placing "Gentleman" after his name, drew up his will, in which he left most of his estate to his wife, Styntje van Horne Cossart, but made provision, "If She marieth to another man or when She is Dead, my whole Estate Shall be devised as follows Att the Experation of one year and Six weeks." Here follow bequests to his three sons and six daughters and to the heirs of two deceased children. As the births of all eleven of these children are recorded in the Dutch Reform Church of New York, the last being in 1719, the family presumably did not move to Bound Brook before this date. To his son Francis he left "one hundred acres of Upland and ten acres of the back part of my mowing meados—and a Dutch Bible." He also designated that the other brothers must help David build a house "as high and as wide and as long as the house that now Standeth on the hundred and ten acres which is affore willed to Francis."

About 1765, Francis and his wife, Margaret van Nest, moved to York County, Pennsylvania, where he became a member of the Committee of Correspondence, a delegate to the Convention of 1776, a member of the Provisional Assembly, and one of those who helped frame the first state constitution. He was one of about 170 Jersey families which had settled in Conewego near Hunters-

town, six miles northeast of the present Gettysburg, where at the time of the Revolution the Dutch Church had one thousand members. Francis Cossart and David Van Duyn, whose children were later to marry, were trustees of the church. Soon the colony dwindled, and by 1817 there were only five families left, most of the others having moved west into Kentucky; the church ceased to exist and the town name, Conewego, disappeared.

David Cossart, son of Francis, married Sarah Van Duyn, thus again introducing Dutch blood into the greatly minimized and by now scarcely remembered French strain. David, who belonged to the York County militia and was a member of the Pennsylvania Legislature, about 1800 changed the spelling of his name to Cassat. Usually such changes are the result of fitting spelling to a local pronunciation, which in this case suppressed an "r" and changed the quality of a vowel sound. Stress was made on the first syllable; not until after the middle of the century did the family accent the second syllable. Even then older people continued to pronounce the name to rhyme with Basset.

More changes took place as the family moved farther west and new blood streams came in through later marriages. Denis (or Denys) Cassat, son of David and sixth generation from the Frenchman Jacques Cossart, married in Pittsburgh Lydia Simpson, a Scotch-Irish girl, then moved to Wheeling, where he made unfortunate investments in Ohio lands and died insolvent in 1808. His widow went back to her brother Robert Simpson's house in Pittsburgh, where her children, Robert and Mary, grew up. In 1830, Mary married Dr. Joseph Gardner, whose father, Dr. Frank Gardner, like so many Pittsburgh residents, had come west from Chester County. In the meantime her mother married for her second husband Paul Morrow.

Then on January 22, 1835, her brother, Robert Simpson Cassat married Katherine Kelso Johnston in Trinity Church, Pittsburgh. Here four of their children were baptized, as had been Katherine herself.[1]

[1] The original records of Trinity Church (now Trinity Cathedral) list under baptisms for March 26, 1820: Catherine Kelso, born October 8, 1816, of Alexander

The day after their marriage they moved into their own house in Burgess Row, Liberty Street, Pittsburgh. Colonel James Johnston, Mrs. Cassat's grandfather, who had fought in the Revolution, came to live with them and remained until his death in 1842. Their first child, Katherine Kelso Cassat, was born December 30, 1835, and died the same day. After a year they moved into a house built by Robert at the corner of Penn Avenue and Hay Street, Pittsburgh, and there Lydia Simpson Cassat was born July 23, 1837. Alexander Johnston Cassat, later destined to become the president of the Pennsylvania Railroad, was born in the same house on December 17, 1839.

The following year they moved across the river to a house which Robert had built on Rebecca Street (now Reedsdale Street) in Allegheny City near the Manchester line. At that time this area near the Ohio River was considered a most desirable place to live, but these old houses have long since been torn down. The Baltimore and Ohio Railroad tracks spoiled the section, which is now made up of row houses of the eighties and nineties and is a depressed area of tawdry shops and run-down tenements. Ridge Avenue, which runs off Rebecca Street up to a high bluff, became the fashionable street of the so-called "old North side." In 1907, Allegheny City was incorporated into Pittsburgh.

Robert Kelso Cassat, the fourth child, was born in the Rebecca Street house on June 5, 1842. Under "Births" in the family record Robert Cassatt recorded in Spencerian hand the birth of their fifth child.

Mary Stevenson Cassatt, daughter of Robert and Katherine K. Cassatt was born in Allegheny City, Allegheny County, Penna.

and Mary Johnston. The Trinity Church marriage records show under January 22, 1835:

> Robert S. Cassat
> Katherine K. Johnston *Witnesses:*
> Wm. McKnight
> Sam'l P. Darlington

Apparently Mrs. Robert Cassat changed the spelling of her first name from a "C" to a "K"; yet this was not consistent, for under the baptismal records of three of her children the parents are listed as "Robert and Katherine Cassat" while in the baptismal record of her fourth child, Mary, she is called "Catherine K. Cassat."

in the house built by her father on Rebecca Street on Wednesday night, May 22d, A.D. 1844 at 55 minutes past eleven o'clock.

Her original baptismal record in Trinity Church, Pittsburgh reads: Mary Stevenson, baptized April 2, 1847 (born May 23, 1844) daughter of Robert S. and Catherine K. Cassat.[2] The Reverend Dr. Upbold officiated. The birth year 1844 is substantiated, but the day is May 23 instead of 22, a reasonable error if, as her father stated she was born so close to midnight. Mary Cassatt's birth year has almost always been given as 1845, but this is not only discounted by the records but would in any case have been impossible since by May, 1845, her mother was already expecting another child.

Mary Cassatt dropped her middle name later, but it is significant that it was her maternal grandmother's name, just as her sister was named for their other grandmother and their older brother for their maternal grandfather. All three of these grandparents were Scotch-Irish, thus accounting for three-quarters Scotch-Irish blood in Mary Cassatt and indicating that the family was proud of the fact. As three previous generations of Cassatts had married into Dutch families, a considerable portion of the remaining quarter of their heritage was Dutch, while the actual amount of French blood remaining in the family was very slight.

On January 22, 1846, George Johnston Cassatt was born in the house on Rebecca Street, but died less than a month later, on February 17. Robert was mayor of Allegheny City that year and in 1847 and 1848 was president of the Select Council, but during the year 1848 the family moved back to Pittsburgh to the corner of Penn Avenue and Marbury Street, later changed to Evans Way. All this section has now been razed to make way for a large office building which is part of the new Golden Triangle project. Before the year was out, they went to eastern Pennsylvania and acquired Hardwick, a country place near Lancaster, where their

[2] Although the baptismal records all spell the name Cassat with one "t," Robert in his recordings usually (but not always) spells the name with two "t's." He was the first member of the family to do this, but seems not to have been consistent in his use of the double "t" until sometime in the 1840's. The spelling of his wife's first name is also inconsistent.

7

seventh child, Joseph Gardner Cassatt, was born January 13, 1849.

Dr. Joseph Gardner, uncle by marriage, for whom the Cassatt baby had been named, died on March 10, and shortly thereafter his widow, Mary Cassatt Gardner, sold his personal property and medical books and established her house in West Chester. About this time the Robert Cassatts moved into a rented house at 496 West Chestnut Street, Philadelphia, in the newly developed area several blocks west of Broad Street. On November 19 the directors of the Athenaeum of Philadelphia approved Robert's admission to membership to their subscription library after he purchased a share on the market.

As the Cassatts were Episcopalians, they attended the Church of the Epiphany, where their youngest child, Joseph Gardner, who would later be called by his middle name, was baptized on June 15, 1851.

In this same year Robert Cassatt had a group portrait painted of his three sons. Alexander appears at the left as a handsome, dark-haired boy of eleven, next to him is Robbie, a blond lad of nine, and in front is little Gardner, scarcely two. The painter of this very charming group was almost certainly James Reid Lambdin (1807–89), a contemporary of Robert Cassatt with whom he had grown up in Pittsburgh. Lambdin was a pupil of Sully for a year, but returned to Pittsburgh to paint portraits and to open the first Gallery of Fine Arts in the West. In 1838, however, he went back to Philadelphia, where Robert Cassatt discovered him and renewed their boyhood acquaintance. It is to be regretted that he did not also paint Mary and Lydia.

Mr. Cassatt had been settled in Philadelphia scarcely two years when he decided to take the whole family for an extended trip abroad. As they had been a good deal on the move up to now, they looked upon the proposed trip as another adventure, although they hated to leave Hardwick, the Lancaster County country place, where in the luxuriantly rolling green hills the children enjoyed country life and all its accompanying farm animals.

Mary Cassatt at this time learned to ride horseback, benefiting from good early training which was the basis of her becoming such an excellent horsewoman. She not only rode superbly, but became a masterful driver, expecially of a tandem.

Travel in Europe was leisurely in the fifties, trains were slow and uncertain, journeys were tiresome, and people tended to remain in a place for some time before moving on to the next. In the fall of 1851 the Cassatt family was comfortably installed in the Hôtel Continental in Paris. The children were taking up French, which, to be sure, they had already started at home with their mother, who was a French scholar trained in Pittsburgh by an American woman who had studied at Mme Campan's in Paris. Mary gained a facility which was to her advantage when she came later to settle in Paris, but she always spoke with a Pennsylvania accent. Her father, though well read in French, never had facility in speaking.

On December 2, Robert Cassatt went out on the street fairly early but returned shortly and told the family to remain quietly in their rooms as trouble was brewing. After investigating further, he came back and said, "Well, Louis's done it!" This was the day on which Louis Napoleon accomplished his *coup d'état* ushering in the Second Empire. Although Mary Cassatt was only seven on this momentous day when Napoleon III achieved status as emperor, she remembered the event clearly in later life. Nearly twenty years after this she witnessed Napoleon's downfall and was forced by her family to return home. Again, in 1914, German bullets were whizzing around her to such an extent that she had to escape to the Riviera. Fortunately, she did not live to witness the ravaging of her château which took place during World War II. Disaster was always brushing near, but appeared unable to touch one so indomitable. As far back as April 10, 1845, when she was less than a year old, the great Pittsburgh fire had all but laid the whole city in ashes. From across the Allegheny River the Cassatts grimly watched the holocaust which swept away a thousand houses at a loss of five million dollars. In October, 1871,

during her enforced visit to America to escape the Franco-Prussian War, Mary Cassatt and two cousins, who were visiting in the Middle West, just escaped being caught in the Chicago Fire.

While in Paris in the early fifties, the Cassatts had a furnished apartment on the Rue Monceau and then one on the Avenue Marbeuf just off the Champs Élysées. As Alexander, the oldest of the brothers, showed great talent along technical lines, his education became of primary concern to the family. They decided that German schools offered better facilities for him than Monsieur Gachotte's in Paris, so they moved to Heidelberg in order that he might attend an excellent boarding school. While living there, four members of the family were included in a group portrait done in pencil by Baumgaertner and dated Heidelberg, 1854 (Plate 3). At the left Gardner, by now a boy of five, stands in a Scotch plaid suit with an elbow on the table. Next to him is seated Robbie, leaning on his left elbow intent on a chess game, which he is playing with his father seated across from him. Between them, looking intently out toward the spectator, stands Mary in a velvet dress with lace collar. This is our earliest impression of the artist, and her features already show at the age of ten the salient points which will characterize her for the rest of her life. We see the wide-apart, kindly, but intense gray eyes, prominent brows, the somewhat large and slightly upturned nose, the long upper lip and tightly compressed mouth, and, most marked of all, the long pointed chin. Her hair, parted in the middle, braided, then doubled up and tied with a pair of hair ribbons, gives her a prim look. By no means a pretty child, she has, nevertheless, most appealing qualities, a wistful charm, an alertness, and, above all, character. One can plainly see these very qualities intensified in pictures of her as an older woman. Never beautiful, she was imposing, aristocratic, dynamic, forceful, and self-assured. Already these traits began to be apparent in the little child in Heidelberg.

Since Alexander demonstrated marked ability in engineering, the family went to live in Darmstadt so that he might attend the *Technische Hochschule*, one of the outstanding technical uni-

versities in Germany. Robbie, the middle son, had not been at all well and, as spring approached, he grew far worse. He died on May 25, 1855, and was buried at Darmstadt. At the time of his death his father recorded the circumstances at length in the family history and went on to say:

〰 It being the intention of his parents to have his remains brought to the United States as soon as practicable, a simple grave stone is placed over his grave in Darmstadt merely recording his name and country. For almost five years previous to his death Robert had been afflicted with disease of knee joint.[3] He suffered very severely at times. He was a model of fortitude and patience.

Since the family did not return immediately to America, nothing was done about the transfer of Robbie's body until years later when Mary Cassatt went to Darmstadt to perform this duty. Difficulties were put in her way which she finally overcame by bringing her brother's remains back to France as part of her personal luggage. Reinterment was then made in the family burial plot at Mesnil-Théribus.

While the educational needs of Alexander kept the Cassatt family a good deal in Germany, first in Heidelberg, then in Darmstadt, they were always attracted to Paris. Having witnessed without mishap the *coup d'état* of 1851, which brought imperial status to Louis Napoleon, they were ready to celebrate with the new Emperor the successful establishing of the Second Empire. Wishing to show both the strength and the progressiveness of Napoleon III, France organized a great World's Fair, the *Exposition Universelle*, in Paris in 1855. For the first time there was included a big international art section. The most discussed French artists of the time were Ingres, with forty canvases in the exhibition, and Delacroix with thirty-five. Which was more important, line or color? Which trend should one follow, the classic or the romantic? One faction supported Ingres with his clean-cut line, orderly, static compositions, which were classical in their

[3] It is probable that one of their reasons for going abroad was to take Robbie to European bone specialists.

composure; others championed Delacroix, alive with color, action, and dynamic qualities that broke every rule of tradition and bespoke the romantic movement. The public should decide which to follow, but they ended by continuing the argument, and, as in most art quarrels, nothing was settled. Degas and Pissarro were at the *Exposition*, and so was Whistler, all just beginning their careers as artists.

Mary Cassatt was eleven at the time and had never heard of her compatriot Whistler, still less of Degas and Pissarro, both of whom she would know so well at a later date. Her impression of the Fair did not lead her to discussions of line versus color; she was rather more impressed by the pageantry of the occasion. A very colorful account of this side of the spectacle is given in a letter written by a fellow Philadelphian, the young painter William Stanley Haseltine, August 30, 1855, addressed to his mother on the occasion of Queen Victoria's visit to the Paris Fair:

On Saturday the Queen entered Paris. The streets from the depot of the Chemin de Fer to the Palais de St. Cloud were thronged with people. A double line of soldiers was formed along the whole distance, which is about ten miles, and it is calculated that there were as least a million people present.

I had a very good look at the Queen; for this satisfaction I had to wait six hours in a dreadful crowd. On different occasions I also saw the Emperor, the Empress, Prince Albert, Princess Royal, Prince of Wales, Prince Napoleon, etc. The Queen is a youthful-looking lady and not bad-looking; the Emperor, however, has nothing to boast of in that line; his only prominent features are his nose and his moustache; the latter by its peculiar curl, sets the fashion for the shape of all similar appendages in Paris. Prince Albert is quite handsome; Prince Napoleon resembles, to a shade, the portraits of his Uncle; he is the Heir-Apparent to the throne, should Napoleon die without issue.

Paris according to all accounts, never presented a gayer appearance than it does at present; the houses are covered with flags.

Embarking on a Career

BEFORE GOING to Europe, Robert Cassatt had frequently visited his sister, Mary Gardner, at West Chester and delighted in this little town in the country, located some twenty-five miles west of Philadelphia. While resident in Heidelberg on June 2, 1853, he purchased for $1,900 from Howard P. Davis one and one-half acres of land at the corner of Church and Union streets, West Chester, but, as he had not carried out his intention of building a house on this lot, on returning from Europe late in 1855, he moved the family into a rented house at the corner of High and Minor streets. Two years later they were living in another rented place, a large brick double house on the north side of Chestnut Street between Walnut and Matlack streets. Meanwhile Robert Cassatt sold the building lot at an $800 profit, and for $2,200 purchased ten acres of ground on the east side of New Street from Jonathan T. Marshall and his wife. This adjoined a place belonging to Philadelphia cousins, the Gillies Dalletts, who spent the summer in West Chester. Mr. Cassatt, deciding that he did not wish to live so far from town, purchased for $4,000, on March 18, 1858, a house and lot in Philadelphia on the south side of Olive Street, at the corner of Fifteenth Street. This was soon renumbered 1436 South Penn Square, a four-story brick house which is still standing, the only private residence left

on the square. Now covered with yellow stucco and housing the Penn Bar-Grill, this house used to be one of many in the charming residential area surrounding the little park then known as Center Square, where earlier in the century the Fairmont Waterworks had stood. Designed by Benjamin H. Latrobe in 1801, this building was one of the most distinguished architectural features of the city; later in the century the City Hall usurped the whole square and the residences around the sides gave way to commerce.

Alexander Cassatt, who had greatly benefited from his studies in Germany, entered Rensselaer Polytechnic Institute in Troy, New York, in January, 1857, and graduated in 1859 as a civil engineer. This training fitted him admirably for his career as a railroad man, yet for a time he must have been involved in one of his father's impractical short-lived projects. On November 17, 1860, he wrote from Dalton, Georgia:

In three years Mary will want to go to Rome to study and by that time our vineyard would be in bearing, and you could all afford to go and leave me here to work for you.

This casual reference to Mary Cassatt's early desire to study abroad is revealing since it indicates that at the age of sixteen she had already mapped out a career for herself. Alexander's suggestion about their all going abroad is also significant since it shows that he was well aware of the fact that his father loved to travel in Europe and that he had really no great interest in business or any activities associated with earning a living. At the end of the three years, however, travel was impractical since the United States was then in the midst of the Civil War, Alexander had begun his career as a railroad man, and in 1868 was married. His father had to put off for a few years any idea of going abroad to live since he could not expect his son with responsibilities of his own to "work for him."

Meantime Robert Cassatt sold his ten acres in West Chester at a slight profit and purchased on March 30, 1860, thirty-seven and a fraction acres for $3,232.47 at Cheyney, in Thornbury Town-

ship, Chester County, with the privilege of building a water wheel in Chester Creek. Here in 1861 he built a country house which the family used at first for week ends, but made it their year-around residence in 1863, when on December 8 they sold the Philadelphia house for $7,500 to William W. Keys. This was a simple stone house built very much in the style of the eighteenth-century farmhouses except for the Victorian porch and round-arched end windows.

Robert Cassatt's constant shifts in real-estate holdings indicate his lack of decision regarding what he wanted to do. Although he maintained a brokerage office in Philadelphia, he was never a very successful businessman; on the other hand, he was seriously interested in his farm at Thornbury Township, where he was respected by his country neighbors. Although he had taken out a new membership share in the Athenaeum of Philadelphia in 1857, he did not belong to any other clubs and took no part in civic or public affairs.

In the fall of 1861 his daughter Mary, then a girl of seventeen, decided to become an art student. As the Pennsylvania Academy was not only one of the very few art schools in the country but the only one in Philadelphia, she took advantage of the sole opportunity at hand. In Mary Cassatt's time the Academy occupied its old quarters, a classical building on the north side of Chestnut Street between Tenth and Eleventh streets. The original building, attributed to the noted architect Benjamin H. Latrobe, had been erected in 1806. Broad marble steps led up to a portico of two Doric columns. In the center was a circular room over which was a dome in the style of the Pantheon. After a disastrous fire in 1845, the Academy was rebuilt in the same style, then sold in 1870 when the move to larger quarters at Broad and Cherry streets was contemplated. Over the doorway of the present building is a statue of Ceres which stood in a corner of the courtyard of the old building under the shade of the largest hawthorne tree in the United States.

Through her fellow-student, Eliza Haldeman, we gain some impressions of life at the Academy:

~~~ We have several new pupils, both male and female but Miss Cassatt and I are still at the head (i.e., of the ladies). Most of the old gentlemen scholars have gone away to paint.

So Miss Haldeman wrote to her father December 21, 1861. On the following March 7 she wrote him about an Academy escapade and enclosed a photograph in which Mary Cassatt and other art students are seen working on a project, describing in detail the incident:

~~~ DEAR FATHER:

We had some fun about a week ago. Miss Welch, one of our amateur students, that is to say, she don't intend to become an artist, wanted to cast the hand of a friend of hers, a gentleman, so they came down one morning and commenced. As she did not know the first thing about casting you may know how she proceeded. Miss Cassatt and I went in to look at her and asked why don't you do this? How will that come out? You have too much undercasting here, so she finally found it would be well to have some assistance, introduced us to the gentleman and asked us to help her, which we did, making an excellent cast and flattering the specimen of Genus Homo exceedingly; his experience of artist life was so pleasant that he begged if we were willing to send for a photographer and have the whole scene taken just as we were. We consented, and got Mr. Cope's permission to go in the galleries and had it taken there with the Gates of Pisa or Paradise for the background and the little bust of Palm Springs and another on each side. Miss Welch had a hammer and chisel knocking off the plaster. Miss C. had the plaster dish and spoon which we had used before. Inez Lewis was knocking also. I had a spoon helping Miss C. and Dr. Smith, the owner of the hand in question, was behind. It was an excellent picture and he is going to present us each with one when they are finished.

Up until 1868 the Academy was run by a "Committee on Instruction," who were also members of the board of trustees. Under them the school operated four departments, the largest of

which was the Antique Class in which students drew from Greek and Roman casts. They also conducted a Life Class, with strict requirements for entrance, and Professor Amos Russell Thomas, M.D. gave a regular series of lectures in anatomy. Dr. Thomas graduated from Syracuse Medical College in 1854, and was professor of anatomy at the Pennsylvania Medical University from 1856–66; during the same period and on to 1870 he was lecturer in "artistic anatomy" at the Pennsylvania Academy. The fourth activity was copying from examples of painting in the Academy's permanent collection. On December 8, 1864, permit No. 53 was granted to "Miss Cassatt to copy a portion of picture Deliverance of Leyden by Wittkamp." This large and ponderous Dutch painting was for years a landmark and until a few years ago hung high in the stair hall of the Academy's present Victorian-Gothic building. Copying even a portion of a Wittkamp must have been as tedious in its way as the constant drawing from dull, lifeless casts. Mary Cassatt after four years certainly found it so, and at twenty-one had sufficient maturity to be fully aware of the inadequacies of her teaching. It was quite obvious to her that the meager facilities of the Pennsylvania Academy were not up to what she needed.

Robert Cassatt was not averse to his daughter's interest in art, but he was a stubborn man and could not comprehend the idea of the daughter of a gentleman having any thought of making painting a career. As a conservative broker, providing his family with a moderately good living, he had an interest in cultural pursuits, but to him it was unthinkable for a young woman of means and social position to go out into the world as an artist. Mary Cassatt was determined in her efforts and decided that the only possible solution was to convince her father that she must have prolonged study in Europe. At length, in 1866, Mr. Cassatt reluctantly gave his permission for her to go abroad.

If Mary Cassatt had not gone to Europe, or at any rate had not remained there, she would have been brought up in a conventional, well-bred Philadelphia where her family and their friends would have regarded her as an eccentric, and some of them would

have been caustic and ruthlessly outspoken in their condemnation of her "career." It is safe to say that she would never have achieved a position of distinction in the art world, for Mary Cassatt was not a very inventive painter and could prosper only when she was surrounded by strong influences. In Philadelphia there was no Degas, no Courbet, no Renoir. She matured slowly, and even with years of European training did not paint a picture worthy of anyone's attention until she was twenty-eight years old. Had she returned to Philadelphia at that time, her work would probably have remained traditional, Impressionism might never have touched her, and Japanese art, so important an influence, would have remained unknown to her. One can only be grateful that she did choose to cast her lot with the French.

Robert Cassatt was only too well aware of the criticism that would be aroused by permitting Mary to go to Europe alone, and he went to great pains to see that her life was arranged in the most circumspect manner. In Paris she lived with friends of the family and, as far as her social life went, conformed to all dictates of the most correct *haute bourgeoisie*. Her friend Eliza Haldeman was there, other Philadelphia friends and relatives came and went, and both Mrs. Cassatt and Lydia were with her part of the time. She studied briefly at the atelier of Charles Chaplin but soon realized that his suave and luxuriant style, academic and over lush, was not her métier. She met American art students, such as Walter Gay and Alfred Q. Collins, with whom she exchanged sketches, but she felt that her future lay in working on her own. A small early portrait, "Head of a Young Girl," which she gave to Gay in 1878, is now in the Museum of Fine Arts in Boston, and a similar sketch, given to Collins, was owned by his brother-in-law, Forbes Watson. Collins and Gay were then students of Léon Bonnat.

While Mary Cassatt plodded slowly through the formative stages of her development as an artist, her brother Alexander made fast progress as a railroad man. His career was not only of the greatest interest to the rest of the family, but his growing prosperity gave them all a sense of stability. He was very con-

genial with his sister Mary, and often mentioned her in letters to other members of the family. These references, brief though they may be, are of the utmost value in helping us follow her movements.

With Mary Cassatt's plans of study abroad and Alexander's progress in the railroad world both maturing at the same time, the older Cassatts decided to give up their country place and devote their efforts to the interests of their children. On April 7, 1866, Robert Cassatt advertised in the *Village Record* of West Chester, that on April 18, a sale was to be held of farm stock and furniture, all of which were enumerated in detail. On April 23 he sold the land and house for $10,000 to Mr. Addinell Hewson of Philadelphia. Presumably the Cassatts then went abroad for a while to establish Mary in Paris, but they were soon back in Pennsylvania.

In 1867, Alexander Cassatt was stationed at Irvineton, Pennsylvania, on the Allegheny River as superintendent of the Warren and Franklin Branch of the Pennsylvania Railroad. That fall he became engaged to Lois Buchanan, a niece of President Buchanan. In October Lois recorded in her journal:

He [Alexander] was with us a great deal and we went up to Irvineton and paid a short visit to his home, where his father, mother and sister Lydia are living with him.

Well-to-do Pittsburgh families favored Irvineton as a charming and quiet place to spend the summer. On October 23, 1867, Alexander wrote to his fiancée from Irvineton:

Father and Mother are talking about moving to Philadelphia this winter. They will certainly go if I am transferred to Altoona [where he was sent the following month]. Gard [his brother, J. Gardner Cassatt] will be through that school by spring, and intends going into a Banking House in Philadelphia and Mother would of course like to be near him. I don't know why, but Gard has a great fancy for being a banker, and does not want to be a Railroad man at all he says.

Presumably the older Cassatts stayed on at Irvineton, as they were not in Altoona and there is no indication of their being resident in Philadelphia at this time. On February 8, 1869, Robert Cassatt's membership in the Athenaeum was declared forfeit for nonpayment of dues.

Then on November 27, 1867, Alexander wrote Lois from Altoona:

I received a letter from my sister Mary the other day. Mary was always a great favorite of mine, I suppose because our tastes were a good deal alike. Whenever it was a question of a walk, or a ride or a gallop on horseback, it didn't matter when or in what weather, Mary was always ready, so when I was at home we were together a great deal. We used to have plenty of fights, for she has a pretty quick temper and I wasn't altogether exempt from that failing myself; but we very soon made friends again.

Again on January 16, 1868, he wrote:

The Postman favored me today, for I have three letters, one from home, one from James[1] and one from my sister Mary. Mary's I will show you when I see you. I want you to know her, and as she is likely to remain in France another year, you can only become acquainted with her through the medium of her letters.

Although Alexander and Lois had been engaged since the previous fall, she did not yet wish it announced. Alexander's courtship had been anything but easygoing. He had in the first place been interested in Lois' sister, Harriet, but as he received no encouragement, he shifted his affections to Lois, who in turn was not sure of her ground. There was also a good deal of tension since she and the rest of the Cassatt family did not get on very well. Delay in the announcement of the engagement caused much comment.

Lois was overly sensitive and, if she fancied that she had been slighted, took her revenge in forbidding Aleck's visits at times. "Don't you think you are a cruel little tyrant?" was his comment.

[1] Lois' brother, James Buchanan, who died of typhoid, July, 1871.

She was also prudish and deplored his interest in the opera and theater and his lack of regular attendance at church. Lois' parents gave only a provisional consent to the engagement, realizing her uncertainty. Meantime all the Cassatts anxiously awaited a favorable decision as, whatever their feelings about Lois might be, they wanted Aleck to have the wife of his choice.

On August 24 Alexander wrote to Lois:

I also had a letter from Mary today she sends her love to you and wants to know what has become of that photograph of you that I was to send her. She asks me whether she may not soon write to you. I shall tell her that she can do so at once. She has sent home two of her pictures. I expect they will be here in a few days; and talks of painting another, subject *Mariana of the Moated Grange.* The lines always struck me as very pretty. Mary is an enthusiastic admirer of Tennyson, and she always said she would paint a picture of Mariana.

Mrs. Cassatt's letter of August 31 brought matters to a head.

My dear Lois,

We have just had a visit from Aleck who tells me that after all the delays and impediments which have postponed the announcement of your engagement, I may now address you as *almost* one of our family. I hope you will now do your best to enable me soon to call you altogether one of us. I am selfish enough to wish for this on Aleck's account, who I know will be so much happier and more comfortable when married and who really ought to be settled down soon. Now won't you be a very good girl and arrange so that I may soon have the pleasure of wishing you all the happiness I dare say you both anticipate in your own house? Also that I may be able to say that I have three daughters instead of two. I shall look for a favorable answer to this very soon.

Mary in her last letter says she is only waiting for permission to write to you. She congratulates him heartily.

Alexander Cassatt and Lois Buchanan were finally married at Oxford, Pennsylvania, November 25, 1868, with Lois' father, the

Reverend Edward Buchanan, officiating. Although Edward Buchanan was an Episcopal clergyman, his family were North of Ireland Scotch Presbyterians who had emigrated in the late eighteenth century to south central Pennsylvania, where his father was a storekeeper. Lydia Cassatt was not asked to the wedding, an omission that did not help the family relationships. The newlyweds lived in Altoona for three years, then moved permanently to Philadelphia in December, 1871.

Alexander's father gave him a French clock which had been owned by the family since about 1800 and had formerly belonged to Marie Antoinette. She had given it to a gentleman of her court who brought it to America and sold it to a great-uncle of Robert Cassatt.

Lois' mother, as the punctilious wife of a minister, was distressed for fear that her daughter would not mind her *p*'s and *q*'s in the more exalted world into which she had entered, and scolded her soundly for chasing after rich people in Pittsburgh who had not yet called on her. She had little cause for worry since the growing wealth and prestige of Alexander Cassatt assured his wife's position. A Philadelphian of impeccable background, however, once referred to Lois as "that little nobody, a niece of President Buchanan."

It is refreshing to turn from Mrs. Buchanan's petty admonishments to the sprightly account Mary Cassatt gave of her summer sketch tour. Although she had mentioned feeling homesick, there is no evidence of it here. This letter, the earliest of which we have any knowledge, was written to her newly acquired sister-in-law on August 1, 1869, from Beaufort sur Doron, Savoie, France.

MY DEAR LOIS:

I am here with my friend Miss Gordon from Philadelphia, and we are roughing it most artistically. We made quite a trip before getting here the first place we stopped at was Macon where we were perfectly disgusted and from there we went to Aix-les-Bains a very fashionable watering place entirely too gay for two poor painters, at least for one, for although my friend calls herself a

painter she is only an amateur and you must know we professionals despise amateurs, so as Aix was too gay we went to the mountains of Bauges to a place called Leeschesenseet[2] our original destination. Unfortunately our hosts had but two beds and as we occupied them both they were obliged to sleep in the barn so we took pity on them and left and after further journeyings we came here. The place is all that we could desire as regards scenery but could be vastly improved as regards accommodations, however as the costumes and surroundings are good for painters we have concluded to put up with all discomforts for a time. The Savoyards are a most civil people and talk a sort of mixture of French and Italian very hard to understand. We are just on the borders of Italy, we took a mountain excursion the other day and waded up to our ankles in snow, but were rewarded by a magnificent view of Mont Blanc and the St. Bernard, however we think we will rest satisfied with that and not try it again as we had to walk some twelve hours.

Now my dear Lois I expect to have a long letter from you soon, indeed I don't know whether it is indiscreet but I expect a very very interesting piece of news from Altoona before long, it will give me sincere pleasure to hear that it is all satisfactorily over and I may venture to congratulate you beforehand, for my part I want a nephew.[3] Give my love to Aleck and believe me, very affectionately your sister

MARY S. CASSATT

During the summer of 1870 the political situation between France and Germany became acute, and in August hostilities broke out. In order to avoid being embroiled in a catastrophe, Mary Cassatt reluctantly went back to Philadelphia on what she regarded as an enforced visit, and was determined to remain there only so long as the Franco-Prussian War lasted. Henrietta Buchanan mentioned calling on Mrs. Cassatt in Philadelphia on December 10, noting that Lydia was sick and Mary out. During

2 The spelling of this mountain hamlet may not be correct; it cannot be located on any map for verification.
3 Edward Buchanan Cassatt was born August 23, 1869.

the course of her Philadelphia visit, Mary Cassatt painted a full-length portrait of her nephew Eddie Cassatt, age two, in a red velvet suit and lace collar (Mrs. C. Oliver Iselin III Collection, Washington, D.C.). She attempted a sort of eighteenth-century elegance with rich colors and textures, but her achievement was limited by muddy tones and a lack of technical competence. It is difficult to believe that after all her study abroad her techniques were no further advanced.

In the fall of 1871 Mary Cassatt visited relatives in Pittsburgh then went on to Chicago with two cousins. She had some paintings with her and hoped to make some sales in the Middle West, but her ambitions were abruptly squelched by the disastrous Chicago Fire. Four days after the holocaust Alexander Cassatt wrote:

ALTOONA Oct. 12, 71 My dear little wife, Mother it appears did not go to Chicago, but stayed at the Meadows with Mrs. Johnston. Mary went on with Minnie and Aleck Johnston. They are now back at Pittsburgh, saved their baggage, but Mary's pictures were lost. I am glad they got off so easily.

The Alexander Cassatts were about to move from Altoona to Philadelphia, where in December they took up residence at 2035 Walnut Street. Their second child, Katherine Kelso Cassatt, had been born July 30, 1871. After a year on Walnut Street, they moved to 2030 De Lancey Place and bought a large tract of land in Haverford, where they built their country place, Cheswold.

Perhaps her loss in the Chicago Fire hastened Mary Cassatt's return to Europe in order that she might seriously take up her painting again. She sailed for Italy and spent a good deal of time in Rome, but the most important part of the journey was the eight months that she settled down in Parma to make an intensive study of the works of Correggio. There were, even then, important examples of his paintings in the museum, the "Madonna and St. Jerome" (*il giorno*) and the "Madonna della Scodella," painted originally for Sansepolcro. Besides these were the three frescoed domes: "The Camera" of the Convento di San Paolo,

which was the refectory of a nunnery; the "Ascension" in San Giovanni Evangelista; and, the greatest of all, the "Assumption," in the dome of the Cathedral. The healthy, natural, unsentimental virgins and children modeled with diffused shadows made a lasting impression on her. They not only were a formative influence in her style, but also directed her towards the maternal theme which we invariably associate with Mary Cassatt. Parmigiano's erect, commanding figures also made a strong impression on her. While in Parma she studied with Carlo Raimondi (1809–83), a painter and engraver who was head of the department of engraving at the Art Academy. Although she wished first to master the art of painting, she must have had at this time an introduction to graphic techniques under the tutelage of this Italian master. It is well that during the course of his teaching he did not impose on his American pupil anything of his own dry, conventional style. She painted a portrait of a peasant woman and inscribed it "*à mon ami C. Raimondi.*" Although not as tight and conventional as Raimondi's own work, this portrait would scarcely attract notice if it were not for the fact that it enables us to follow the development of Mary Cassatt's early style. Her progress was amazingly slow when we consider that at the age of twenty-eight she had not yet evolved a mode of painting that was in any way personal. She deliberately chose the long and difficult way – the way which she considered the soundest. Above all she felt that a painter should immerse himself in the old masters, to study, copy, and emulate them. She believed that too much art-school instruction was dangerous lest a teacher impose his own style on her; furthermore, she distrusted most art schools, for she sensed more than a tinge of commercialism. The last thing that she wanted was to be taught to do a slick portrait that would be salable. Mary Cassatt's desire to maintain her own independence certainly kept her from becoming set in her ways at an early age, but at the same time it took her years to master the techniques of painting. Other paintings from her early period are "The Bajadere" (Hindu dancing girl), signed, "Mary Stevenson Cassatt, Parma, 1872," and a "Bacchante" (Pennsylvania

Academy), signed, "Mary S. Cassatt, Parma, 1872." Though academic in style, these paintings show considerable spirit and vigor.

From Rome she sent to the Paris Salon of 1872 a picture of three people on a balcony in Seville which she called *"Pendant le Carnaval"* (Philadelphia Museum). This was accepted, her first painting to be admitted to the Salon, and is No. 1433 in the catalogue, with her address, Chez M. H. Vieille, Rue de Laval, 35. She is listed modestly under her middle name Stevenson (Mlle Mary). It was customary for unknown artists to list their teachers in the catalogue; she gave the names Soyer and C. Bellay. Often the names were not necessarily teachers but jury members or persons who had helped in one way or another. These men were presumably Paul Constant Soyer (1823–1903) and Charles Alphonse Paul Bellay (1826–1900), two Parisian artists, both of whom exhibited in the Salon of 1872.

In Spain she painted the two most distinguished pictures of her early career, one was "Offrant le *panal* au *torero*" (Clark Museum, Williamstown), which was accepted for the Paris Salon of 1873, and is listed No. 1372 in the catalogue under Stevenson-Cassatt (Mlle Mary). The picture is signed "Seville, 1873," and shows a young girl in profile offering a glass of a sweet drink (*panal*) to a gaily dressed bullfighter. He wears a bright red cape, a purple jacket, and a narrow pink tie over a white shirt. The brush strokes are broad; the approach is fresh and lively; and the painting is full of light, and has an air of vivacity.

A painting of even greater importance is the "Toreador" (private collection, Chicago) (Color Plate I), also painted in Seville in 1873, using the same model. While the first picture is more of a conversation piece with little interpretation of the people, the second is a dashing and robust portrayal of a bullfighter lighting a cigarette. Here the composition is better organized and the character analysis is vivid. The cool and sparkling silver and blue of the jacket form a contrast with the red tie and the cape, which is placed over a wooden fence. This picture, mature in concept, was presumably done after the other and

marks the high spot of Mary Cassatt's early career. These are the most significant of her early paintings.

She was enormously impressed by the Rubens at the Prado and carried on her interest by going to Antwerp to study more paintings by the great Flemish master. Perhaps she owed to Rubens the interest in bright, clear colors which was first discernible in her work in this all-important year of 1873. No direct stylistic influence is evident any more than one could call her earlier work Correggesque, yet these two masters both made an impact on her.

The earliest known portrait of her mother (Mrs. Horace B. Hare Collection, Radnor, Pennsylvania) is dated Antwerp, 1873, during a period when Mrs. Cassatt was abroad visiting her daughter. She wears a dark bonnet with a red flower in it and a dress of black sprigged lace over cream-colored silk; her face is boldly modeled in clear colors and is strongly high-lighted. Mary Cassatt also visited Holland at this time, being chiefly interested in the work of Frans Hals. In Haarlem she copied his "Meeting of the Officers of the Cluveniers-Doelen" of 1633, and managed to achieve the spirit and freshness of the original, without slavish imitation of each brush stroke. In later years she was proud of this copy and used to show it to young art students, assuring them that such an exercise was essential for their development.

CHAPTER III

Early Paris Years

MARY CASSATT had known Paris well since 1851, when she first went there as a seven-year-old child and witnessed the beginning of the Second Empire. Although she had spent months in Italy and Spain, she realized that Paris was the center of activities in the arts and decided to settle in this stimulating milieu. Here she met a few of her compatriots, but it was the French artists who really helped her career. Among the American artists she knew in Paris was J. Alden Weir,[1] whose godmother, Mrs. B. R. Alden, had written him in 1873:

If you ever meet a Miss Mary Cassatt, quite a successful young artist I hear, I wish you would make her acquaintance by mentioning us. Her father was a cousin of my mother's and it seems she has developed this talent and is improving it abroad.

While gaining in proficiency as a painter, Mary also developed a remarkable facility in judging the work of her contemporaries, and at the outset of her career made an acquaintance which enabled her to have unprecedented opportunities of advising on the purchases for one of America's greatest art collections.

A good friend of hers in Paris was an Italian woman, Madame

[1] J. Alden Weir was born in 1852 at West Point, where his father was professor of art. He was named for the commandant, Captain Bradford Ripley Alden, whose wife was his godmother.

Marie Del Sarte, who ran a fashionable boarding school for young ladies. One day in 1873, Mary Cassatt visited the school and was introduced to a vivacious young American girl in her teens by the name of Louisine Waldron Elder. Miss Elder, who later became Mrs. Henry O. Havemeyer, wrote in her memoirs:

꙳꙳꙳ I remember that when I was a young girl, scarcely more that fifteen years old,[2] a lady came to visit Madame Del Sarte, where I was a pensionnaire, and I heard her say she could not remain to tea because she was going to Courbet's studio to see a picture he had just completed and then she spoke of him as a painter of such great ability that I at once conceived a curiosity to see some of his pictures.[3]

Mary Cassatt, then twenty-eight, became fond of the young Elder girl who showed such an interest in art. One day they looked into the window of a little art shop and saw a Degas pastel, *"La Répétition de Ballet."* Miss Cassatt expounded so enthusiastically on the great beauty and excellent quality of the picture that Miss Elder bought it for 500 francs, all her spending money. This pastel costing about $100 in 1873 was the first purchase of what later became the famed Havemeyer Collection, which was so astutely nurtured by Mary Cassatt. One of Degas' best, showing old Jules Perrot, the ballet master, rehearsing his group of young dancers, it hung in the apartment of Mrs. Havemeyer's grandson, Mr. George Frelinghuysen.[4] Mrs. Havemeyer wrote of meeting Whistler the following year, using her friendship with Mary Cassatt to gain his respect:

꙳꙳꙳ My acquaintance with Whistler, not with his works but with Whistler himself, began when I was a girl in my teens, I think it was the year after I bought my first Monet and my first

2 Born July 28, 1855, she was actually seventeen.

3 Louisine W. Havemeyer, *Sixteen to Sixty, Memoirs of a Collector.*

4 Although Paul-André Lemoisne in his book, *Degas et Son Oeuvre,* indicates that this pastel was purchased in 1875, he is wrong by two years. Mrs. Peter H. B. Frelinghuysen stated definitely that this is the pastel which, on Mary Cassatt's advice, was her mother's first purchase in 1873. On April 14, 1965, Mrs. Havemeyer's grandson sold the pastel at the Parke-Bernet Galleries for $410,000.

Degas. I was passing the season in London with my mother and a friend of hers, and we visited an exhibition in Grafton Street.[5] It was the first time I saw Whistler's work and I cannot at this moment recall all the portraits or nocturnes he exhibited there, but I know I was deeply impressed with the portrait of Little Miss Alexander which I believe was shown there for the first time. At any rate the portrait created a furore with the public and with the critics and also with me. The critics led the public like the poor *tête de mouton* that it is, and one could hear in the gallery passing from picture to picture its silly remarks based upon the morning criticisms in the leading dailies.

As a result of their interest in the exhibition, they wrote to Whistler and asked for an appointment to see his studio. On arriving at Cheyne Walk, Miss Elder stated her errand directly:

I said: "I have thirty pounds to spend and, Mr. Whistler, oh indeed I should like something of yours. Have you anything you would like me to have?"

He stood for a second and looked at me, and I looked at the white lock in his intensely black hair. "Why do you want something of mine?" he asked.

"Because I have seen your exhibition and—because Miss Cassatt likes your etchings," I answered.

"Do you know Miss Cassatt?" he asked quickly.

"Indeed I do," I answered. "She is my best friend and I owe it to her that I have a Pissarro, a Monet and a Degas."

"You have a Degas?" he asked looking at me curiously.

"Yes," I said, "I bought it last year with my spending money. It is a beautiful ballet scene and cost me five hundred francs."

For the thirty pounds Whistler selected five pastels, which Mrs. Havemeyer kept for years and ultimately gave to the Freer Gallery in Washington.

5 Mrs. Havemeyer, in recalling these events, had become confused. The exhibition to which she refers was Whistler's first one-man show which opened June 6, 1874, at 48 Pall Mall. "Miss Alexander, Harmony in Gray and Green," painted in 1873, was the great bone of contention among the critics.

It is evident that Whistler held Mary Cassatt in high esteem and was visibly impressed that the Elder girl was her friend.

In the Salon of 1874, Mary Cassatt was represented by a fine portrait of a middle-aged woman, "Madame Cortier," and for the first time is listed in the catalogue under her own name. Edgar Degas, who at this time had not met her, visited the Salon with his friend Tourny, looked at the portrait of Ida (Mme Cortier), and said, *"C'est vrai. Voilà quelqu'un qui sent comme moi."* This chance discovery by Degas had very important consequences for Mary Cassatt and may be considered to be a decisive moment in her career. Ida was a fairly small canvas, simply the head of a woman, but the bold modeling, the high-keyed red hair, and the luminous and cheerful face portrayed bluntly and without flattery showed a viewpoint that was rare as early as 1874. There is something here of the vigor of Courbet, a suggestion of the paint quality of Monticelli, both artists whom she greatly admired. It is not in the least surprising that this richly painted little canvas should have attracted Degas. At thirty Mary Cassatt had at last reached maturity as a painter; her development had been a long struggle, but it had progressed along lines of complete independence. She was not impressed by the facile young painters who came to Paris and picked up a "style" in a few months. One of these was her compatriot, John Singer Sargent, who began work at the *École des Beaux-Arts* in 1874, and in October entered the studio of the fashionable Carolus Duran. Although she was friendly with Sargent in these early days, she later ignored him.

In 1874, Mary Cassatt, who wished also to have recognition in America, showed at the National Academy of Design in New York her two early Salon successes, "Offering the Panal to the Bull Fighter" and "A Balcony at Seville." Her address was listed as Rome, Italy.

For the Salon of 1875 her "Portrait of Mlle E. C." was accepted, but a second picture, a portrait of her sister, was rejected as being too bright. She toned the picture down, and it was accepted for the Salon the following year along with the "Portrait of Mme W." This was the fifth successive year that she was ac-

cepted by the Salon, but it was her last. The following year she was turned down and after that she never sent again as new and far more exciting opportunities presented themselves.

Being admitted to the Paris Salon for five successive years might seem flattering for an unknown American woman artist in the 1870's, yet Mary Cassatt was dissatisfied with the reactionary Salon juries, and by the fact that they had accepted the portrait of Lydia at the second submission only after it was toned down. She had watched with great interest the exhibition of a lively, independent group of artists who first showed together in 1874 and had repeated their exhibitions in 1876 and 1877. Known first as *La Société Anonyme des Artistes, peintres, sculpteurs, graveurs, etc.*, they were given the name Impressionists as a derisive term coined by the art critic Louis Leroy from the title of one of Monet's canvases, "Impression: Sunrise." His abusive article in *Le Charivari* was headed, "Exhibition of the Impressionists." One of the leaders of the group was Edgar Degas, whose work had interested her enormously and one of whose pastels she had urged Louisine Elder to buy. Degas, having first noticed Miss Cassatt's work in the Salon of 1874, showed increased interest and finally came to see her with his friend Tourny in 1877 and asked her to join the independent group who were known as the Impressionists. Joseph Gabriel Tourny, an artist of minor importance, made a living copying old masters, but he was greatly interested in the new movement and had once met Mary Cassatt in Antwerp where they were both making copies of Rubens. She joined the group eagerly and decided never again to send to the Salon.

At the time of this meeting Mary Cassatt was thirty-three and Degas was ten years her senior. Born of an aristocratic family, he felt that great French society, the *ancien régime*, had fallen apart after the Franco-Prussian War. Being a person of great intelligence and great taste, he sensed these same qualities in Mary Cassatt and was at once attracted to her. Her obvious good breeding was coupled with a lack of interest in fashionable society, which also paralleled the disinterest of Degas, who, despite being

very well born, shunned society as he grew older. After 1876 he was, in any case, in reduced circumstances because of helping to pay family debts. Degas in the 1870's restricted his close personal friends to a small group which included Vicomte Lepic, Henri Rouart, Duranty, Bracquemond, and the Valpinçon family, in addition to Mary Cassatt, whose brutal frankness and decisive opinions appealed to him. He could not talk to French women as he could to her, but even she was at times pulverized by Degas' biting comments. Despite this quality, Mary Cassatt found him utterly fascinating, such a contrast to Monet, whom she thought stupid, and Renoir, whom she regarded as too sensual. Degas undoubtedly admired Mary Cassatt's work first and foremost because she was a good draftsman. "I will not admit that a woman can draw so well," he exclaimed, while of Berthe Morisot he said that she made pictures the way one would make hats.

During this time Mary Cassatt's family was living at 256 South Twenty-first Street in Philadelphia, two blocks from Rittenhouse Square, between Walnut Street and Locust Street in a small house which is still standing. Her sister Lydia had been abroad visiting her and was frequently a model for paintings during these years. In the fall of 1877, Mr. and Mrs. Robert Cassatt and Lydia came to Paris to settle permanently. Mr. Cassatt retired from his brokerage house, Lloyd and Cassatt, and none of them ever returned to Philadelphia. Mr. Cassatt loved Paris above all other places and delighted in spending day after day exploring the endless historical sites. Being so little interested in business, he was quite content to live abroad on a modest income where a little went a long way. Mary Cassatt's presence in Paris furnished her family with an excuse to go abroad to live, and no doubt they felt that their artist daughter would be more comfortably housed with them than she would as a single person. To be sure, they did enjoy greater ease by combining forces under one roof, but at the same time the older Cassatts' move to Paris imposed an eighteen-year bondage on their daughter, during which time she was beholden to their ill health and could not travel as she once had. As a result she did not visit America during those years and,

at the height of her career, did not have the full recognition in her native country to which she was entitled. By the hardest of work and strictest self-dicipline, she had achieved stature as an artist that was equaled by not more than three or four of her compatriots. Had she been able to visit America more frequently, do more work here, and exhibit more, her impact would have been stronger, and true appreciation would have come earlier.

A fortunate situation arose, however, from Mr. and Mrs. Cassatt's being in Paris, for they were both avid letter writers and sent frequent accounts of their activities back to Philadelphia to their sons, Alexander and Gardner, and to their grandchildren. Through these letters we gain insight into the life of Mary Cassatt, what she was painting, whom she knew, where she lived, and where she traveled. Her own letters are much more sparse and often deal more with her parents' health than with her own activities. Mr. Cassatt wrote to his elder grandson on April 3, 1878, from their temporary quarters at 1, Rue Beaujon, just off the Avenue Hoche, not far from the Etoile:

MY DEAR EDDIE, Oh! if I could only have you all over here for a while wouldn't we have the Champs Elysées parties with its Théâtres Guignols, goat carriages and a thousand and one other delights.

He went on to say that Aunt Mary was at her studio and wrote a postscript indicating that he was keeping up with the latest French literary movements.

I enclose for Papa a likeness of Emile Zola the now celebrated author of the *Assommoir*.

In writing this epic of drink, Zola became the most popular novelist as well as the richest one in France.

On July 2, 1878, Mrs. Cassatt wrote to her granddaughter Katherine from their new apartment at 13, Avenue Trudaine:

It would be such a pleasure to take you out with us to see the many things there are here to amuse children—especially on

Sunday evening last we would have liked so much to have you all with us to see the beautiful fireworks and illuminations which were much finer than those you can see in America. You know we live up very high, higher than your house in town, but we have a balcony all along the front of the house from which we can see over the houses opposite so that we have a magnificent view!

Your grandfather and Aunt Lydia have gone away for the summer and your Aunt Mary and I are to join them very soon. Your poor Aunt Lydia has been very sick since you saw her but we hope she will get better this summer.

We thought it very cunning of Elsie to recognize my photograph as she was not much more than two years old [born August 14, 1875] when I left you.

This apartment, into which the Cassatts had moved in the early summer of 1878, was on the sixth floor of a building on Montmartre, near the Collège Rollin, a block from the Boulevard de Rochechauart which runs into the Place Pigalle. From the other side of the Place runs the Boulevard de Clichy, where at Number 6 Mary Cassatt had her studio. Although certainly not fashionable in those days, it was a respectable old quarter.

Mrs. Cassatt wrote to her son Alexander in July 1878:

My dear Aleck: Mary was very much pleased to hear that the children recognized the likeness and especially that little Elsie should have done so. She must be like Eddie who recognized a photograph of his Aunt Mary after five months absence and when he was only two years and a half old. I think you will like the picture as some people think it the best portrait as far as likeness and color goes they ever saw.[6]

This morning I have a letter from your father which has upset all our plans. Mary and I had decided to start for Divonne on Sunday evening,[7] but he writes that the novelty of the thing

6 They had presumably sent a photograph of Mary Cassatt's early portrait of her mother.

7 Divonne-les-Bains in France near the Swiss border not far from Geneva.

having worn off he is tired of it and wants to come home, is even in such a hurry that he says we had best telegraph as otherwise he may be back before we look for him. Now with his ideas of housekeeping I can't leave him with our cook alone. I must stay and superintend, and then another trouble is that he can't bear not to see everything finished about the house and owing to the exhibition[8] and the fêtes it is impossible to get anything done; so we were glad to get him away until things were all in order. Now he comes back just as we are in the midst of work. He says Lydia looks a little better, but she has had two attacks since she has been there.

The fêtes came off very well everybody having contributed something toward embellishing their own street besides what the city did.

Mr. Cassatt was never content to be away from Paris for very long, was very set in his ways, disliked change, and only with the greatest difficulty was convinced of the advisability of various moves which became necessary because of Mrs. Cassatt's poor health. He was obviously a very difficult man; no one but Mary could handle him, and even she at times found the situation almost more than she could bear.

It is a mistake to think that Mary Cassatt could paint because she had such ample resources at her command. On the contrary she was expected at least to pay her own way. From her father's letter of December 13, 1878, we can see what he expected of her:

Mame is working away as diligently as ever but she has not sold anything lately and her studio expenses with models from one to two francs an hour are heavy. Moreover, I have said that the studio must at least support itself. This makes Mame very uneasy as she must either make sale of the pictures she has on hand or else take to painting *pot boilers* as the artists say, a thing that she never yet has done and cannot bear the idea of being obliged to do. Teubner[9] has fifteen of her paintings on

8 Paris Exposition of 1878.

9 Herman Teubner was a gilder and picture dealer active in Philadelphia in the 1870's.

hand unsold or had when last heard from. Now he is either scheming to tire her out and get the choice of them himself for nothing or else he is asking such high prices as drives purchasers away. Mame offered through Mrs. Mitchell to take $700 clear for the lot but Teubner made no reply. I do not think there is any doubt but that they would sell for that money at public sale. The scamp would not even risk the framing himself but managed to get you to pay for it. I suppose you saw that the Boston paper gave Mame a silver medal. I believe she was the only woman among the silver medals. Her circle among artists and literary people is certainly extending and she enjoys a reputation among them not only as an artist but also for literary taste and knowledge, which moreover she deserves for she is uncommonly well read especially in French literature.

We rarely see any Americans, the Arnolds, Scotts, and lately young Covode. It is curious that even at the Exposition I did not encounter a single American acquaintance. You see we do not go to either of the chapels or in any way court the Colony, and from what we hear occasionally no doubt we thus escape a deal of very petty scandal.

Mary Cassatt's relationship with Mrs. Mitchell became very complicated because of the latter's tie in with Teubner. Mrs. Mitchell, the impoverished widow of a Philadelphia merchant, hoped to turn a few pennies from the sale of paintings. Teubner would give Mary Cassatt no accounting of the pictures he sold, and he disregarded instructions, while Mrs. Mitchell was distressed to have made quite innocently a connection which was turning out to be most questionable. Mrs. Cassatt appealed to her son Aleck to go after the dealer and wrote on November 22, 1878:

꒰꒱ I think that Teubner has an idea that it is no consequence to Mary whether she sells or not and so holds on for high prices in spite of all she says to him. Mrs. Mitchell says he wants to keep the "Musical Party" for himself and pay for it out of commissions from the sale of the rest of the pictures. Now I hate to trouble

you but we want to be done with this thing once for all. Mary wants all her smaller pictures sold at auction either in New York or Phil^a two or three at a time at every important sale that may take place until they are all sold. The three or four large ones, the "Musical Party" the "Torero and girl" the "Theater" and the "Woman with the Pink Veil" she says are good enough to bring higher prices and if Teubner can't or won't sell them she will make arrangements to send them to somebody else. After they are sold she will never send anything except to New York where there is some chance and where she is known and acknowledged to have some talent. In Phil^a it is the case of a "prophet is not without honor etc."

Mary Cassatt's early work, such as the Toreador picture of 1873, and others which can be dated in the 1870's show a broad, fluid brush stroke, the use of firm modeling and high-keyed palette, strongly high-lighted areas, and brilliant color contrasting with darker areas.

A charming small portrait of a woman reading (Museum of Fine Arts, Boston, Spaulding Collection) is signed "M. S. Cassatt, Paris, 1876." Here bright tones are used in the dress and the striped sofa, the face is vigorously modeled, but with a little more suffusion of tones than in earlier pictures. One is reminded of Fragonard, an association which suggests that Mary Cassatt had been studying the late eighteenth-century painters in the Louvre. This was the last time that she turned to the past for inspiration, for from this time on, she cast an appreciative eye on her French contemporaries and became very much immersed in their viewpoint.

A letter from Mr. Cassatt to Aleck, dated October 4, 1878, comments on Mary Cassatt's activity during this time:

Mame is again at work as earnestly as ever and is in very good spirits. She has recently sold one of her last pictures to a French amateur and collector and at the same time received an order from the same gentleman for another, a pendant for the one purchased.

A small self-portrait in *gouache* (Richman Proskauer Collection, New York) (Plate 7), probably 1878, shows the artist in a white dress and very colorful bonnet, leaning on a striped sofa. Here the face is less strongly high-lighted, and the brush strokes are less bold in modeling the features, although the dress is very broadly painted. The pose is unusual, rather daring in its diagonal thrust, and suggests the beginning of homage to Degas.

In 1878, Mary Cassatt painted an interior with four upholstered blue armchairs, *"Le Salon Bleu"* ("Little Girl in the Blue Armchair") (Plate 8). Seated in the chair to the right is a little girl in a white dress with a plaid scarf, on the chair to the left is a little dog, but the whole design is held in place by the irregularly shaped empty center of the floor, which is left between the intricately juxtaposed chairs. This composition, one of the most remarkable of her early career, was sold to Ambroise Vollard and now belongs to Mr. and Mrs. Paul Mellon, Upperville, Virginia. Vollard admired her work very much and had at least seven of her paintings in his collection. Years later he asked her about the armchair picture and she wrote him in "rather queer French,"[10] which in translation reads:

SIR, I wanted to return to your place yesterday to talk to you about the portrait of the little girl in the blue armchair. I did it in 78 or 79. It was the portrait of a child of a friend of Mr. Degas. I had done the child in the armchair and he found it good and advised me on the background and he even worked on it.

I sent it to the American section of the big exposition 79,[11] they refused it. As Mr. Degas had found it to be good, I was furious, all the more so since he had worked on it. At that time this appeared new and the jury consisted of three people of which one was a pharmacist!

This letter is revealing since it shows that Degas actually worked on one of her canvases. Although she was never in the conventional sense a pupil of Degas, it is evident that at least in this instance he was her master. No doubt she learned a great deal

10 Paul Grigaut thus described it.
11 Actually 1878.

from watching him mingle his deft brush strokes with her own and observed the manner in which he solved a problem which she had found difficult. Degas believed that a work of art developed intellectually from carefully controlled reactions to one's experiences. Mary Cassatt certainly learned this lesson and would have agreed with him when he said that painting was easy for those who did not know how, but for those who did, it was quite another matter.

About this time, 1879, she painted the delightful portrait of her sister, showing Lydia drinking tea, seated in a striped upholstered chair ("The Cup of Tea," Metropolitan Museum) (Plate 10). It was exhibited in the Sixth Impressionist show of 1881. Lydia wears a shell pink gown, long gloves, and a pink bonnet, and behind her is a wicker plant stand filled with white hyacinths. Here the tones of the face, dress, and surroundings are well integrated. The creating of a specific portrait is avoided in favor of an over-all conception of a relaxed figure which merely plays its part in an exquisite tonal study. This painting, "The Cup of Tea," belonged to James Stillman and was presented to the Metropolitan Museum by his son, Dr. Ernest G. Stillman.

Mary Cassatt was included for the first time in the Fourth Impressionist Exhibition, which was held at 28 Avenue de l'Opéra from April 10 to May 11, 1879, and showed a most important picture, *"La Loge."* A young girl with orange-red hair, wearing a pink evening gown, is seated in an opera box; behind her, reflected in a mirror, we see a portion of her back, the corner of a chandelier, and a tier of boxes forming a serpentine curve. This picture—painted with rich, luminous, and daring tones with subtle suffusion of light—is the most distinguished work of her Impressionist period. The dynamic thrust of the girl's body and the cropping of an arm show again her admiration for Degas, and there is also a suggestion here in color of Renoir. Yet despite these leanings toward a French style, Mary Cassatt has preserved her own integrity and her own forceful individuality. The vigorous modeling of the figure and the fresh, healthy glow of the girl, who seems very much an American type, set the picture

apart from the work of Degas and Renoir. The elegance of the theater scene fascinated Mary Cassatt, and she used it in at least seven paintings, as well as in several aquatints.

Only fifteen artists were included, but, to make up for this lack, some of them sent large groups of paintings: Monet had twenty-nine, Degas was to send thirty-five, and Pissarro thirty-eight. Degas, however, could seldom be counted on, and he sent only eight of the canvases he had promised. They tried to escape the appellation of "Impressionists," and wished to be called the "Independents," but to no avail, for the old term stuck.

Paul Gauguin came to see the exhibition and commented on the two principal women represented: "Miss Cassatt *a autant de charme, mais elle a plus de force.*"[12] ("Miss Cassatt has as much charm, but she has more power.") The exhibition closed with a profit of 6,000 francs, which was divided among the exhibitors, giving 439 francs to each. With her share Mary Cassatt bought a painting by Claude Monet and one by Degas. Wilenski states that in 1878 she had already bought canvases by Pissarro, Renoir, Sisley, and Monet.

Her father was quite proud of the fact that she had been accepted by the most talked of French group of painters and went to great pains to give all the details to his son Alexander in Philadelphia. On May 21, 1879, he wrote:

In addition to my letters I have also sent you a number of newspapers, art journals, etc. containing notices of Mame. Her success has been more and more *emphasized* since I wrote and she even begins to tire of it. *The Artist* for May, edited by Arsène Houssaye,[13] Alex Dumas, etc. contains an extremely flattering notice of her and the *Review des Deux Mondes* in an article entitled "Les Expositions d'Art" page 478 very hard on the Independents generally, makes an exception as to Mr. Degas and Mame, in terms that under the circumstances and the source

12 Achille Segard, *Un Peintre des enfants et des mères, Mary Cassatt*, 63. As Berthe Morisot was not in the 1879 exhibition, this comment was made probably in 1880 when Morisot, Cassatt, and Gauguin were all included.
13 Arsène Houssaye was the brilliant editor of *L'Artiste* until his death in 1896.

must, I think, also be construed as very complimentary. The Philadelphia Library takes the *Deux Mondes* and you can, of course, get it from them. We hear almost daily of notices in other French and English papers which have escaped our notice. In short, everybody says now that in future it don't matter what the papers say about her. She is now known to the Art world as well as to the general public in such a way as not to be forgotten again as long as she continues to paint! Everyone of the leading daily French papers mentioned the Exposition and nearly all named Mame—most of them in terms of praise, only one of the American papers noticed it and *it* named her rather disparagingly.

The article to which Mr. Cassatt referred was written by Georges Lafenestre, and is revealing in the way it shows us the conservative viewpoint about Impressionism. He says:

⌇ Their exposition, like the famous earlier exposition of the *refusés*, is upheld by a certain vogue for hilarity on which it would be unwise to establish a firm basis. The Parisians love to laugh.

He continues with an interesting definition of terms:

⌇ Actually the little band of Independents is only the last debris of the group of Impressionists which was itself only the tail end of the battalion of Realists.

And then:

⌇ Where are the Impressionists of former days? Where is Renoir? At the Salon. Where is Marcellin Desboutin? At the Salon. Where is the great leader himself, the inventor and the apostle, the incorruptible M. Manet, who, they tell us, carries himself like a valiant warrior, a devout friar and proclaims *Manet Manebit* [Manet will remain]? At the Salon. These defections have reduced the sacred battalion to fourteen combatants. . . . Our independents are in reality merely isolated *retardataires*, forcing open the doors, pleaders for a cause already won. They are not the only ones who understand how to analyze the subtle phenomenon of light or how to place things in their true setting

or to sustain the honest and delicate charm of English art or to seize upon the lively and capricious poetry of Japanese art. The influence of England and Japan is visible in our school but it is not entirely to M. Degas nor to Mlle Marie Cassatt that we owe this movement. M. Degas and Mlle Cassatt are, nevertheless, the only artists who distinguish themselves in the group of independents and who offer some attraction and some excuse in this pretentious show of window dressing and infantile daubing in the midst of which one is almost surprised to find their neglected canvases. Both have a lively sense of luminous arrangements in Parisian interiors; both show unusual distinction in rendering the flesh tints of women fatigued by late nights and the shimmering light of fashionable gowns. M. Degas is more mature and able and is a more experienced draughtsman. As a painter of contemporary life he ranks high; but it is difficult to see how he can claim this as a new process and how a man who combines the imitation of English watercolors with an imitation of Goya can be considered any more independent than his confrères on the Champs Elysée imitating Terburg, Pieter de Hooch, Decamps, Meissonier or Fortuny.

J. K. Huysmans, a more liberal writer, deplored the official Salon of 1879 of overmeticulous painting and tricks, but he went on to say:

⌁ Oh! Much more interesting are the kill joys, so honest, so spurned, the independents. I do not doubt that there may be among them some who do not know their profession sufficiently well, but take a man of great talent like M. Degas, take even his pupil, Miss Mary Cassatt, and see if the works of these artists are not more interesting, more fastidious, more distinguished than all these tinkling little contraptions which hang, dado to frieze, in the interminable rooms of the Exposition.

Degas wrote to the etcher, Bracquemond:

⌁ Tell Haviland who was mad about a little picture by Mlle Cassatt and wanted to know the price of it that it is a simple

matter of 300 francs, that he reply to me if it is no go and to Mlle Cassatt, 6 Boulevard Clichy, if it is a go.[14]

With the exhibition successfully over, the Cassatts could turn their interests to summer travels but, before they went off, a major problem was happily solved. Although Robert Cassatt had been fairly well off during his active business days in Pittsburgh and later in Philadelphia, he had a definitely modest income on which to live when he settled in Paris in the late 1870's. His father had died penniless, but his uncle, Robert Simpson, had left him a small legacy on which they could manage, as living was incredibly cheap in Europe in those days. We gain an insight into the limitations of Robert's resources from his letter to Alexander of May 26, 1879, from which it is apparent that it was only due to the son's largess that they were enabled to acquire their own carriage, almost a necessity because of Mrs. Cassatt's heart trouble. At first they had only a pony and cart:

Your Mother, my dear son, is very much touched with your kind intentions with regard to the Trust which she accepts in the same frank and loving spirit in which it is offered. She bids me say that she really is not in need of anything except a carriage which her growing infirmities make her long for sometimes. To be sure she rides out almost every day in a hack but that is a sort of locomotion anything but pleasant and hardly safe. One feels pained and humiliated at having to ride behind such miserable brutes as Paris hack horses for the most part are. This boon will enable her to keep a carriage of her own and I venture to say that she will never enter it without loving remembrances of the Donor.

14 Félix Bracquemond (1833–1914), the noted etcher, earned a good livelihood as art adviser to the Haviland family, especially Charles Haviland, who was not only a well-known collector of paintings but also of Japanese prints and other Oriental *objets d'art*. His father, David Haviland, an American who went to France in 1840, became interested in ceramics, and in 1842 founded the Haviland firm at Limoges, which is renowned for porcelain dinner services. His brother, Théodore Haviland, established another branch of the firm. In 1867, Bracquemond began study of ceramics and worked for a short time in the Sèvres factory. From 1872 to 1880 he was director of the Paris studio of the Haviland firm.

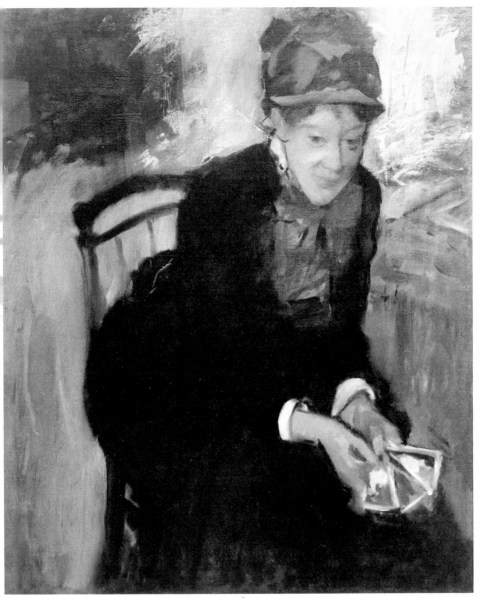

Plate 1

"Portrait of Mary Cassatt," by Edgar Degas (*ca.* 1884)

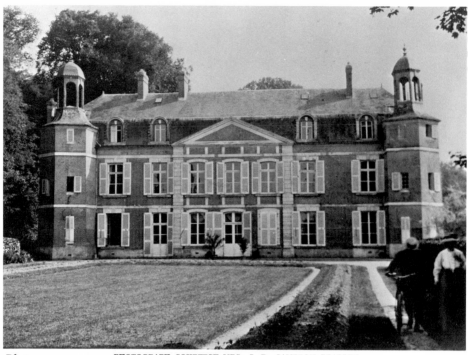

Plate 2-a PHOTOGRAPH COURTESY MRS. J. D. CAMERON BRADLEY

Château de Beaufresne

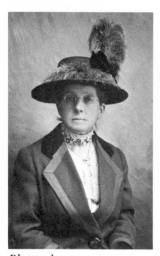

Plate 2-b
Mathilde Vallet
housekeeper and maid

Plate 2-c
Julie Vallet
femme de chambre

Plate 2-d
Armand Delaporte
chauffeur

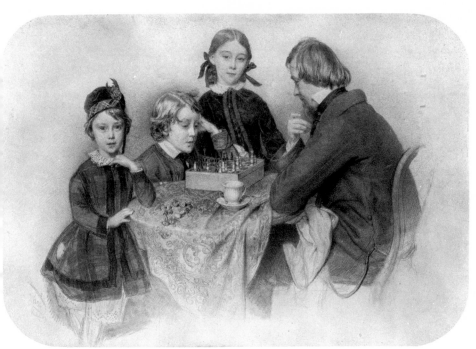

"Mary Cassatt with Her Brothers Robbie [left] and Gardner
with Their Father"
By Baumgaertner (Heidelberg, 1854)

Plate 4

Mary Cassatt in the Cloisters of St. Trophime at Arles, 1912

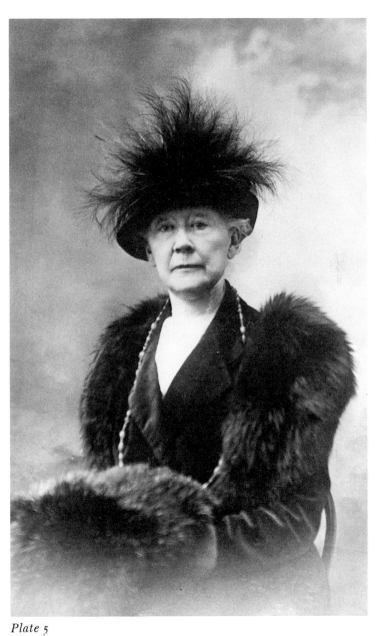

Plate 5

Mary Cassatt (in Reboux hat) at Grasse, 1914

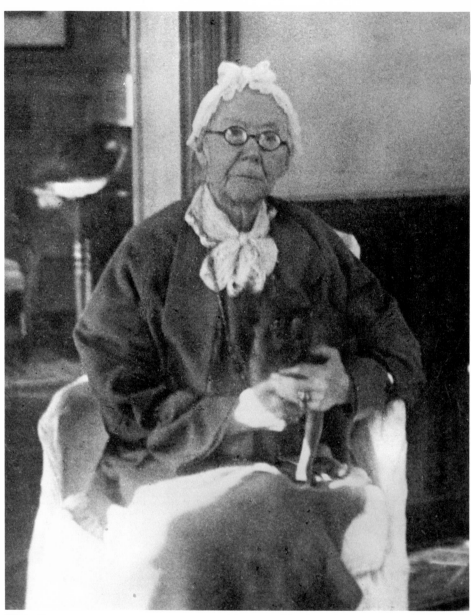

Plate 6

Mary Cassatt at Château de Beaufresne, 1925

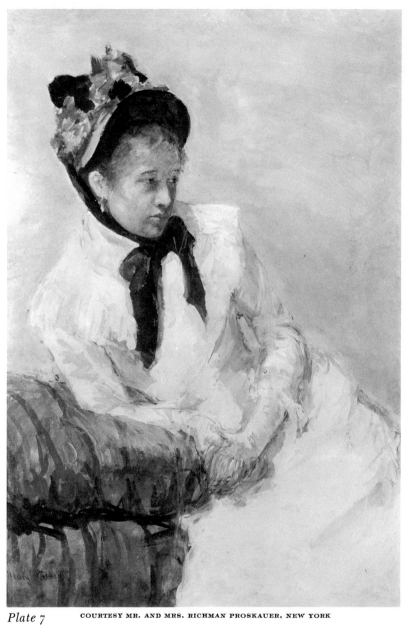

Plate 7

"Self-Portrait" (*ca.* 1878)
(*gouache*—23½" high, 17½" wide)

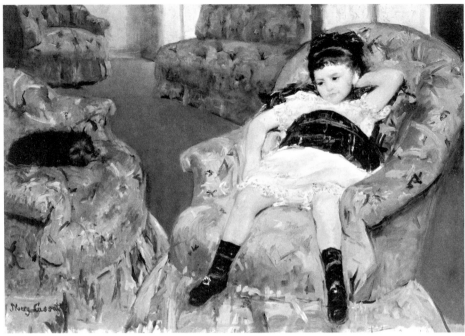

Plate 8 COURTESY MR. AND MRS. PAUL MELLON
UPPERVILLE, VIRGINIA

"Little Girl in the Blue Armchair" (1878)
(oil—35″ high, 51″ wide)

I wrote you only a week ago. Since then we have all continued well. Mame's success begins to bore her. Too much pudding! she says. I sent you the *Voltaire* last week and told you of an article in the *Deux Mondes* for May.

I am glad to hear that your financial success has been so good. The thing now will be to keep it from wasting. Most anyone they say can make money, only the wise know how to keep it.

This was the last summer that they went as far afield as Divonne on the Swiss border; after this they rented a series of villas or châteaux in the environs nearer Paris, usually going each year to a different place until the 1890's, when Mary Cassatt bought Château de Beaufresne. In July, she and her father went to the Isle of Wight and then took a trip to the north of Italy. Robert Cassatt wrote to his son Aleck on September 1:

I returned from my tour Friday evening last. Mame and I had a delightful trip highly favored in weather. Went by way of Geneva, crossed Little St. Bernard in carriage being the first to cross from the French side this summer, then down the Val d'Aosta to Ivrea, Navaraoto to Mame's paradise Varallo and the Val Sesia. At Varallo we remained twelve days, Mame's friends there being away, the principal people of the little city, capital of the Canton District. A lovely clean little town surrounded on all sides by mountains and inhabited by a primitive people. A capital point to make excursions from. Then we returned to Lake Maggiore, Milan and the Simplon to Lausanne where your mother came to meet us and carried Mame back with her to Divonne.

At Lausanne being very much fatigued by the journey from Milan, and finding the place very agreeable and a capital and very reasonable hotel, I remained a week and then home, stopping over a night at Dijon. The whole of this route is extremely interesting—"just lovely" as Mrs. Scott likes to say. There was but one thing to regret in it all, Mame's health did not improve. The fact is the journey to England and the subsequent one to Italy were mistakes. What she required was rest and quiet. She

overworked herself last winter and the moment the Exhibition was over she ought to have gone quietly into the country somewhere near for change of air and repose. When your Mother saw how miserable she looked at Lausanne she at once decided to carry her back with her to Divonne where she seems to be already improving. She has been fretting over the fact that for three months she has not been doing any serious work, and the next Annual Exhibition is already staring her in the face and it is more incumbent on her than ever after her last year's success to have something good to present.

I send you by this mail the number for August 9 of *The Vie Moderne* containing a sketch by Gillot of Mame's Lady in a Loge at the Opera [(private collection, Paris) (Color Plate II)]. You will see that the front of the figure is in shadow the light coming in from rear of box. The sketch does not do justice to the picture which was original in conception and very well executed, and was as well, the subject of a good deal of controversy among the artists and undoubtedly made her very generally known to the craft.

The paper also contains a design by E. Detaille. If his brother can draw horseflesh as well you will probably get the worth of your money from him.

From Mr. Cassatt's next letter we learn more details of the Detaille picture. This was Alexander's first venture in picture buying, a commissioned group portrait of all the family on horseback.

13 Avenue Trudaine
Wednesday Oct. 15, '79

My dear Son

At last I am able to tell you that the picture is finished, framed sent in and paid for. There was no question as to price. Mr. Detaille called yesterday by appointment as he said to receive my "appreciations" of the work, but of course to get his money. I said I believe the price is 2000 fcs. to which he acquiesced and I

gave him a check for the amount and he left seemingly very well content as he undoubtedly had a right to be. As a work of art I hardly think you will like it. It has been rather severely criticized by at least one of Detaille's own friends. You, Lois and Eddie are on an oblique line, Kitty and Robbie in front of you and Lois. Your horse resembles Kennedy in color and size and shape too. Lois' horse same size and color a shade darker. Eddie on a colt same color as his Mother's horse. The horses are all in action ponies rather wooden.

Mame is just now very much occupied in "eaux fortes."

In the meantime she had not allowed her American exhibiting to lapse, showing for the first time in 1876 at the Pennsylvania Academy, and being included again in 1878 and 1879. Her entries in 1876 were "Portrait of a Gentleman," "Portrait of a Child," and "A Musical Party"; in 1878 two works were included, "Portrait of a Lady," and "Spanish Matador"; then in 1879 she exhibited another "Portrait of a Lady" and the "Mandolin Player." She was represented at the Fifty-third Annual Exhibition of the National Academy of Design in New York in 1878 by a portrait of Mrs. W. B. Birney. Her father in his letter of October 4, 1878, to Aleck tells us:

Mrs. Mitchell took some of Mary's pictures home with her in June last and some two or three of them have been sent to the Boston Exhibition[15] and have received very flattering notices from the papers particularly the *Transcript* and Williams [and Everett] the picture dealers have asked to have the agency for her pictures in Boston.

J. Alden Weir, who was in Paris again in 1878, invited Mary Cassatt to exhibit with a new independent group in New York, the Society of American Artists; her reluctant refusal is made clear in her answer:

15 Thirteenth Exhibition of the Department of Fine Arts of the Massachusetts Charitable Mechanic Association where she showed "After the Bull-Fight," "The Music Lesson," and (a sketch) "At the Français."

13 AVENUE TRUDAINE, March 10 [1878]

MY DEAR MR. WEIR

Your letter only reached me yesterday evening. Mr. Sargent forwarded it to me from Venice where it had followed him, that accounts for the delay.

I thank you very much for all the kind things you say about my work. I only wish I deserved them.

Your exhibition interests me very much. I wish I could have sent something, I am afraid it is too late now. We expect to have our annual (Impressionist) exhibition here and there are so few of us that we are each required to contribute all we have. You know how hard it is to inaugurate anything like independent action among French artists, and we are carrying on a despairing fight and need all our forces, as every year there are new deserters.

I always have a hope that at some future time I shall see New York the artist's ground. I think you will create an American school.

You have been so kind to me I feel thoroughly ashamed of myself for not having done something good enough to send you, next year I will do better, and I hope my artist friends here will send with me. With many thanks, Very sincerely yours,

MARY CASSATT

At their Second Annual in 1879 she exhibited a portrait lent by Mrs. Alexander Cassatt and "The Mandolin Player," lent by G. H. Sherwood.

In the summer of 1881, William C. Brownell wrote as follows in a third article on "The Young Painters of America," and reproduced "At the Opera," which was probably one of the pictures that Mrs. Mitchell brought over.

The portrait which Miss Mary S. Cassatt sent from Paris to the Second Exhibition of the Society of American Artists stimulates a lively regret that she should keep her countrymen in comparative ignorance of the work she is doing. If it be said that, judging from that canvas, and from the accompanying "At the Opera" [(Museum of Fine Arts, Boston) (Plate 11)] this seems to

lack charm, it is easy to see, on the other hand, that in force few, if any, among American women-artists are her rivals. There is an intelligent directness in her touch, and her entire attitude, beside which a good deal of the painting now abundantly admired seems amateur experimentation. Her work is a good example of the better sort of "impressionism," and the sureness with which, contrary to the frequent notion of it, this proceeds; and perhaps it is especially successful in this respect because Miss Cassatt served an Academic apprenticeship, and "went over" to Dégas [*sic*] and the rest of the school only after she had acquired her powers of expression.

Mary Cassatt's early exhibition pieces were probably the first Impressionist pictures shown in America. As a result of her favorable reception with the Society of American Artists, she was asked by J. Alden Weir to join the group and was a member from 1880 through 1894. She was not greatly interested, however, and exhibited with them only once again when she was represented by three portraits in their retrospective exhibition of 1892.

In 1880 she exhibited at the Thirteenth Annual of the American Water Color Society held at the National Academy of Design, Twenty-third Street and Fourth Avenue. Her entry was simply called "A Study" and was lent by Mrs. A. S. W. Elder (mother of Mrs. Havemeyer).

In 1879 or 1880, Edgar Degas instituted plans to start an art publication to be called *Le Jour et La Nuit* which was to be largely financed by Ernest May and the well-to-do painter Caillebotte. Various artists were to contribute to it, and we read in one of Degas' letters that Pissarro had something ready and that Miss Cassatt was working on a plate. Mary Cassatt's contribution was "In the Opera Box," a soft-ground etching and aquatint, of a young woman seated, holding a large open fan, while behind her is seen the balcony at the opera. This is closely related to the oil, *"La Loge"* (private collection, Paris) and to a pastel, *"La Loge,"* in the Miss Mary Hanna Collection, Cincinnati Museum, which is a study for an oil of the same title in the

Chester Dale Collection (National Gallery of Art). In the *"La Loge"* of Hanna and Dale, there are two figures, one of whom is the daughter of Stéphane Mallarmé, the French poet.

Degas' own contribution to the periodical was an etching and aquatint of Mary Cassatt, called *"Au Louvre: Musée des Antiques."* She stands with her back to the spectator, leaning on an umbrella and looking at an Etruscan tomb[16] in a glass case, while nearby a companion, perhaps Lydia, is seated holding a catalogue. An even more notable Degas etching of about the same time is *"Au Louvre: La Peinture"* (Mary Cassatt). She is seen through a doorway, standing, leaning on an umbrella much as in the other print except that she is in a picture gallery. Here we note her slender, erect figure, neatly tailored, and her crisply furled umbrella—all conveying to us something of Mary Cassatt's tense, energetic character. The greater concentration of the second print makes it seem evident that it was done after the other although Delteil dates them both 1876 (?).[17] A pastel study of the figure of Mary Cassatt is owned by Henry McIlhenny in Philadelphia, and another pastel study of the two figures is owned by Mrs. Wolf Dreyfus in New York. Although Degas' publication came to nothing, it was one of the means of bringing about a closer association between Mary Cassatt and himself. About 1884 he painted a portrait of her seated, leaning forward and holding a group of small photographs (Plate 1). She wears a tan hat with green trimming and a brown dress, gazes thoughtfully towards the floor and seems unaware of the spectator. The long pointed chin and tightly compressed mouth have changed little from the Baumgaertner drawing done at Heidelberg when she was ten. In later years, Mary Cassatt took a great dislike to the portrait and in 1912, just before the World War I, asked Durand-Ruel to dispose of it as an unidentified woman to some collector in a remote place. They were so successful in carrying out their mission that

16 Famous tomb from Cernetri (Caere), Italy, sixth century B.C.

17 The date must be about four years later as Degas did not meet Mary Cassatt until 1877 and the style of the dresses and hats is that worn only from 1879 to 1881. Lemoisne dates the two pastel studies 1880, which is undoubtedly correct. Paul Moses, the most recent authority on Degas' prints, dates both prints 1879–80.

the portrait was lost for many years. In 1951 it turned up at the Wildenstein Gallery in New York. The gallery had acquired it from the Baron Matsukata Collection in Tokyo, Japan, where it had been all these years. The picture was bought by M. André Meyer in New York. Mary Cassatt also made a portrait of Degas, but the fact that it was destroyed makes it appear that she was not satisfied with it.

From April 1 to 30, 1880, the Fifth Impressionist Exhibition was held at 10 Rue des Pyramides at the corner of the Rue St. Honoré. Mary Cassatt was again included, but the records of these exhibitions are so vague that it is impossible except now and then to identify the paintings that were shown.

In reviewing the Independent show, Huysmans said:

It remains for me now, having arrived at the work of M. Degas which I kept for the end, to speak of the two lady painters of the group, Miss Cassatt and Madame Morizot [*sic*], pupil of Degas. I see it in the charming picture of a red-headed woman, dressed in yellow her back reflected in a mirror in the purple background of an opera box. Miss Cassatt is evidently also a pupil of English painters, for her excellent canvas, two women taking tea in an interior [(Museum of Fine Arts, Boston) (Color Plate III)] makes me think of certain works shown in 1878 in the English section.

Here it is still the *bourgeoisie*, but it is no longer like that of M. Caillebotte; it is a world also at ease but more harmonious, more elegant. In spite of her personality, which is still not completely free, Miss Cassatt has nevertheless a curiosity, a special attraction, for a flutter of feminine nerves passes through her painting which is more poised, more calm, more able than that of Mme. Morizot, a pupil of Manet.

According to Huysman's description, one of the pictures must have been "A Cup of Tea" (Museum of Fine Arts, Boston), showing two women seated on a sofa beside a tea table. At the left is a young woman, no doubt posed by Lydia, although it is in no sense a portrait, while next to her a woman in a bonnet is raising a cup

to drink so that it obscures her face below her eyes. Prominent on the table is a round silver tray and a silver tea service[18] (these now belong to Mrs. Percy Madeira, niece of the artist). The composition is more carefully constructed than anything she had painted up to this time. Vertical lines in the wall paper give strong accents, while across the picture play various diagonals, formed by the side of the table, the back of the sofa, and the placing of the ladies' arms. These methods indicate further observation of the paintings of Degas. How daring it was to obscure the greater part of one woman's face with a teacup, but how important this is in the design of the picture, for a diagonal tension is set up with the teacup on the tray, while the saucer suspended between the two becomes the anchoring point of the whole composition. A soft ground etching and aquatint of similar composition, but in reverse, is called "Lydia and Her Mother at Tea."

"*La Loge*," supposedly shown in 1879, is close to Huysman's description of a girl in an opera box, shown in 1880, yet his girl is in yellow, not in pink, so it may well not be the same picture.

Mrs. Cassatt gives us some illuminating comments both on the publication and on the exhibition:

<div align="right">

PARIS 13 AVE. TRUDAINE
April 9th [1880]

</div>

The exhibition of the "Independents" is now open. It is not such a success financially as it was last year, but as the *Figaro* has opened on them this morning, it may do them good in that way. Mary had the success last year, but in this one she has very few pictures and is in the background. Degas who is the leader

18 The silver service (not all shown in the painting) consists of six pieces: two teapots, a coffeepot, a sugar bowl, a creamer, and a slop bowl. On one teapot, the sugar, and the creamer is "P. Garrett," which is the mark for Philip Garrett, active silversmith in Philadelphia, 1801–35. The other pieces marked "R & W W" are by Robert and William Wilson, active in Philadelphia, 1825–46, indicating that these were probably added a generation later in the same pattern as the original three pieces. As these three earlier pieces are initialled "M. S. 1813," with a later initialling "K. K. J.," it is evident that they were a wedding present to Mary Stevenson (Mary Cassatt's maternal grandmother), who married Alexander Johnston in 1813. Later, probably in 1835, the other pieces also initialled "K. K. J." were added for her daughter Katherine's wedding when she married Robert Simpson Cassatt.

undertook to get up a journal of etchings and got them all to work for it so that Mary had no time for paintings and as usual with Degas when the time arrived to appear he wasn't ready, so that *Le Jour et la Nuit* (the name of the publication) which might have been a great success has not yet appeared. Degas never is ready for anything. This time he has thrown away an excellent chance for all of them. As I said they have not had such a success financially but nearly all of the exhibitions have sold, which shows that the school is beginning to succeed even with the public.

For the summer the Cassatts rented a villa at Marly-le-Roi. This was far pleasanter than staying in resort hotels, and it gave Mary Cassatt greater freedom to paint.

Visitors from Home

ON JUNE 19, 1880, the Alexander Cassatts and their four children sailed for Europe on the *Rhineland* and remained abroad until September 1. This was the first time in his twenty years with the Pennsylvania Railroad that Alexander had taken a real holiday, and it served to inaugurate a long series of family trips, for they went abroad about every two years after this. The children visited their grandparents and aunts at their villa at Marly-le-Roi, while Mr. and Mrs. Cassatt stayed at the Hotel Meurice in Paris. On July 10, Mrs. Cassatt wrote home to her mother:

The children are all so happy out at the C's that they do not seem to care to be in town at all. Sister says there is danger of their being spoiled a little, especially Elsie who is inclined to be a little disobedient to the Aunts. I quite agree with her as she has all sorts of little frills today. Aleck is going out again tomorrow to spend the day and stay all night.

I have been to all the principal dressmakers here and I must say they are too awfully dear to buy much. Their prices are quite equal to those in New York. I have almost made up my mind to bring materials home and have them made up there. I have gotten several pretty white dresses or rather ordered them, not that they are cheap, but because the trimmings are new and very

pretty. Underclothes at the best places are also very high, but at the Louvre they are pretty moderate. To do what we want to do properly for the house[1] and all we ought to stay the entire time in London and Paris. We will go to London on Wednesday to stay a week and come here again for a little time. Mary is going to paint Aleck's portrait and that will take a good deal of time.

Mary Cassatt enjoyed to the utmost this visit of her nieces and nephews, and she went with them and their nurse, Mary Berger, on all sorts of expeditions. Although for the most part they behaved well, from time to time a little "switch tea" was recommended to calm Eddie's exuberant spirits. Robert, on the other hand, to his aunt's infinite joy, showed definite signs of artistic ability. At Versailles they were enthralled by Queen Marie Antoinette's apartments and the Petit Trianon and were both delighted and terrified by the balloon ascensions as they were afraid they would fall on them. As a climax to their visit they saw the gardens and the *grandes eaux* illuminated at night. On another day they visited the *Jardin d'Acclimatation,* where Elsie rode in a carriage drawn by an ostrich and Katherine had a ride on an elephant. Their parents spent a brief time in England, where Eddie warned his father to keep away from Newmarket lest he lose too much on the horses. Their mother was glad to leave London, where there were, as she said, "Nothing but blasted Englishmen everywhere," and on her return to Paris, she remained alone in town with her maid Lizzie, while Aleck went out to Marly with the rest of the family so that Mary could paint his portrait. She found it difficult to catch her brother in a relaxed pose and felt that his uncompromising dark clothes were a hampering element, unlike the colorful or patterned feminine attire which she had in the past painted with such deftness.

Her sister-in-law Lois preferred to remain apart from the family in Paris, and, left to her own devices, she poured out her inner feelings in all frankness on August 6 in a letter to her sister Harriet:

1 They had just built a new wing at Cheswold and needed more furniture.

〜 Everything is still lovely between me and the C's, that is to say as far as I know but the truth is I cannot abide Mary and never will. I cannot tell why but there is something to me utterly obnoxious about that girl. I have never yet heard her criticize any human being in any but the most disagreeable way. She is too self-important and I can't put up with it. The only being she seems to think of is her Father. She tries to be polite to me however, and so we get on well enough. The children all seem to prefer her to the others, strange to say. Enough of this.

This most revealing letter states very clearly a situation that was never to be alleviated. Mrs. Alexander Cassatt and her sister-in-law Mary were both too strong as personalities to be able to get on congenially. Although a reasonably amiable relationship was maintained as long as the Cassatt grandparents were alive, an open rift finally developed and Lois tried to prevent any association between her children and their aunt. In later years Mary Cassatt was quite friendly with her nephew Robert and his family, but his brother and sisters had little to do with her. Although she did many paintings, pastels, and dry points of members of her family, the only known portrait of Mrs. Alexander Cassatt is a pastel done in the mid-eighties.

Mary Cassatt was temperamental, outspoken, opinionated, and determined—qualities that kept her intent on her painting and compelled her to proceed independently according to the tenets to which she passionately held. Mrs. Alexander Cassatt was too unimaginative, narrow, and prosaic a woman to understand the character of her remarkably gifted sister-in-law. She mistook self-assurance for self-importance, regarded her independent actions as "obnoxious," and could not understand that the children in preferring their Aunt Mary were exercising that rare instinct that unprejudiced youth has for quality.

Mary Cassatt's close association with her brother during the portrait sittings had an important result, for she was able to arouse his interest in buying French paintings. He was reluctant to plunge in immediately, but asked Mary to be on the lookout

and when she saw something at a reasonable price that she thought he might like, to go ahead and buy it. She was most anxious for her brother to have an important Degas, but there were difficulties. A large picture which she liked was unfinished, and Degas said it would have to be entirely repainted and he did not wish to do that. Some artist, he said, who did not care whether it was finished or not would buy it after his death. She told her brother she was afraid to commission anything from Degas as he might make something so eccentric he would not like it.

From Degas we have an impression of her work at this time, for on October 26 he wrote to his friend Henri Rouart, the painter and collector:

The Cassatts have come back from Marly. Mlle is installed in a studio on the street level which seems to me is not very healthy. What she did in the country looks very well in studio light. It is much more firm and more noble than what she did last year.

Perhaps he was referring to a portrait of Lydia which Mary painted at Marly in 1880 and exhibited at the Sixth Impressionist show in 1881.

During the winter of 1880–81, Mary Cassatt worked hard in her studio getting ready for the Sixth Impressionist Exhibition. Intensely interested in this group and greatly admired by them, she was now invited for the third time to join in their exhibition. Her days were by no means entirely her own, as her family began worrying about a suitable place to spend the next summer and also felt the need to move their winter residence to a more modern apartment. It was Mary who had to go off to look at summer villas at Christmas time and to inspect various new apartments which were beginning to be built in great numbers in the newer areas of Paris to the west. Her mother reported on the situation in a letter to Aleck on December 10.

We are still thinking of going to Marly next summer. Gard agrees with you in thinking it unsafe to buy so it is not

likely we will do so. The trouble is we cannot rent the place we want because it is furnished and the landlady is such a shrew that I would be afraid to have anything to do with her furniture. Although not so large a place as the "Coeur Volant" which it joins it is more cheerful and much better furnished and she asks as much for it in rent as Rimmel does for his "Coeur Volant." Rimmel is an Englishman who has made a large fortune as a "parfumeur" in France and has lived so long here that he is almost a Frenchman. I wouldn't mind at all renting his place although it is furnished as he is by no means a shrew "tout parfumeur qu'il est" as Degas says. The garden has all the appearance of being laid out by Le Nôtre and is just as it was in the time of Louis Quatorze. That is the place we wanted last year, it would have been charming for the children.

I see you are going to have the famous "Sarah" as I suppose of course you will see her let me know what you think of her. I never saw her but once and didn't like her at all, but then it was in one of Octave Feuillet's worst pieces "The Spring" and they said she didn't care how she played it as Croizette had the best rôle. I like to be amused and consequently don't like French tragedy, so I never was tempted to go to see Sarah a second time.

We have abandoned the idea of moving for the present. We were tempted by the modern improvements in some new houses in the neighborhood of the Parc de Monceau but the doctor and everyone we spoke to of our intention held up their hands in horror at the idea of our becoming *"essuyeurs de plâtre"* as they call the first lodgers in new houses.

MOTHER

Alexander Cassatt sent bountiful Christmas boxes to the family in Paris, the most welcome of which contained American apples, sweet potatoes, hams, and canvasback ducks.

"My dear Aleck, the apples are perfect," wrote Mrs. Cassatt on December 29, 1880:

Mary who hasn't tasted an American apple for years begrudges every one I give away and when we tell her that she has

found at least something better in America than here she says, "Oh I never denied that the living was far better at home than here," and she is right. Canvasbacks and hams and our turkeys and oysters and apples and cranberries to say nothing about the terrapin make an enormous difference in our favor when we come to count up the luxuries of the table and then the delicious vegetables in the summers. They make the most of what they have got over here and the cooks are more accomplished than ours for the same reason that the Scotch gardeners are the best (the coldness of their soil calls forth all their skill). From this you will think I am a horrid gourmande but that is not true, it is only as a housekeeper that I feel the difference.

Mary Cassatt added her thanks through her nephew Eddie and a word of encouragement to his younger brother, the budding artist:

I want you to tell Rob from me that when he gets his paint box he must promise to draw very carefully a portrait of one of you, beginning with the eyes (remember) and send it to Grandmother. That would please her more than any other Christmas present she could get.

One of the pictures that Mary Cassatt worked on the hardest was a group portrait of Mrs. Cassatt reading fairy tales to three of the grandchildren, Katherine, Robert, and Elsie (Anthony Drexel Cassatt Collection, New York). Started at Marly during the summer, the painting was finished in time to show at the Sixth Impressionist Exhibition held from April 2 to May 1, 1881, at 35 Boulevard des Capucines. In the summer she usually liked to paint out of doors, but in this instance she found it easier to concentrate the group in an interior setting. Although much more ambitious than the portrait of her brother, the group painting is far better organized and has a relaxed mood and a sense of deep preoccupation. As this was a family picture, she did not wish to sell it despite a good offer.

There had been a good deal of friction during the organization of the exhibition. Degas had objected to the fact that Monet and

Renoir had shown at the Salon and thus gone against the creed of the Independents that they would not subject themselves to juried exhibitions. Furthermore Degas had caused dissention by inviting friends of his to exhibit with the group, such artists as Zandomeneghi, Bracquemond, and his wife, who were not Impressionists in any sense.

Huysmans commented at length on the exhibition:

I wrote last year that most of Miss Cassatt's canvases recalled the pastels of Degas and that one of them derived from modern English masters.

From these two influences has come an artist who owes nothing any longer to anyone, an artist wholly impressive and personal. Her exhibition is composed of portraits of children, interiors, gardens, and it is a miracle how in these subjects, so much cherished by the English, Miss Cassatt has known the way to escape from sentimentality on which most of them have foundered, in all their work written or painted.

Oh! those babies, good heavens, how their pictures make one's hair stand on end. Such a bunch of English and French daubers have painted them in such stupid and pretentious poses! . . . For the first time, thanks to Miss Cassatt, I have seen the effigies of ravishing youngsters, quiet bourgeois scenes painted with a delicate and charming tenderness. Furthermore, one must repeat, only a woman can paint infancy. There is a special feeling that a man cannot achieve, at least they are not especially sensitive, their fingers are too heavy not to leave a clumsy imprint, only a woman can pose a child, dress it, adjust pins without pricking themselves; unfortunately they turn to affectation or tears like Miss Elisa Koch in France and Mrs. Ward in England; but Miss Cassatt, thank heavens, is neither one of these daubers and the room where her paintings are hung contains a mother reading surrounded by urchins and another Mother kisses a baby on the cheek, these are the irreproachable pearls of Oriental sweetness, this is family life painted with distinction and with love; one thinks at once of the discreet interiors of Dickens, of Esther

Summerson, or Florence Dombey, Agnes Copperfield, Little Dorrit or Ruth Pinch who dangle children on their knees, while in the adjoining room the soup kettle hums and where the light reflected on the table sparkles on the teapot and the cups and saucers and the plate piled with buttered bread. There is in this series of works by Miss Cassatt an effective understanding of the placid life, a penetrating feeling of intimacy that one finds comparable to the Three Sisters by Everett Millais shown in 1878 in the English section.

Two other pictures, one called The Garden where in the foreground a woman reads[2] while on a diagonal behind her there are masses of green dotted with red geraniums with a border of dark purple of Chinese nettles extending as far as the house. The other called Tea [Metropolitan Museum] in which a woman dressed in pink, smiling, seated in an arm chair holds a teacup in her gloved hands, adding to this tender, contemplative note the fine sense of Parisian elegance. And it is thus that with a special inherent indication of talent, Miss Cassatt who is an American, paints us, the French, but in houses so Parisian she puts the friendly smile of an "at home." She achieves something that none of our painters could express, the happy contentment, the quiet friendliness of an interior.

Mary Cassatt received more favorable notices than she ever had before, and even the *Figaro*, which had always been bitterly hostile to the Independents, was complimentary. As she had nothing to do with the American colony in Paris, their three papers generally ignored her, but on this occasion the *Parisian* did comment briefly. Her reaction to so much attention was to cry "too much pudding." What she most enjoyed was the fact that she was really established and that artists of talent and reputation and others prominent in the art world asked to be introduced to her and complimented her on her work. Another favorable result was that she made several sales.

2 Although he says the woman is "reading," this is probably the portrait of Lydia knitting or crocheting in the garden, painted at Marly in 1880, now in the Mrs. Gardner Cassatt Collection.

At this time she acquired a Pissarro for her brother and also a Monet for which she paid 800 francs. Degas had promised to furnish a picture, but, as usual, he was delayed. On April 18, 1881, Mr. Cassatt wrote Aleck:

When you get these pictures you will probably be the only person in Philadelphia who owns specimens of either of the Masters. Mame's friends the Elders, have a Degas and a Pissarro and Mame thinks that there are no others in America. If exhibited at any of your fine arts shows they will be sure to attract attention.

From this it appears that Alexander Cassatt in 1881 became the second collector of French Impressionist paintings in America. He had been preceded only by Miss Elder (soon to become Mrs. Havemeyer), but both of them had been persuaded to collect in this very controversial field by the compelling enthusiasm of Mary Cassatt. Thus she planted the seeds in America for a taste which during the succeeding decades grew to overwhelming proportions. William Merritt Chase, who was in Paris in 1881, saw his friend J. Alden Weir, who was studying abroad, and urged him to purchase Manet's "Boy with the Sword" and "Woman with a Parrot" for Erwin Davis of New York, who had commissioned Weir to buy some French pictures.[3] Today, American museums and private collections are incredibly rich in French Impressionist paintings while the collections of France are correspondingly lacking. Had it not been for Gustave Caillebotte, the Jeu de Paume in Paris would have scarcely an Impressionist picture to show. His bequest of 1894 to the French State was looked upon with embarrassed horror, and only forty of the sixty-five were accepted. All the major Impressionists as well as Cézanne were in this group.

[3] According to the Weir papers he met Erwin Davis in New York in 1880 and soon after was in Paris, where he bought the two paintings at Manet's studio. Chase is not mentioned as having been the instigator. Davis must then have entered the collecting field at almost the same time as Alexander Cassatt. It is probable that the purchases were made at Durand-Ruel as Manet, very ill and approaching his death, received almost no one at his studio.

After having worked so hard for the exhibition, Mary Cassatt gave herself up to a more or less idle summer in the country at Louveciennes near Marly, where they had been the previous year. There she enjoyed riding horseback and the pleasure of a visit from her younger brother, Gardner, as yet unmarried, who had not been abroad since he was a child. Having bought an old racer "gentle as a lamb with plenty of spirit" she expected to dispose of him in the fall, but she became so attached to him that she could not bear to sell him for fear that he might be badly treated. They all went to Trouville to see the regattas and enjoy a breath of the sea.

Louisine Elder was in Paris again, and Mary Cassatt took her to see the great Courbet show held at the Théâtre de la Gaîté during the summer of 1881. In her memoirs Mrs. Havemeyer wrote:

I owe it to Miss Cassatt that I was able to see the Courbets. She took me there (foyer of the Théâtre de la Gaîté), explained Courbet to me, spoke of the great painter in her flowing and generous way, called my attention to his marvelous execution, to his color, above all to his realism, to that poignant palpitating medium of truth through which he sought expression. I listened to her with such attention as we stood before his pictures and I never forgot it. She led me to a lovely nude, the woman drawing the cherry branch down before her face and I recall her saying to me, "Did you ever see such flesh painting? Look at that bosom, it lives, it is almost too real." And she added, "The Parisians don't care for him. You must have one of his nude half-lengths some day."

The picture which they commented on in the exhibition was "*La Branche de Cerisiers*," which the Havemeyers later bought and which is now in the Metropolitan Museum.

Mary Cassatt's enthusiasm for Courbet has been frequently noted. Théodore Duret, the great French critic, said, "I remember Miss Cassatt one day at the Louvre in front of the Burial at Ornans. She shouted out all of a sudden while showing the pic-

ture to a group of women, '*C'est grec!*' " She obviously felt that the composition of the picture had great stability and a classical sense of order.

On returning to the Avenue Trudaine in the fall, Mary Cassatt busied herself with securing more paintings for her brother Aleck. She sent off through Durand-Ruel a picture by Degas and photographs of three more, two of horses, and one of dancers rehearsing. Degas had come to dine with the Cassatts on November 2 and asked especially after the "little painter"—young Robert, who, they all felt sure, would some day be a great artist. Mary Cassatt encouraged this idea as she felt that it added kudos to the family's artistic talents and would make her seem less an isolated phenomenon if one of the young men in the family were to carry on the tradition of painting as a career.

One of Mary Cassatt's most significant early works is the "Woman and Child Driving" (Philadelphia Museum) (Color Plate IV). Both the date and identification of the people have been questioned, although the persons were generally thought to be Mrs. Alexander Cassatt and her daughter Elsie. Mrs. Robert Cassatt described the painting in a letter to her grandson Robbie:

PARIS 13 AVE. TRUDAINE
Dec 16th [1881]

MY DEAR ROBBIE: I am glad you are all so fond of the farm and that you take such an interest in all that goes on there. Your Aunt Mary is so fond of all sorts of animals that she cannot bear to part with one she loves. You would laugh to hear her talk to "Bichette" our pony. She painted a picture of her head and your Aunt Lydia standing beside her giving her some oats from her hand [Mrs. Horace B. Hare Collection] and she also painted a picture of your Aunt Lydia and a little niece of Mr. Degas and the groom in the cart with Bichette but you can only see the hind quarters of the pony. I am going to send your Uncle Gard a photograph of the picture and he will show it to you.

Degas' niece must be one of the daughters of his sister, Mme Henri Fèvre (Marguerite De Gas), possibly Odile, the youngest.

Various elements such as the figures off-center at the right, the clipped composition showing only the hindquarters of the pony, and the top of the wheel suggest again the influence of Degas. The figures have firmness and solidity and at the same time have a sparkling quality due to the luminous color. The little groom or *tigre*, also very Degas-like, is not individualized, yet Miss Cassatt has so successfully caught his type that he is the very essence of all grooms.

Alexander's trust fund, which was established in the spring of 1879, enabled them to acquire the pony and cart and they were all traveling most of that summer, so Bichette was presumably purchased in the fall of 1879. The painting could have been done any time from then until the date of the letter, but their enthusiasm for the pony was such that it is likely that Mary Cassatt did the painting when the equipage was fairly new—1879 or perhaps 1880. Lydia would have been too ill to pose driving as late as the summer of 1881. One of the last pictures for which she did pose was the highly distinguished *"Femme à la Tapisserie"* (Brahms Collection, New York) (Plate 12).

The Cassatts seem not to have been very social in their contacts in Paris. They knew a certain number of artists and literary people, but there is no evidence of their mingling with the great French society of the Faubourg St. Germain, and their opinion of the American colony is only too clearly stated in Mrs. Cassatt's letter to her son, December 23, 1881:

~~~ We jog on as usual, make no acquaintances among the Americans who form the colony for as a rule they are people one wouldn't want to know at home, and yet they are received as species of the best society in America. The morning's paper mentions that Mrs. Mackay[4] the wife of the California millionaire and her mother and father and sister (the Hungerfords) have just dined with the Ex-Queen of Spain in company with the Minister from Spain and other dignitaries. Now they say that the Hungerfords are as low and common as it is possible to be. Mrs.

4 Mrs. John William Mackay, daughter of Colonel Daniel E. Hungerford, once a barber-druggist. Her mother was a seamstress.

Mackay I suppose has learned something and besides is young and pretty.

Lydia I am happy to say is better than she was last winter but not much to boast of yet. Mary works away as usual. Your Father takes his walks abroad every day and amuses himself seeing everything that Paris has in the way of sights. It would be hard for a native to show him anything about the tramways or omnibuses. His health is excellent.

# New Horses and New Models

I N THE SPRING of 1882 there was a quarrel about the organiza-
tion of the Seventh Impressionist Exhibition. As a result,
Degas refused to exhibit with the group and Mary Cassatt with-
drew, too, and went into "exile" with him. Degas had withdrawn
because Caillebotte and the nucleus of the group demanded that
his non-Impressionist friends be excluded. Durand-Ruel, the
dealer, who was the great champion of the Impressionists, was in
financial difficulties on account of the depression of 1882. Hoping
to further sales, he sponsored the exhibition, rented space at 251,
Rue St. Honoré, but insisted that the exhibitors be restricted
solely to the Impressionists. Although some degree of unity was
achieved, differences of opinion persisted.

Mr. Cassatt had remarked on January 19 in a letter to Aleck:

Did your mother tell you that Mame has some artistic
trouble? The Impressionists have quarrelled among themselves
and it is believed now that their annual exhibition will be
dropped! "Kittle Kattle to shoe behind"[1] artists.

Berthe Morisot wrote to her husband, Eugène Manet, at this
time, "Have you seen Miss Cassatt? Why did she withdraw?"
Eugène replied:

[1] This comes from the old Scottish proverb: "Kings are kittle cattle to shoe
behind," kittle meaning difficult.

I have not been able to penetrate the secret of the retreat of Degas [and] Miss Cassatt. An idiotic Gambattiste paper (*Paris*) said this evening that the Exhibition of Impressionists had been *décapitée* by this retreat. . . . Duret, who knows these things so well, feels that this year's exhibition is the best your group has had.

Despite the quarrel among the Impressionists, Mary Cassatt remained always loyal to Degas and his point of view. Their withdrawal brought them even closer together, and she sometimes took time off from her own painting to pose for him. Mrs. Havemeyer once asked her if she often posed for Degas. She replied, "Oh, no, only once in a while when he finds the movement difficult, and the model cannot seem to get his idea." One of the pictures for which she posed was "At the Milliners" (Metropolitan Museum, Havemeyer Collection). This was painted the year of this exhibition and shows her trying on a hat in a pose that must have been one of those that the model found difficult. Degas had no interest in making this a portrait; in fact it would be impossible to recognize the figure as Mary Cassatt.[2]

Her own time for painting was subject to fewer interruptions because her mother had taken Lydia to Pau in the south of France in a futile attempt to restore her to good health. Pau, not too cold, not too windy, not too rainy, had been virtually taken over by the British as a winter Paradise. Of this situation Mrs. Cassatt in a letter to Aleck, dated February 5, 1882, had some tart comments to make:

Lydia says it makes her angry to see the English, they look as if the town belonged to them and they have brought all their amusements with them, fox hunting three times a week, polo, lawn tennis, cricket etc. to say nothing of gambling which goes on to a great extent though I dare say the French take a hand at

[2] Degas showed his homage to her in a humorous sort of way by writing one of a group of eight sonnets about a parrot and dedicating it to her. It is called "Perroquet" followed by "*A Miss Cassatt à propos de son Coco chéri.*" A dry point of 1891 called "The Parrot" shows Mathilde holding Coco.

that, being perhaps even more given to that amusement than the English. They have four-in-hands and dog carts and tandems with *three* horses, a very handsome English clubhouse to give bachelor balls and in short amuse themselves generally. We haven't as yet explored the neighborhood but the view of the Pyrenees capped with snow on a brilliantly sunny day is very fine and, as they are not more than twenty miles off, people make excursions to the baths there. If it were always as dry and bright as it has been this winter, Pau would soon be at the head of "winter stations" as they call them but I can't imagine the attraction in ordinary seasons unless it is as a Scotchman said to me, "If you lived where I do and it rained four fifths of the time, you would think you had got to Heaven." It still continues foggy and gloomy in Paris and Mary writes that on Friday last she couldn't see to work.

By May, Mary Cassatt had secured for the summer what she regarded as the perfect retreat, the villa called Coeur Volant, which was situated next to the house they had occupied the previous season at Louveciennes. From a point of view of comfort, the place was inferior since there were no modern conveniences in the house and all water had to be carried from a spring. Attractive furnishings and a charming garden full of fruit trees compensated for the primitiveness, and the lush markets of nearby St. Germain and Versailles assured them of a good table. Mary Cassatt acquired for herself another riding horse, this time getting a twelve-year-old trooper which she purchased from an army officer for 900 francs. "Mame's old steeplechaser and war horse has turned out so far quite a trump," her father said, adding:

She has a very good saddle and bridle which cost her seventy francs (2nd hand of course but good). The horse is a good size for Mame, carries well, is showey even and has unmistakable signs of blood. I ride him a good deal as Mame does not in her rides give him enough exercise.

She was also hard at work painting, as the Impressionists were

planning another exhibition, which, as it turned out, they did not actually arrange for another four years. She kept busy, nevertheless, and had a model come to the house every day since Lydia could no longer pose.

During the fall of 1882 two events took place which meant considerable changes in the pattern of life of the Cassatt family. Gardner, who had seemed to be the perennial bachelor, was finally swept off his feet by Eugenia (Jennie) Carter, daughter of Dr. Charles Carter of Virginia. They were married in St. Mark's Church, Philadelphia, on October 18. Although none of the family were able to go back to America for the wedding, all of them were greatly relieved to have Gardner settled down with a home of his own.

Lydia, eight years older than Mary, who had always been devoted to her sister and was always a willing model, suffered for years from Bright's disease, which made her a constant invalid. As she had grown far worse in Louveciennes, she was brought back to Paris, where she died on November 7, 1882. Her niece, Ellen Mary Cassatt Hare said, "I was told by a cousin that Lydia was *charming* and very gentle and kind. From her photograph she was quite handsome and attractive. Aunt Mary *adored* her." She was buried at Marly at her own request, but was later moved to Mesnil-Théribus.

The Alexander Cassatts heard of Lydia's death by cable the very day they left Cheswold, their country place, for New York to sail on the *Servia*. Alexander had just retired from the Pennsylvania Railroad as first vice-president (although he was recalled in 1899 as president), and he now had leisure for travel. Being an important railroad man, he was treated with great deference when abroad. On landing in Liverpool, he and his party were taken off the ship by special tug, were "passed" to London in the British equivalent of a private car, and settled luxuriously at the Bath Hotel in Piccadilly. From their windows they enjoyed a splendid view of the great military parade in honor of the troops returning from Egypt, where they had put down the attempt of a military dictator to usurp the power of the khedive.

After a brief visit in London, they went to Paris on November 27, where Mr. and Mrs. Robert Cassatt and Mary met them. They took a double suite at the Chatham on the Rue Daunou and entered Ed in the *École Monge*, where he remained after the rest of the family returned to America in April.

During these trips of her brother's family to Paris, Mary Cassatt had a marvelous opportunity to use them as models. When they were there in 1880, she had completed two oils, one of Alexander and one of Mrs. Cassatt reading to three of the grandchildren (both in the collection of Anthony Drexel Cassatt, New York). Although the group is very successful, the portrait of her brother is stiff and lacks the ease and detachment of her portraits of women and children. She did another portrait of her brother in 1882 which was even less successful; obviously the painting of men was not her forte.[3]

A far more important outcome of these visits was the series of aquatints and dry points which she was inspired to do by the presence of her two nephews and two nieces. As the oldest, Ed, was at school, Robbie and his sisters Katherine and Elsie were the ones who usually posed for her. This afforded her the most exacting training in draftsmanship and greatly advanced her facility with print techniques. As a dry point is made with a needle direct on the copper plate, there is no possibility of making corrections; every stroke must be sure, and one false move can ruin a plate. She achieved remarkable results with a crisp line, a minimum of shading, and a fine sense of pattern. Working very directly, she avoided all tricky effects and anything fussy or decorative.

As in the case of "Lydia and her Mother at Tea" and "In the Opera Box," already mentioned, Mary Cassatt from time to time made prints which had a close relationship with paintings. In 1880 she did two variants in soft-ground etching and aquatint of Mrs. Cassatt reading to her grandchildren. Dry point was also used in the more complete of the two versions. Organizing the off-center composition and the exact placing of the figures ob-

---

3 She also did portraits of her friend M. Dreyfus and of the artist Desboutin but, as these have disappeared, they cannot be used in a qualitative comparison.

viously posed a challenging problem—a problem which she solved with marked success. Subsequent prints of her nephews and nieces were done mostly in dry point and were studies of individual figures or of heads in which she strove for sureness of line and rich, velvety-black textures.

Lydia had been a patient model for several years, but as an invalid she lacked vitality. Now Mary Cassatt was afforded the opportunity of working with a group of young, energetic children. She had the ability to get on with young people and they adored her, for the studio was full of toys and books and she had quantities of stories to tell them. No wonder they were willing models.

Mrs. Alexander Cassatt kept a diary of this trip, which is much concerned with governesses, dancing schools, and shopping, and is full of chitchat about calls, dining out, and the theater—all interspersed with much dissatisfaction and discontent:

~~~~ Found cards of Rev. Mr. Moran, the English clergyman, and a Mrs. Ross. Mary and I went to Redferns to be fitted for our ulsters.

Drove to 13 Ave. Trudaine to bring the little girls home. Saw Mr. Degas there. Mary settled price with Mme. Luguet and the children are to go to her tomorrow. Alex and I dined at the Café de Paris. . . . The weather is so horrible that I am getting very blue, the box of things for home makes me a little more so. Aleck is all right for he sees his own people every day. . . . Julian Hare dined with us here and stayed until very late. . . . Aleck and I went to the Vaudeville to see Feodora and Sarah Bernhardt, it was very good but I hate Sarah.

Friday, December 8:

Aleck's Birthday—43 years old. We took a lovely ride on horseback together in the Bois. . . . After lunch we went to meet Mary and the little girls at the Cour de Danse. Not satisfied with the class. We then went and ordered a Victoria which is Aleck's Christmas present to me. . . . We went to dine at Bignons and took Ed. He was very nice and looks so naif in his Eton suit.

December 14:

I went after lunch for Mary and the little girls and we all went to the Panorama painted by Detaille, it was very good. It is a battle scene from the Franco-German war. After we went to Redfern.

December 19:

Aleck and I went to Ave. T. for breakfast and Aleck sat for his portrait. Mr. Cassatt and I walked out to the top of Montmartre and saw a fine view of Paris. I went to see the new buildings of Sacré Coeur. All went to the Louvre and saw the paintings for half an hour. Aleck and I dined at the Café Durand near the Madeleine and after went to the exhibition of paintings opened for the first time on the Rue Sèze.[4] Mary gave us her invitation, crowds of people but not much of pictures, all by young artists exhibiting for the first time.

On December 22:

Mary came in with Miss Elder [later Mrs. Havemeyer]. On Sunday, December 24, they went to the American chapel where we had a very original service of which I could make nothing. A sort of Methodist performance with the Apostles Creed.

Of their Christmas she wrote her mother a letter which suggests that the older Cassatts were trying to overcome with lavish gifts a lack of sympathy which they knew existed between Lois and themselves:

PARIS Dec. 26th, 1882

MY DEAR MOTHER,

I must give you some account of our Christmas. Grandmother and the children arranged between them that the presents should be given on Christmas eve so we all went there for dinner that night. I went about 4.30 to fix the presents and we had had everything sent up there for everyone. Aleck and the four came at 5.30 and you may be sure it was a great pleasure to them all to see the children enjoy their things. They had very pretty presents. Elsie of course got dolls and dolls things and she is full of them.

4 Georges Petit, 8, Rue de Sèze, formerly with Durand-Ruel, became his great rival.

Grandfather had not let it be known to any of us what he intended to give and when all was ready before the family arrived he walked in with four little purses and a small leather box and remarked here is a leather article for all including the Mama. The purses each contained 20 frs in silver, that is for the three eldest and ten for Elsie and the box for me contained a lovely ring with nine small diamonds. I was perfectly overcome. You can readily imagine how astonished I was as I had received no intimation that any one had a present for me. Then Grandmère handed me a box with a very beautiful lace scarf, of point Appliquée to wear with the evening dress. Don't you think it was a great step in advance for them to do this? Aleck had given all of them very handsome presents but mine were bought before he did so. The ring is a very pretty one as the stones are all very fine and it is made with five little bands with the stones set in each band. The evening was a very happy one as everyone was delighted with their gifts and the children all behaved nicely and were, for once, very appreciative and thanked everybody very nicely for their presents, it was almost eleven before we got home and in bed. Grandmère gave Sister a dear little silver watch with which the child is perfectly charmed. On Christmas day we all took dinner again up there at 6.30 and had a very pleasant time. Elsie on this occasion recited very nicely a French fable which she had been taught by Mme. Luguet for the day and which was also kept a secret. She did it very well and was so proud of it.

Aleck gave me a beautiful ruby ring for Xmas.

On January 6 they went to Marly to see Lydia laid in the vault and on the ninth left for London. Soon they were back in Paris for a brief period of shopping before going to Italy, where they spent a month on a conventional tour. By March 6 they were again in Paris, where Aleck sat to Mary every day until April 1, when the picture was at last finished (Alexander J. Cassatt Collection, Cecilton, Maryland). On April 3 they were in London and went to Whistler's studio at 13 Tite Street, Chelsea, to engage him to do a portrait of Lois. There, it was noted:

◁◁◁ We found the distinguished artist most polite and most curious looking. We proposed to come the next morning and begin at once.

She posed for several days, wearing a riding habit, but when the picture was well advanced she commented that it looked too much like her to be pleasant. This was indeed a bitter piece of self-analysis. On April 28 they sailed for home, leaving Ed at school in Paris.

On May 13 Mrs. Cassatt wrote to Lois:

◁◁◁ We had a visit from Whistler who seemed extremely well pleased with your portrait. He has some landscapes and a full length portrait in the international exhibition now open at Petit's room on the rue de Sèze which are very good but old. Degas says he gave him some rubs when he was there.

Mr. Cassatt commented further to Aleck:

◁◁◁ Mame hasn't touched your portrait yet, but promises to do so now. Whistler was over here the other day in search of a *medal* they say and not being able to get a promise of one, went away in a rage declaring that there wasn't an artist in France! A day or two ago I mailed you a book Huisman's[5] [*sic*] (pronounced Wismann) *Modern Art* in which Mame is very favorably noticed. Huisman is a well known author and art critic here. *Punch* of May has caricature notice of the Impressionist Exhibition in London does not notice Mame however, but hits the others very hard.

Gard is building a house, hope he provided at least double the money the architect said it would cost. And a few days later:

◁◁◁ Mame has got to work again in her studio, but is not in good spirits at all. One of her gloomy spells. All artists I believe are subject to them. Hasn't put the finishing touches to your portrait yet.

5 J. K. Huysmans, *L'Art Moderne.*

And on June 1:

⁓ Mame is not well at all—*dyspeptic*.

Despite the gloomy account given of her by her pessimistic father, Mary Cassatt took an active interest in showing her nephew Eddie the sights of Paris. They went one afternoon to see the greenhouses at Passy which were then in full bloom, and another day to Marly, stopping en route at Bougival to see Deauville, Mary Cassatt's horse, put there for treatment. They also took a great interest in the races and went one day to the Grand Prix, which greatly delighted Eddie. They came home, Mr. Cassatt wrote, "looking like millers actually white with dust."

On July 4, Mrs. Cassatt confided to Aleck:

⁓ We are silly enough to watch the results of the races with great interest (Mary and I) at which your father looks grim and scolds.

Mary Cassatt had written to her sister-in-law June 15:

⁓ Father is in England but I suppose will not stay long; he expected to be in London today, was at Ryde, Isle of Wight, when he last wrote. I am very much disappointed not to have been able to get to London this spring; if we go in August all the exhibitions will be closed and it will be as dull as ditch water.

Tell Aleck I will send the portraits as soon as I get back Elsie's and I have not the least idea when that will be. The man who has the exhibition is making money and won't close as long as the public are willing to go. Durand-Ruel don't trouble his head any more about it. Whistler has been awarded a third class medal at the Salon, he asked for one and the jury were determined to punish him for his nonsense by putting him in the 3rd class, he behaved like a fool here, he and Oscar Wilde together. Whistler told me he would have been glad of twenty-five minutes more on your portrait, he told me he did not make you stand much. You gave him but few sittings he said.

We were all much interested in the races. Eddie very much

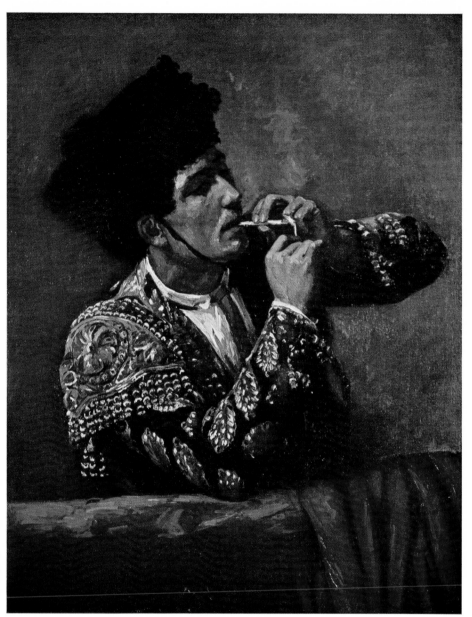

Color Plate I

"Toreador" (1873)
(oil—32¼″ high, 25½″ wide)

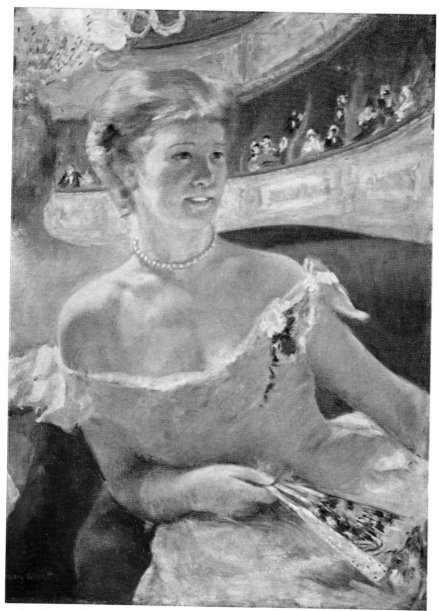

Color Plate II

"La Loge" (1879)
(oil—31⅞″ high, 23½″ wide)

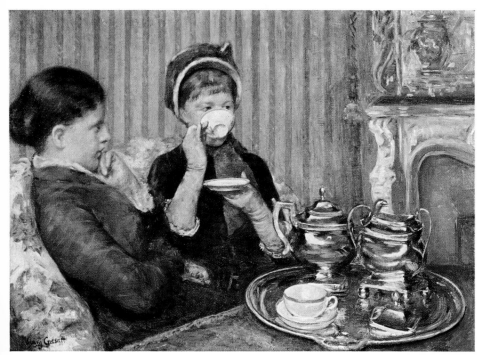

Color Plate III

"A Cup of Tea" (1880)
(oil—25½″ high, 36½″ wide)

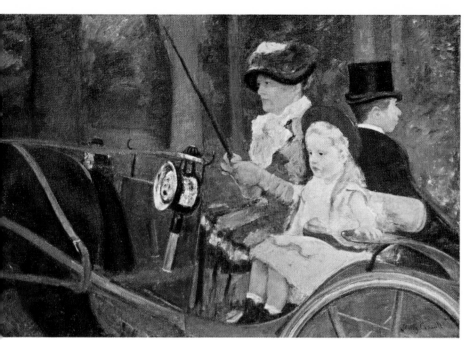

"Woman and Child Driving" (*ca.* 1880)
(oil—35¼″ high, 51½″ wide)

pleased with Ricer's success. Deauville is at the veterinary school at Alfort, has been operated for lameness, the nerve cut just above the hoof. A horse dealer told us yesterday to sell him immediately, "on fiche quelqu'un dedans" he said with a laugh; and when the lameness returns as it surely will, then the purchasers will hunt up the place where the nerve has been cut and he will understand that it is all up with that horse! The reason they cut the nerve was for a contraction of the foot. If Aleck would like me to be corresponding veterinarian for the farm I am willing to undertake the post!

Deauville became one of the most famous horses in France we learn from a paragraph in Mr. Cassatt's letter of June 25 to Aleck:

I believe I wrote you of Deauville's great promotion? He has actually been received as a patient at Alfort where his case is considered very remarkable, only three others like it known in the history of the establishment! Head Proff performed operation himself in presence of 200 élèves, lectured and then consigned the interesting patient to the special care of his *plus* fort pupil. Fancy Mame's pride in being the owner of a horse like this. A historical horse, treated at the expense of the Government. Almost decorated. I doubt if any sum of money will induce her to part with him *willingly* after all this.

Eddie was doing very well at the *École Monge*, which he felt was a far better school than Haverford, and he stood third in his class. Although he had always been able to ride well, Mary Cassatt insisted that he continue riding lessons in order to become perfect. "He has improved very much," she wrote his father, "can put his horse through the *haute école* quite well."

Mrs. Ellis told Mother they were struck with the change in him "à son avantage" as the French say. The school has done him good, he has been obliged to put up with an immense amount of hazing and nagging from the boys, it was very hard at first he says but he don't mind it now and answers them back. I cannot

understand you and his Mother putting him in Haverford amongst those Quakers, their grammar[6] alone is enough.

On July 19, Eddie wrote his mother from Fontainebleau, where he had gone with his Aunt Mary to recuperate from a slight illness. His teen-age point of view not only is refreshing but shows him to be perceptive and at the same time full of humor:

DEAR MAMA: 10.30 A.M. They brought me out here for my health as I am not very strong yet after the little attack I had on Friday. Aunt Mary and I went over to the doctors and he said we had better come out here.

They have very good dinners here but I cannot eat them. They have a fearful lot of soldiers also. Nearly every tenth man you see is one.

Aunt Mary found some people she knows here, one of them is one of the most celebrated doctors in Paris so if I fall sick I will be well treated.

It is good fun doing nothing as I am not sick and I don't go to school. I just walk around and do what I like. There were no bugs in my bed last night but they might come any time. I saw a deceased cat this morning. We did not bring Batty [Mary Cassatt's dog] along, thank fortune, as I would have had to carry him and the valise and the shawl strap and two umbrellas, to get the tickets and find a compartment which would hold all those thing. Will you all club together and give me a thousand mile ticket for a birthday present? That is all I will want. If we have a pass don't get. We don't expect the "Americans" as Anna calls Uncle Gard and Aunt Jennie till Saturday. I am to go back to school on Monday perhaps, mabe today I hope.

Aunt Mary is going to paint a water color picture of me about a foot square. My head is to be about an inch and a half in diameter so you can imagine how small it is to be.

1.10 We have just had a pretty good breakfast. We saw the

6 By "grammar" Mary Cassatt meant the "plain speech" of the Quakers. If her own grammar seems at fault, it must be remembered that "he don't" was acceptable in the late nineteenth century.

palace but there was not much to see except the throne of Napoleon the first. This will interest Sister. It was an arm chair sitting on three steps and about it were curtains covered with gold Bed Bugs, at least that is what they looked like.

A whole gang of Cook's Tourists just came in to the reading room and they make an awful racket.

6.10 P.M. We had a lovely drive. We were out about three hours and we climbed a mountain for there are some in the neighborhood. We went into an old brigand's cavern. It had a dining room and a chimney and a dark passage. The coachman and I talked politics, I got a lot of fleas. The coachman got a squirrel, a little young one and he had a very hard time catching it. I keep my writing paper in the bottom of my hat.

There is a young man here who plays most beautifully. I am having a snap time.

With much love to all I am your affectionate son

EDWARD B. CASSATT

Mr. Cassatt, just as the family had suspected, cut his visit to the Isle of Wight short, and was back in Paris after eight days. He fled England because of the cold and wet, but Paris was confronted with something far worse than vagaries of weather; there was a serious epidemic of typhoid fever. This was generally attributed, no doubt correctly, to the unwholesome effects of drinking water from the Seine. Unfortunately there was a general belief that the deleterious effects of the water could be overcome merely by the addition of a little red wine. Mr. Cassatt was most exercised by the fact that Ed refused "at least to redden his [water] with a little Bordeaux." He was even more exercised by the women of the family, who insisted that they must keep two horses, one for the carriage and one for riding, whereas Mr. Cassatt believed that one good horse would serve both purposes:

Mame is lamentably deficient in good sense about some things and unfortunately the more deficient she is the more her mother backs her up. It is the nature of women to make common cause against the males and to be especially stubborn in main-

taining their opinions about matters of which they are ignorant! They try my patience to the last point of endurance sometimes.

In late July, Gardner Cassatt and his bride, Jennie, arrived in Paris where they were warmly received by the elder Cassatts, who were very pleased with their new daughter-in-law. They all attended Ed's graduation from the *École Monge* and were very proud of the prizes and high honors which he received. Mary Cassatt, who was very sympathetic and understanding towards young people, fully realized that his experience at the school had been very tough. "None knew what he had suffered," she told her brother.

Gardner sold his mother's pony, Bichette, and the cart and bought for her a new gray colt named Joseph (after himself, Joseph Gardner Cassatt). His sister Mary took a dim view of the situation, "I hope he will be useful," she said, "he has no style, in fact is common looking."

On August 3, Robert Cassatt took his grandson, Ed to Antwerp, where he boarded the *S.S. Pennland* for home. After Eddie's departure Mary Cassatt took her mother to Cowes on the Isle of Wight where Gard and Jennie joined them after a visit to Rouen and Dieppe.

"It is filled with Lords and Ladies and the gayest place imaginable," Jennie wrote to Lois on August 17:

~~~~ . . . for such a harbor of yachts I have never seen and the coming and going delightful to watch. We are all at the hotel but can't quite decide whether to stay for more than a week as it is very expensive, and the hotel abominable, but for one week certainly Paris is the place for me, I never imagined what a fascinating place it was even in the dead of summer.

I bought three dresses, a bonnet and a pair of corsets in Paris and a cloth dress and bonnet in London, but you know my mean streak about clothes.

The family have been delightfully kind and never have I received more kindness and delicious eating and I feel perfectly at

home. Tell Sister that the mashed potatoes were all she said they would be.

P. S. The Centennial block or Oriental plaid are the only dresses I wear. The C. B. is a little gone in the back and the O. P. altogether but still—

Mr. Cassatt wrote in a gloomy mood to Aleck, August 20:

I am here all alone. The rest including Gard and wife being somewhere in England, when last heard from they were at Cowes, but on Thursday your Mother wrote me from there not to send any more letters there or anywhere else until further directed. Mame was very sick in crossing, had to be carried off the boat. Never was such madness as for her to undertake a journey of pleasure in which crossing sea water was included. She is dreadfully headstrong in some things and experience is lost upon her.

# cA Change in Style and a cNew Address

Back in paris Mary Cassatt wrote to her brother Aleck on October 14, 1883, that while in London she had gone to Whistler's studio to check on whether he had finished the portrait of Lois.

It is a work of Art, and as young Sargent said to Mother this afternoon, "It is a good thing to have a portrait by Whistler in the family."

Mary Cassatt, then thirty-nine, would have considered Sargent at twenty-seven "young." He had shown the Boit children at the Salon that year and people were duly impressed by the talented young American, but the following year his "Portrait of Madame X" so shocked visitors to the Salon, as well as the lady's family, that he had to flee to London.

Mary Cassatt had asked Sargent to join the Impressionist group but he had no interest. In fact, despite his friendship for Monet, whom he met in 1876, he did not think much of them. Berthe Morisot also tried to bring in Sargent and wrote to her brother Terbource on August 20, 1883, about the next exhibition of Impressionists:

If you speak with Miss Cassatt, she will perhaps be useful to you, 13 Avenue Trudaine; she is intelligent. Did you send

[notices] to the American Sargent? We were at Nice together; he left suddenly for Paris just when we were going to be presented to each other. He said the most flattering things about me. He is having a great success and is a pupil of Carolus Duran.

Years later Mary Cassatt refused to see Sargent when he called, since he had done, so she said, such a "dreadful" portrait of her brother Aleck. Both the slick style of his mature work and his financial success at the hands of society disgusted her. On the other hand, the artist whom she admired above all others was Degas, and at this time she was making every effort to interest Aleck in his work and was trying hard to find a painting which would please him.

"Did you get the photographs I sent you?" Mary wrote Aleck, on November 18:

I only sent them to give you an idea of Degas' style, I don't like to buy anything for you without your having some idea of what it would be like. The pictures from which the photographs were taken have all been sold and Degas has but one racing picture finished and that is the large one; I was just thinking of buying you a smaller picture of ladies and children on horseback when a dealer picked it up and I don't see anything else in horse subjects that I can get for you just at present. I feel it almost too much of a responsibility, am afraid you won't like my selection; and Mother does not give me much encouragement as *au fond* I think she believes picture buying a great extravagance.

I sent home a Diaz to the Elders, for Mrs. Havemeyer.[1] They are polite enough to say they were pleased. I hope they were. Do call on them, I am sure you will like them.

Father talks of a trip to Rome, but as usual it will end in talk.

I have a Swedish model whose family are in America and who is going over soon. When she goes I will give her your address.

1 On August 22, 1883, Louisine Waldron Elder, daughter of George W. Elder, married Henry Osborne Havemeyer. He had previously (March 1, 1870) been married to her aunt, Mary Louise Elder, and they had been divorced. To avoid confusion with the first wife, who called herself Louise E. Havemeyer, the second wife dropped the E. of her maiden name and always called herself Louisine W. Havemeyer.

Tell Lois I think she will find her an excellent sewing girl. She was at Worths for some time and makes dresses very well. Lois might find her very useful.

I have Rob's drawings and his little picture hung up in the studio, don't tell him but they are very much admired.

Over the years Mary Cassatt worked hard to build up a distinguished collection of nineteenth-century French paintings for her brother Alexander. On her recommendation he bought at least four landscapes by Monet, including the "Stairs at Vétheuil"; Manet's *"Vue en Hollande"*; Berthe Morisot's "River Scene"; a landscape by Pissarro; two figure pieces by Renoir; and a few others. More important than any of these was the "Ballet Class," by Degas (sold by one of the Cassatt heirs to the Philadelphia Museum). Despite the fact that Alexander acquired several good pictures, he did not begin to take advantage of all the favorable opportunities which his sister offered him. The fact of the matter is that he was really not very much interested in pictures and lacked completely the collector's enthusiasm which so possessed the Havemeyers and inspired Mary Cassatt to outdo herself on their behalf. Alexander's wife had no use whatsoever for paintings and discouraged her husband from collecting, for she felt that he was throwing his money away on rubbish.

Gardner Cassatt had even less interest in pictures than his brother and preferred indulging in the considerably more expensive hobby of yachts. He did, to be sure, buy a few pictures on his sister's advice, but he was in no sense a true collector.

At this time, or possibly in 1882, Mary Cassatt painted the most distinguished portrait that she ever did of her mother, called "Reading *Le Figaro*" (Mrs. Eric de Spoelberch, Haverford, Pennsylvania) (Color Plate V). Mrs. Cassatt is seated in a flowered armchair wearing a simple white dress with ruching at the cuffs and at the neck and front. She wears pince-nez with a ribbon and is intently reading the newspaper. The background behind the chair is a blank light area, but at the left is the section of a large mirror. The picture is painted with broad, fluid brush strokes;

the figure is solidly, in fact monumentally, conceived, and the deep concentration on the part of the sitter gives the picture great psychological intensity. This is certainly one of Mary Cassatt's finest achievements. Here we still see the strong painterly quality rich in surface texture. After this her work tended more and more toward smoother textures, less body to the paint, and more emphasis on the linear aspect of the design; that is to say, her technique became less impressionistic. She had really only been an Impressionist in the broadest sense of the word, using light tones, a certain amount of brilliant color, and broad brush work. She held, however, to the tenets of the independents and shared their beliefs in objecting to juries and in accepting no awards.

In November, 1883, she began the "Lady at the Tea Table" (Metropolitan Museum) (Plate 13). This was a portrait of Mrs. Robert Moore Riddle, born Mary Johnston Dickinson, a first cousin of Mary Cassatt's mother. The tea set, Japanese porcelain made in the style of Canton ware, is still in the family, owned by Mrs. Hare. Mrs. Riddle, with hair parted in the middle, is rather primly attired in a deep-blue caped dress and wears a lace cap with lappets tied under chin. In contrast to the bold treatment used in earlier portraits, the face here is very delicately modeled, but is accented by the intensity of the blue eyes, which pick up the strong blue of the tea set. The figure is more of a silhouette and the outline counts as an important element in the design, in which line is emphasized rather than mass. This picture marks a turning point in her career.

Mrs. Cassatt wrote to her son Aleck, on November 30, 1883:

I don't know if your Father or Mary told you of the presents of porcelain Mrs. Scott sent us after we got home from England, and you know she insisted on our being her guests at the Hotel in London. When they came here Mary asked Mrs. Riddle to sit for her portrait thinking it was the only way she could return their kindness and she consented at once and Annie [her daughter, Mrs. Thomas Alexander Scott] seemed very much pleased. The picture is nearly done but Mary is waiting for a

very handsome Louis Seize [frame] to be cut down to suit before showing it to them. As they are not very artistic in their likes and dislikes of pictures and as a likeness is a hard thing to make to please the nearest friends, I don't know what the results will be. Annie ought to like it in one respect for both Degas and Raffaëlli said it was "La distinction même" and Annie goes in for that kind of thing. Lois wrote from London that Mrs. Riddle enjoyed buying pretty things for presents beyond anything and I suppose Annie does also, otherwise one would and indeed does feel overwhelmed.

Annie went to Durand Ruel's the other day and bought a picture by Mary, perhaps you may remember it—two young girls at the theatre [ (Edgar Scott Collection, Villanova, Pennsylvania) (Plate 9)].

Mrs. Scott was most displeased with the portrait, as she thought her Mother's nose, generally considered to be very beautiful, was far too large. As a result the picture was put away in a storeroom and forgotten until years later, in 1914, when Mrs. Havemeyer discovered it and proudly showed it to Durand-Ruel, where it was a sensation when exhibited. In 1923, Mary Cassatt gave it to the Metropolitan Museum.

Painting was interrupted for a time when, on December 21, 1883, Mary Cassatt and her mother left for Spain, where it was hoped that her rheumatism and heart trouble would be improved in the mild climate of Alicante on the southeast coast. They took Mathilde, their Alsatian maid, with them and also Battie, the dog.

Mary Cassatt described the trip to her brother:

FONDA DE EUROPE
TARRAGONA
Jan. 5th, 1884

DEAR ALECK: Here we are in Spain and what is not so pleasant, waiting for the visit of a Spanish Doctor. Poor Mother is suffering with dreadful headaches, has not been able to leave the house, hardly her bed since we have been in Spain. Her cough is much better certainly, in fact it has ceased almost entirely but

the headaches have alarmed me very much. I felt very badly at leaving Father in Paris, more especially as he evidently considered the whole thing perfect nonsense, he really cannot be made to understand that Mother is a sick woman and that if we want to keep her with us, she *must* be taken care of. Annie Scott was shocked when she saw her in London. The fact is that apartment is too much for her, those five flights of stairs; Father does not feel them and thinks nobody else ought to. When you write to him you might say that you are glad to hear that he intends to move, that you are sure it is too much for Mother and that you hope he is going into a house with a lift. Now *Please* don't forget this, remember that it is *most important.* I dare not open my mouth, he won't listen to a word I say. He thinks I want to move for my own pleasure, whereas I like our apartment very much and would never dream of moving were it not for Mother. The sad associations are hard for her too.

We have got to the right place for climate, the most delicious Spring weather, the town is on a rock some eight hundred feet high on the Mediterranean about five hours from Barcelona. It is one of the oldest places in Spain built by the Carthaginians the walls still standing. It is picturesque beyond description and the country around most beautiful, not in the least like Italy, much grander.

I suppose you have the pictures by this time, and I hope they are not spoiled by their long journey. I have no doubt that the one of Mother and the children is rather black, with being shut up so long. I wrote to you that we had found a beautiful Monet for you; Manet's sale takes place next month; and I told Portier what to buy for you if the prices were low enough. Annie Scott bought a picture and two pastels before the sale and I believe that she intends to buy something more at the sale. You cannot do better and as long as you have begun to get a few pictures you might as well go on.

After a few days they went on to Alicante, where in the very mild climate Mrs. Cassatt's health greatly improved. In fact, she

felt so much better that when they left on the seventh of February and went through Madrid, she insisted on doing the Prado and promptly had a relapse. After a week they moved on to Biarritz, where Mrs. Cassatt gradually recovered, but they did not return to Paris until the twelfth of May, since they were changing apartments and she did not want to go back until the new place was completely in order. Mary Cassatt spent a busy spring commuting between Biarritz and Paris looking for a new apartment and attending to the moving. Her frantic appeal to her brother resulted in his writing a sharp demand to their father that a move to an elevator apartment was absolutely necessary because of their mother's health. Reluctantly Mr. Cassatt agreed to the change. Alexander, realizing that the Spanish trip and the cost of moving would put a strain on his parents' income, sent his father a check for $1,000. Mary Cassatt gave her brother a frank picture of the health and monetary situation, and also expressed her utter disdain for the British. "At Alicante I think she was doing better," she wrote of her mother:

but she was determined not to stay although the climate was heavenly; we met there the Marquis Casa-Loring, George's cousin, who is a man of about sixty speaks English perfectly and was most kind to us, when we came away he sent to Madrid for a carriage for us and we had a compartment reserved for the journey. The journey from Madrid here was very fatiguing and the change of climate was bad for Mother.

I am so glad you wrote to Father about the apartment. He sent me your letter and is now willing to change; before that he kept saying he would but whenever it came to the point he backed down. The Doctors forbid Mother to go up even half a flight of stairs, I don't think Father gave in on account of the money, because we really don't need it at all. Mother had money enough saved for her journey this winter, and it was not so expensive as it sounds at Alicante we only paid 27 frcs a day for all three of us including everything. Besides that I am in hopes that we can get the fifth floor above the Dreyfus for 4000 frcs (with a lift) and

with one room more than we have which will enable me to take a room for a studio. We can perfectly afford to pay 4000 frcs rent. This winter if it had been necessary to practice strict economy we could have dismissed Martin and sent Joseph out to board at the Vets at St. Germain; whereas Father has had the carriage ever since we left. When we were in England last summer Mother paid the expenses with addition of what was saved out of the housekeeping allowance; so you see Father has been at no extra expense at all. Our apartment we could have rented easily and no doubt will soon find a tenant again but Father the moment we left for Spain told the concierge not to allow it to be visited by any one. I hope he will not take the $1000. you sent but I am afraid he will, he is all wrong about money matters and insists upon it that you are ruining yourself and points with triumph to poor Gard not having got along so well.

This place is full of English, about a hundred in this hotel; some of the "bluest blood" in England opposite me at the table d'hote. I wish you could see them husband and wife. Alongside of me at table I have an English clergyman who is a rich man as well, he is intelligent and tolerably well informed, but he cannot understand how they can give a dinner party in America where there is no "precedence." I propound different problems of precedence to him, he little imagines the immense amusement he affords me.

Mary Cassatt encountered many problems in apartment hunting, but eventually was successful. She looked at one on the Rue de Monceau opposite where they had lived thirty years previously, but, when she came to final negotiations, the proprietor raised the rent far above the first asking price. Inexpensive apartments were available in any number of newly built houses in the Avenue du Bois de Boulogne, but this section was considered way too far out at that time, since there were no shops nearby and few people wanted to live there. At length she found a most desirable apartment, very "elegant" as her father said, at 14, Rue Pierre Charron. This very fashionable area was near the Trocadero, and the street

ran through to the Champs Élysées, but the section of the Rue Pierre Charron where they lived has now been renamed the Rue de Servie. Being rather far out even here, they found themselves remote from bakers and butchers, the great *fournisseurs* to whom they were accustomed.

One great advantage of the new apartment was that it was large enough that Mary Cassatt could take over one room as a studio, thus eliminating the necessity of renting one outside. Some of the problems she encountered in moving are recounted in two letters written to her brother from the Hotel d'Angleterre in Biarritz, when she went to bring her Mother back to Paris.

April 17, '84

The apartment in Paris is very nice and even Father seems satisfied now, but I sometimes despair of being able to take Mother back there. Father went on like a crazy man for the first three weeks and nearly killed me, but latterly he seems reconciled and I have no doubt will much prefer this apartment to the other. He was so unreasonable about allowing me to rent the other that we lost about 1000 francs by his obstinacy, he begins to realize I think that he is no longer able to manage matters for himself.

Sunday, April 27

The house is very handsome and the rooms nicely furnished and ceilings much higher than in Ave. Trudaine; considering the difference in the house and quarter the rent is not any higher in proportion. Father told me before we went to Spain that he would pay 4000 frcs and this is 50 frcs under that [$790 a year, about $65 a month].

I will get the Monets for Mr. Thompson if I can at the price, I know of one that Annie Scott wanted to buy but thought it a little larger than she could find room for. When I was in Paris I found Portier had sold two of my pictures for me and more were wanted but I have not touched a brush since we left home, have not been out of Mother's room except for a walk while I have been here. It will do me good to get to work again. Elsie's portrait was the first picture hung in the new apartment and looks much better

than in the old one. I am going to take the salon for a studio and Father has a small salon arranged for him.

Annie Scott, married to Thomas Alexander Scott, who had been president of the Pennsylvania Railroad in the 1870's, could well afford to indulge in paintings and did at this time buy a Corot for a modest 15,000 francs. At one time she had been engaged to Scott's telegraph operator, young Andrew Carnegie. Scott, in marrying Annie Riddle, incurred Carnegie's lifelong enmity.

By June, Mrs. Cassatt's health was greatly improved, no doubt aided by the daily visits of her cousins, Mrs. Riddle and Mrs. Scott. During the course of settling the new apartment, a painting by young Robert came to light and was mentioned in Mr. Cassatt's letter of June 8 to his son:

Apropos of Rob, this morning the head of a girl which he daubed (in a moment of inspiration) on a small canvas when over here the last time, turned up this morning accidentally and his aunt put it up on the mantel in the salon where we all laughed and wondered at it at the same time. There is really something surprising in it when one remembers that he was but 7 years and when he did it had not any instruction and that it was struck off at "one heat." Degas you know would not believe that he had done it without help.

As to Whistler, he is behaving in what in anyone else than an artist, would be considered a very dishonorable way. Last week young Durand-Ruel being about to visit London, was requested by Mame to call in her name on Whistler and enquire about the portrait. He did so and Whistler of course promised that it should be finished forthwith and forwarded it to you. That will probably be the last of it. Mame's advice to you is now to wait say a couple of months and if within that time you do not receive the portrait, then have some London businessman call and demand the picture *finished* or the return of the *money peremptorily*.

Eventually Mrs. Cassatt was sufficiently well for them to go to

the country for the later summer and fall. They rented a place in the little village of Viarmes, north of Paris between the Forests of Chantilly and Carnelle. In the fall the area was of great interest as it was a center of stag hunting. On October 23 they returned to their new apartment at 14, Rue Pierre Charron, where, because of the elevator, Mrs. Cassatt could get out more easily and enjoy rides in the nearby Bois de Boulogne.

At the end of the year Alexander Cassatt and young Robert, accompanied by a manservant, Louis, came over to Paris for a visit. They landed at Antwerp on Christmas morning, and went on to Paris, where they took a suite at the Westminster on the Rue de la Paix. In writing to his wife he said:

Mrs. Scott, Mrs. Riddle and Mrs. Fisher[2] are all here with their children stopping at the Liverpool on this street near the Continental.

Yesterday we all went, that is to say Mrs. Scott, Mrs. Fisher, Mary, Edgar and his tutor and I to the *first* performance of Sardou's new play *Theodora*. Mrs. Scott had secured a box and was kind enough to invite me. It was a very fine performance and the house was crowded with fashionables, artists, literary people and all those who go to *premières*.

Robbie went this morning with his grandfather to see Bartholdi's bronze statue of Liberty.[3] He describes it as an immense affair, they went up into the head and could look over all the surrounding houses.

Mary has commenced portraits of Robert and me together, Rob sitting on the arm of my chair [(Philadelphia Museum) (Plate 14)]. I hope it will be a success this time. I don't mind the posing as I want to spend several hours a day with Mother anyhow and Rob will not have to pose very much or long at a time.

Mary has done an excellent portrait of Mrs. Riddle quite as good in its way as the one we have of Mother, but I don't think Mrs. Scott quite likes it. We have word that Whistler is actually

2 Mrs. Fisher was Mrs. Riddle's younger daughter Bessie.
3 Presented to the people of the United States by the people of France, placed on Bedloe's Island in New York Harbor, dedicated 1886.

working on your portrait. Of course I shall go to see him as soon as I get to London.

Mary Cassatt in writing to her sister-in-law also mentioned the portrait:

⌁ I hope Aleck will get Whistler to give up your portrait, he is now working on it I hear. Lucas at my request wrote to him about it. I am sorry you don't like it. You remember I recommended Renoir but neither you nor Aleck liked what you saw of his. I think Whistler's picture very fine.

From London he wrote,

⌁ I first went to Pools where I ordered a lot of clothes. After lunch I went to see Whistler. When the old janitor, who is there yet, announced me, I heard Whistler gasp out in a frightened whisper, "Mr. Cassatt," but after a few seconds he came into the dining room where I was as self-possessed as ever. He took me into the studio, got the picture down, sponged it all over so as to bring it out and promised most faithfully to have it finished by my return here in two or three weeks.

What do you think of my bringing home a maître d'hôtel and his wife, the latter is a first class Cordon Bleu? Mathilde's sister, a very superior woman, who has been in Grandes Maisons and is a first class lady's maid, seamstress, can make dresses, can cook, is out of a place. I think she is the sort of woman to secure.

Back in Paris he wrote on January 22:

⌁ We have taken passage by the *Germanic* from Liverpool Janny 29th. We have the captain's room, a fine one on deck. Mary has got far enough with Rob's and my portrait to be able to finish it without us.

This turned out to be by far the best portrait that Mary Cassatt did of her brother.

Young Robert gave his impressions of the trip to his mother and sisters:

I play chess a great deal with grandmother, Aunt Mary and Papa. Aunt Mary is painting a picture of Papa and I sitting on a chair. I go often to see Edgar Scott at their Hotel Liverpool. They have an new man cook at Grandmothers'.

He says in another letter:

My dear Mama: I am taking riding lessons at that place on the Avenue of the Bois de Boulogne. I have only taken two lessons. I have them from half past four till six. I posed for Aunt Mary from half past ten till half past twelve and after breakfast too yesterday. Papa took me to the theatre last night and it was awfully funny. We stayed till eleven o'clock. We took a nochen to go all of a sudden. The vet was here until eight o'clock and when he went papa asked me if I wanted to go to the theatre and I said I did and he said to get my coat and I did and we went. I went again to see the statue that is going to be in New York Harbor with papa. We left the Hotel d'Alba because it was not a very good hotel and it was too far up town. I am your affectionate son

ROBERT KELSO CASSATT

Mrs. Cassatt gave her impressions:

PARIS 14 RUE PIERRE CHARRON
JANUARY 21ST, 85

My dear Katherine, Your Aunt Mary had a little thing only two and a half years old to pose for her and it is funny to see her pretending to sew. She put in the needle and pulled it out exactly as if she was making stitches and exactly as she had seen her grandmother do who was an embroideress by trade and by the way she posed so beautifully! I wish Robbie would do half as well. I tell him that when he begins to paint from life himself, he will have a great remorse when he remembers how he teased his poor Aunt wriggling about like a flea. He laughs and says he isn't afraid of the remorse, he has just this instant opened the door to say, "Aunt Mary would like you to come here Grandmother," and I know it is to try to make him pose a little as his father has just gone out.

94

# Impressionists: Paris and New York

SHORTLY AFTER Alexander and Robert returned to America, Lois wrote to Mary Cassatt ordering dresses. Since their first trip to Europe in 1880, they had accustomed themselves more and more to the luxuries of Parisian *couturiers* and London tailors. Aleck traveled with a valet, Louis, frequented only the most expensive hotels and restaurants, and bought fine French carriages and Thoroughbred English horses. If money was no object in his way of life, the contrary was true with his parents. Despite the comfort with which the elder Cassatts appeared to live, we can see from Mr. Cassatt's letter of December 3 that they survived on a close margin indeed if a loss of 1,000 francs income a year ($200 at that time) necessitated borrowing. This was little more than Lois expended on one dress.

14 RUE PIERRE CHARRON
Dec. 3rd, 1884

MY DEAR SON:

Gard informs me that there is or will be this January another default in our income viz that from New Orleans and Pacific. This with that confounded Denver will make a deficit in our income of 1000 frcs a year. Very inconvenient, to say the least, in view of increased rent and other absolutely necessary expenditures which our situation the last year have rendered absolutely

necessary. I have therefore been obliged to borrow 1000 frcs and have sent Gard a note of that amount which I must ask you to endorse. I might have told him to put up a bond or collateral instead of your endorsement but did not think of it in time. This amount will put me all right at close of year and I will be able to pay it off out of income of 1885, I hope.

I think I may honestly congratulate you and this country on the result of the election.[1] I had a sort of sympathy for Blaine on account of his birth as a Pennsylvanian and because I knew something of his family in early days which however did not go so far as to wish for his election.

I suppose you intend to make Whistler toe the mark? What a miserable fellow! Mame has got to work again in a sort of way. Just now she is engaged in *etchings*.

She was invited to meet Clemenceau (the great Radical leader) at breakfast the other day and went. When you come she will tell you what she thought of him. Mame is very well just now and I am wearing very well.

In reply to her sister-in-law's belated request, Mary Cassatt gives us a glimpse into French *haute couture*:

14 RUE PIERRE CHARRON
28 Jan. [1885]

DEAR LOIS:

Your letter unfortunately only reached me on Sunday afternoon and we had said goodby to Aleck and Robbie on Sunday morning so that the dress order came much too late, for which I am very sorry. I went to see Armand this morning to ask her what her price would be for two dresses such as you want, but I did not find her in. However I saw some of Miss Mackay's[2] wedding dresses. Armand is making her trousseau, sixty-five dresses! The whole thing is to be exhibited, the dresses on lay figures in the

1 Grover Cleveland was elected in 1884.

2 She was the stepdaughter of John William Mackay, the Nevada-California multimillionaire who made an enormous fortune out of the Comstock Lode. Her name was really Evelyn Julia Bryant, and she was Mrs. Mackay's daughter by her first husband; she married in Paris February 11, 1885, Prince Ferdinand Colonna.

salon of Mrs. Mackay and cards of admission are to be given, sixty-five pairs of shoes embroidered to match the dresses, and I should like to go for the fun of the thing. One of the dresses I saw this morning was very splendid white silk covered with hand embroidery. It was certainly very nice of her to give the whole order to Armand who is a small dressmaker and to whom it was a great advantage, rather than give the order to one of the great houses who didn't need it. They say she is a very nice little thing.

I did not get your gloves exactly the shade you sent because they had nothing but the suede colors, they are the fashion now and worn even with white dresses.

Aleck will tell you about Mathilde's sister, Bertha, she is at Nice and cannot leave before the spring. She is a thoroughly reliable woman, an excellent lady's maid, dresses hair very well and is a good milliner. She also makes dresses and sews very well, at her present place she is a sort of housekeeper, overlooks everything, does all the preserving, etc., and she speaks better French than Mathilde and excellent Italian, besides *Arabic*. Aleck will tell you about the "chef," we gave him eight days warning this morning, as he adds on to his bills too heavily, otherwise he is a decent man and a very good cook. I told him that tradespeople did not give commissions to the servants in America, *but* it seems that Louis, Aleck's man, told him that they had begun to do so in New York. I hope it is not true.

And a few weeks later she gives some interesting side lights on the servant problem:

<div align="right">14 Rue Pierre Charron<br>1st March [1885]</div>

Dear Lois:

I hope Aleck is better and has had no return of his vertigo, if he has had, do make him take "douches." Please tell him, if he is still troubled with his eye to try bathing it in very strong cold tea. I am trying it and find that it is very strengthening. [Apparently she had eye trouble even at this date.]

We have had a disagreeable experience in our "chef" who

proved too much of a cheat and for two weeks were without a
cook, when Mathilde went into the kitchen and astonished us all
by her talents. I must say I liked the chef's cooking. The other
day Madame Berard was here and I told her I had never eaten
such a good dinner as at her house and that it gave me a good
opinion of chefs, she said he certainly cooked well but he was
*never* sober, and she had had him for ten years! Do you want
Bertha to take you over anything, if you do let me know in plenty
of time.

I asked Armand about the two dresses you wanted. She said
she would make you the grey costume for 400 frs simple. I sug-
gested steel bead embroidery and steel bead collar, then it would
be about 700 frs with mantle. Black faille would be from 400 frcs
to 500 frcs, depends on how handsome you wish the trimming to
be. Armand said if you wished anything to send a dress lining
that fitted you well, as well as your measure, you could send it
in a newspaper.

Have you got Whistler's picture? We have just been reading
Lord Malmesbury's Memoirs, he says that Landseer painted the
portrait of Lady M. and that he got the picture *forty-four* years
afterwards from Landseer's executors. There is consolation for
Whistler's lecture[3] was very successful (*"Truth"* says); the Eng-
lish adore humbug.

Tell Robbie I am working away on his picture from all the
sketches I ever made and all the old pastels and that he is very
like himself.

On May 6 she gave a further account of dresses and servants:

Your dresses are "en train." As you did not limit me as to
price, I settled on 600 frcs apiece. Armand tells me that the black
dress will cost her nearly that and that she won't have any profit
on it, but she is anxious to get you for a customer. I believe it,
as the material is very expensive, it is a stripe of moiré and an open
stripe that looks like Spanish lace. It is to be handsomely trimmed
with Spanish lace and "moonlight" jet. The white dress is crêpe

3 The "Ten O'Clock" lecture, delivered on February 20, 1885.

with pink rosebuds, I chose peach pink rosebuds as the color was more delicate. The skirt is to be white, I believe, she asked me to leave it to her taste. The lining you sent is to be stuffed with horse-hair and the dress fitted on it.

Your "chef" or rather the one Aleck wanted is going to Switzerland. He had a letter asking for a character from Baron somebody. Why have you such a horror of one? I should think you would find it the greatest comfort. Mme. Berard who spends seven or eight months a year in the country, has a chef because she says a man cook knows better how to provide in advance and Mrs. Bickly told Annie Scott she never knew what comfort was until she had a man cook. I believe I wrote you that Bertha was a beautiful ironer and Mother says they have all sorts of con-veniences here, a great variety of utensils, such as she thinks you have not at home for ironing fine dresses. If we were sure you had not the things required Mother would send them, perhaps they are to be found there now.

Bertha was sent across second class on the *Normandie* at a cost of 250 francs ($50) and took with her the new clothes for Mrs. Alexander Cassatt. She reported that the ship was "magnificent." Her wages, $5.00 a week, were princely at the time.

During the summer of 1885 the Cassatts rented still another furnished house north of Paris at Presles in the department of Seine-et-Oise, just west of the Forest of Carnelle. Mr. Cassatt gives a description of the house:

> PRESLES, S. ET O.
> FRANCE
> July 6th [1885]

My dear Lois,

Mary has really been suffering, the doctor called it bronchitis and though she had very little fever if any, she coughed badly and has not yet ceased, though better.

We like our place here very much as the neighborhood is pretty, the drives various and good and the garden large and plenty of fruit and vegetables. As to the house it is old and has

none of the modern conveniences, not one, and the furniture literally tumbling to pieces though some of the bureaux, if it would be possible to repair them, might be thought worthy of the attention of a *marchand de bric-à-brac*. Mary has her eye on one hoping to be able to buy it for a song, but I am afraid she won't have the luck.

By the time you get this I suppose you will be settled at Long Branch.

The Impressionist group were trying to organize another exhibition, but disagreement among them delayed their getting together. Pissarro wrote Manet, December 7, 1885:

For some time there has been much talk about the show, it is discussed on every side. I paid a visit to Miss Cassatt. From the very first we spoke about the show. All of us, Degas, Caillebotte, Guillaumin, Berthe Morisot, Miss Cassatt and two or three others would make an excellent nucleus for a show. The difficulty is coming to an agreement.

His letter of March 5, 1886, is even more significant:

The exhibition is completely blocked. Guillaumin was not able to go with me to M. Eugène Manet's yesterday, it has been put off until Saturday. We shall try to get Degas to agree to showing in April, if not we will show without him. If we do not settle the whole thing in the next four or five days, it will be dropped altogether. Degas doesn't care, he doesn't have to sell, he will always have Miss Cassatt and not a few exhibitors outside our group, artists like Lepic.[4] If they have some success he will be satisfied. But what we need is money, otherwise we could organize an exhibition ourselves. I shall find out what Madame Manet thinks, but I am afraid she will not want to appear with us if Degas does not. In that case the whole thing will be off, there won't be any exhibition, for to spend money exhibiting at the

4 Degas felt that the inclusion of Vicomte Lepic, Rouart, de Nittis, and Zandomeneghi, friends of his who were well-known semi-official painters, toned down the impact of the exhibition and would make an appeal to a wider public.

same time as the official Salon is to run the risk of selling nothing. Miss Cassatt and Degas say that this is no objection, but it's easy to talk that way when you don't have to wonder where your next meal will come from!

I just ran into Bracquemond. He talked a good deal about color and about his experiments with warm and cold tones. His conclusions are very interesting and curiously enough are close to what we spoke of.

The suggestion that the more wealthy members of the group should support it pointed, of course, directly at Mary Cassatt. This made her intensely angry and caused her to wonder whether these artists might not be more interested in her money than in her art. Without a doubt this incident was one of the important factors in building up her resentment against the French.

It may seem curious that Mary Cassatt was regarded as "wealthy" considering the fact that her father lived up to the last sou of his modest income and sometimes had to borrow from his sons in order to make both ends meet. From the many references in family letters we are made aware that Mary Cassatt sold her work rather well over the years. From her sales she paid her models and other expenses of a studio, and she also had to maintain her various riding horses. She bought her own clothes, but, by living with her family, presumably did not have any basic living expenses. That being the case, she would easily have had a surplus which enabled her to help finance the last Impressionist show, and, as time went on, there were other causes to which she lent financial aid. Monet probably sold better than Mary Cassatt, but, as he had the full obligation of a family, there was no surplus, although by 1890 his sales were so great that he became prosperous. Pissarro, whose work did not sell well, was in a poor financial position.

The spring of 1886 was a momentous one for the Impressionist group as it marked the end of one phase and the beginning of another. On May 15 they opened over the Restaurant Dorée at l, Rue Laffitte at the corner of the Boulevard des Italiens, the Eighth—and what proved to be the last—Impressionist show.

Mary Cassatt was included despite her annoyance at being expected to be a fairy godmother. Degas showed a series of pastels of women at milliners', for some of which Mary Cassatt had acted as model.

Mr. Cassatt wrote of the exhibition:

<div align="right">

14 RUE PIERRE CHARRON
Wednesday April 14, 1886

</div>

My DEAR SON:

Mame is pretty well and working like a beaver getting ready for an exhibition which they propose having in May. She is now engaged on a little red-headed girl in demi-costume dressing her hair before a glass [(National Gallery of Art, Chester Dale Collection) (Plate 15)]. The two or three experts and artists who have seen it praise it without stint. As for Degas, he was quite enthusiastic for him.

This picture, "Girl Arranging Her Hair," is most effectively composed, showing a young girl in an off-white chemise arranging her hair in front of a washstand. A striking diagonal thrust is set up with the raised left elbow, while the warm, flowered wallpaper forms a colorful background for the simply clothed figure. This indicates that Mary Cassatt had become more adventurous in making use of intricate poses. Although a stronger interest in design began in 1883 with the "Lady at the Tea Table," she shows in "Girl Arranging Her Hair" far greater emphasis on form. The head, neck, and arms of the girl are firmly and compactly modeled, solid, and well rounded. In the chemise Mary Cassatt has used a broader paint technique, but the garment, too, has a solidity to it and with the angular folds and blue-white tone with blackish shadows, it is reminiscent of a Cézanne tablecloth. Such an influence is not inconceivable inasmuch as she owned a Cézanne and must also have seen many more of them at her friend, Ambrose Vollard's.

On May 5 Mr. Cassatt commented further on the exhibition:

They have secured a very central position and at a reasonable rent, in the Maison Dorée, Boulevard Italiens, rent 3000 fs.

Degas and his friend Lenoir, Mme Manet [Morisot] and Mame are the parties who put up the money for the rent and are responsible for all deficiencies in expenses and entitled to all profits if there are any and needless to say they do not hope for or expect any, the other exhibitors being admitted free. Mame has positively forbidden the appearance of her name in the advertisements. Nevertheless as you will see by the enclosed slip the papers have already got her name as one of the exhibitors but that is a different thing from being one of the getters up of the affair. There are symptoms of trouble already appearing but there always are when artists are concerned. So it may go off well enough.

Whistler has a picture in the salon this year but it is not Lois' portrait. Mame has not seen the picture but hears that it is badly hung and has not anything remarkable in it.

Mr. Cassatt, who must have been a very lonely man, took a lively interest in reading and often exchanged ideas about books with Aleck:

I am not surprised that you do not like the Russian books.[5] I offered to bet Mame that you would not be able to read the last one (of 3 vols.) sent. What she found in them to be so pleased with I don't know. The description of the Battle of Borodine seemed to strike her as particularly fine but it is not to be compared to De Segur which if you haven't read I advise you get from the Library and read. De Segur to be sure excuses Napoleon on that day by his dreadful suffering from an attack of the disease that finally carried him off or something of that kind.

We have lost Mrs. Scott and her mother and we miss them very much. I miss them I think more than the others as there is not a soul in Paris that I knew before coming over here and nobody that I can talk as freely to as I could to them.

In the meantime, Durand-Ruel was having a very difficult time financially; in fact, they were on the edge of bankruptcy. Mary

[5] Presumably Tolstoy's *War and Peace*, published in a French edition at this time.

Cassatt lent them money and undoubtedly by so doing averted disaster. Not being able to sell well in Paris, they tried sending a group of paintings to London, where they were shown at Dowdeswell and Dowdeswell at 133 New Bond Street. There were three paintings by Mary Cassatt in the group, but no sales were effected. Durand-Ruel's great rival, Georges Petit, had organized an *Exposition Internationale* and had phenomenal success. In 1885 he showed several of the Impressionists and sold six or seven canvases by Monet at 3,000 francs each. All this took business from Durand-Ruel, but in going over to Petit, the Impressionists felt that they were helping their own cause by showing the public that more than one dealer believed in their work. Mary Cassatt had advised her brother's friend, Mr. Thompson, to go to Petit, hoping that he might make purchases at more advantageous prices.

On May 17, Mary Cassatt mentioned Petit's exhibition in a letter to Aleck:

➤ This morning I went to see Degas and he insisted on my going to see the exhibition at Petits Gallery *at once* as he wanted me to judge of the Monets. They have managed to nearly kill him. They were up until three in the morning the day before the opening and every time one of Monet's pictures was hung the painters next took theirs away. Finally they separated all his pictures and put them in different corners. We are looking out for notices of the Monets you sent to New York.

A fortunate solution to Durand-Ruel's problems came from the other side of the Atlantic. In 1885, James F. Sutton, representative of the American Art Association, invited Durand-Ruel to organize an exhibition to be shown in their New York galleries. Sutton, who had formerly been an executive of Macy's Fourteenth Street Bazaar, and an auctioneer named Thomas E. Kirby had founded the American Art Association in 1877. They ran art competitions with large prizes mostly underwritten by business friends and customers, and gave the impression that they were an educational institution organized for the advancement of cul-

ture on a nonprofit basis. Because of this, the customs officials let in forty-three cases of the Durand-Ruel exhibition duty free. About three hundred pictures were sent over, including twenty-three paintings by Degas, seventeen by Manet, forty-eight by Monet, forty-two by Pissarro, thirty-eight by Renoir, fifteen by Sisley, and several by Boudin and Berthe Morisot.

An occasional Impressionist picture had been seen in America before the 1886 Exhibition. Mary Cassatt had shown at the National Academy in 1874, at the Pennsylvania Academy in 1876, 1878, and 1879, at Boston in 1878, and at the Society of American Artists in 1879. In November of that same year a French opera singer, Madame Émilie Ambre, had brought over Manet's "Shooting of Maximilian" as a sort of extra attraction to her concert tour. After a mild reception in New York and an indifferent one in Boston, she returned to France with the picture and sent the bill for expenses to Manet. She explained that she had had to supply much punch and champagne in an attempt (futile as it proved) to win over the press. Mme Ambre's portrait by Manet was bought in 1883 at Mary Cassatt's instigation by her cousin, Mrs. Thomas Scott, from the artist's widow for 3,000 francs ($600). Mr. Scott was so opposed to the purchase that he would only consider it as part of a deal which included a Corot for 20,000 francs ($4,000).

On September 3, 1883, the Foreign Exhibition opened at the Mechanic's Building in Boston. Durand-Ruel used this as a trial balloon and sent two Manets, three Monets, six Pissarros, three Renoirs, and three Sisleys. Although this was a fairly impressive showing, they were so surrounded by Salon pictures that they were scarcely noticed. Much more important, however, was the Pedestal Exhibition, which was opened by General Grant at the National Academy of Design in New York, December 3, 1883. Organized by William Merritt Chase and Carroll Beckwith to help finance the building of a pedestal on Bedloe's Island for the Statue of Liberty, which recently had been given to the people of America by the French government, the exhibition included not only Corot and the Barbizon men, who were by then high in

popular favor, but also several Impressionist pictures. At the same time the Salon painters had been excluded. Although Chase's effort was a valiant one, there was little public acceptance of the Impressionists.

The Durand-Ruel exhibition opened April 10, 1886, at the American Art Association in Jackson Square. Because this space was available for only a limited time, the entire exhibition was moved to the quarters of the National Academy, where it opened on May 25. Twenty-one paintings were added, making a total of 310, including two by Mary Cassatt, several in the group having been lent by Alexander J. Cassatt, Erwin Davis, and H. O. Havemeyer. Mary Cassatt's "Family Group" and "Portrait of a Lady" were lent by her brother. Some $18,000 worth of pictures was sold, on which Durand-Ruel had to pay $5,500 import duty. This was an occasion of the greatest significance in that it was the first major showing of Impressionist pictures in America. An Impressionist exhibition of such size was a big event as early as 1886 and was an *avant-garde* gesture just as important in that day as the more famous Armory Show of 1913. In 1886 the Impressionist painters were far from being accepted in France; their advent in America, where taste was much more conservative, was an event of the first order.

Mary Cassatt wrote at this time:

PRESLES (S. ET O.)
Monday Sept. 21st [1885]

DEAR ALECK, I have no doubt that you will see Durand-Ruel by the time you get this for he wrote to me that he intended going to America and as I was in town a couple of weeks ago I called and gave him your address; he wanted me to give him a letter to you but I thought that quite unnecessary. The New York Art Association have offered him their rooms for an exhibition and he is going over to make arrangements. Affairs here he complains are at a standstill and he hopes to have better luck in America. I doubt it however. I gave him your address at your office. I am glad you will lend the pictures to Thompson, you never

told me what was thought of the Monets you sent to New York.

We are getting on much as usual here, I am at work again and have done a large pastel of Father on Isabella [Mrs. Percy Madeira Collection, Berwyn, Pennsylvania] with which he is much delighted, but he says you will never believe that she is as handsome as I have made her. Just now poor thing, she is under the weather, I had to have her fired for a splint on her fore leg. She has been the delight of Father all summer as he has done most of the riding when I was ill. I will send the portrait to Gard as I have never given him a portrait of Father and he is disgusted because I won't send him Jennie's portrait.

I had a letter from Scott a dreadfully cheeky young English painter who was in Paris last spring. He had been to see Whistler and saw Lois' portrait which he said was very fine but not done yet, that Whistler was dreadfully distressed, but could not find a model to finish the dress with.

We all take the greatest interest in the racing news, Mother seizes the paper the moment it arrives, and won't give it up until she has read all about your horses, it is very funny as she does not know anything about the terms and appealed to me at first to know what a "ch. c." was, I suggested it must be a chestnut colt, but now she has it all pat although she declares that she wished you would give it up.

We were very much surprised to hear from your letters that you had horses entered for the Grand Prix 1887. We had not seen it in the *Turf Field* and Mother rushed for the back nos. but we found Father had given most of them to the servants to light the fires with. We are expecting a new no. tomorrow and will see your bunch at Coney Island.

Our stay here will soon be over, we have the place until the 15th Oct. and if the weather is not too bad we will stay until then. I think the place very nice and certainly it has done Mother an immense amount of good, although she will not own it, by any means, still she looks ten years younger than when you saw her, and has not seen the doctor once this summer on her own account, he came out once on mine.

After spending two summers in areas to the north of Paris, Mary Cassatt decided in 1886 to take a place near her friends the Berards. She found a house at Arques-la-Bataille, four miles from Dieppe, which gave them access to the sea without being directly on it; too close contact with the ocean only served as a reminder of her extreme susceptibility to seasickness. Between painting sessions she enjoyed horseback riding, but as her horse Joseph proved unsatisfactory, she sold him. However, since Martin, their coachman, tried to extract a percentage, the sale was canceled and Martin was discharged on the spot. Joseph was then sold for the second time, and the mare, Isabella, was used both as a saddle horse and a carriage horse.

On the first of September they were all delighted at the news of the birth of Gardner Cassatt, Jennie's first child.

On returning to Paris in the fall, Mary Cassatt was again on the lookout for an apartment since they wanted to be a little nearer the center, where there were better shopping facilities. Street after street of new apartments had been built on the outskirts, but half of them remained unoccupied. After exhaustive search she found what proved to be a completely ideal apartment at 10, Rue de Marignan, just off the Champs-Élysées, a little above the Rond Point. There was an elevator, their quarters were more commodious, and the location was more convenient. Mary Cassatt kept this apartment, into which they moved in March, 1887, until the time of her death.

Here she had her winter studio in the bedroom next to the salon. They were served by the faithful Mathilde Vallet who was housekeeper, lady's maid, companion, and general manager of the household from almost the time that the elder Cassatts came to live in Paris until 1926, when Mary Cassatt died. Mathilde was in service with them for forty-four years. With her were a cook and a maid, all of whom had attic rooms up above the apartment. They kept a coachman up to 1914 and were served for years by Pierre, first as coachman, then as chauffeur; they also had a little *tigre* or groom, who appears in the painting, "Woman and Child Driving."

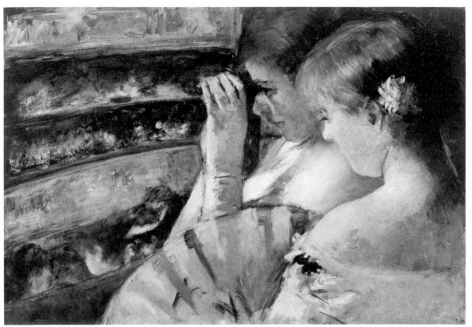

*Plate 9*

"In the Box" (*ca.* 1879)
(oil—17″ high, 24″ wide)

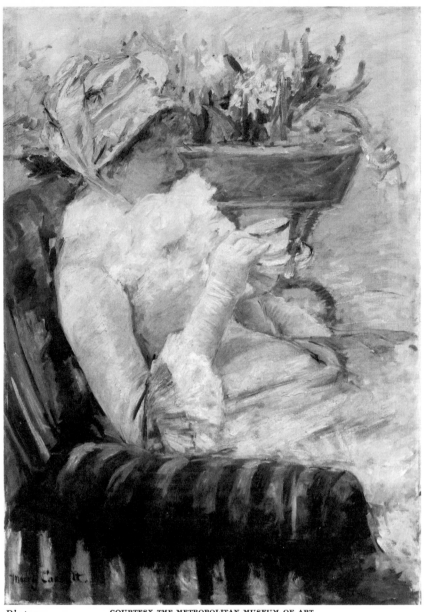

Plate *10*

"The Cup of Tea" (1879)
(oil—36⅜" high, 25¾" wide)

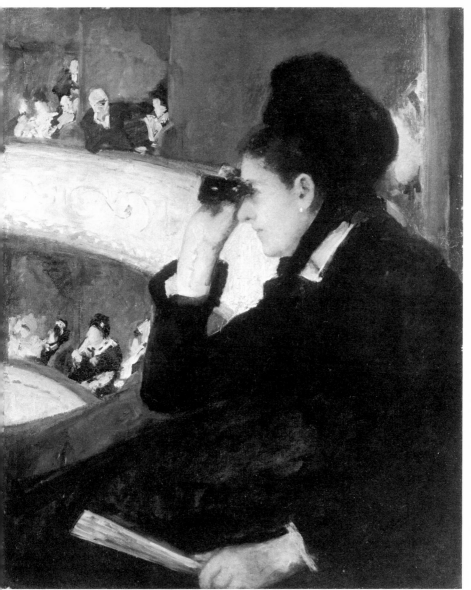

Plate 11

"At the Opera" (*ca.* 1880)
(oil—31½" high, 25½" wide)

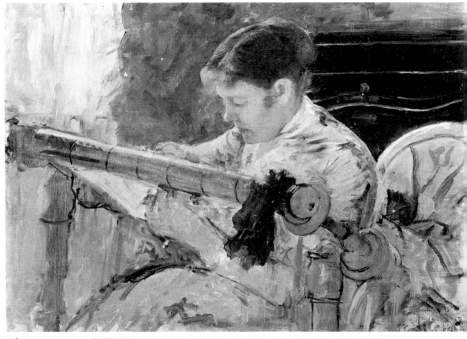

Plate *12*

*"Femme à la Tapisserie"* (1881)
(oil—25⅜″ high, 36¼″ wide)

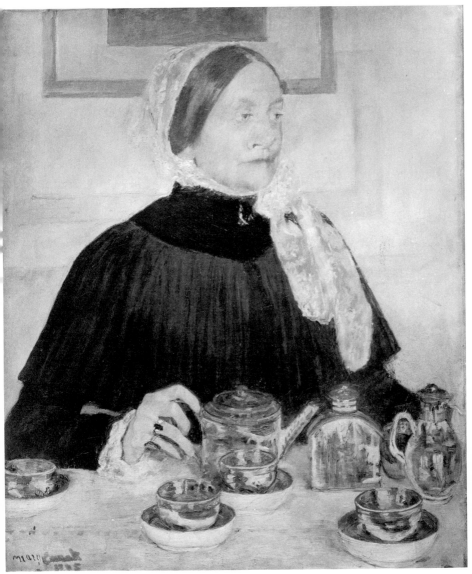

*Plate 13*

"Lady at the Tea Table" (1883–85)
(oil—29″ high, 24″ wide)

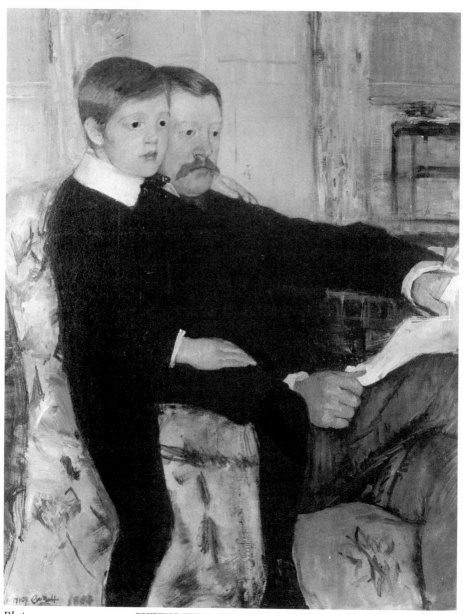

Plate 14

"Alexander J. Cassatt and His Son Robert Kelso Cassatt" (1885)
(oil—39″ high, 32″ wide)

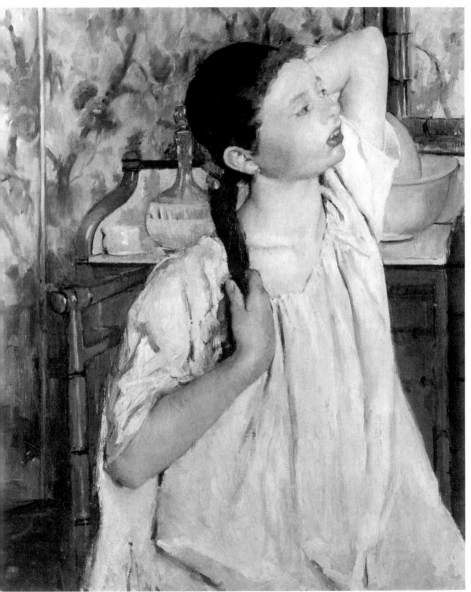

*Plate 15*

"Girl Arranging Her Hair" (1886)
(oil—29½″ high, 24½″ wide)

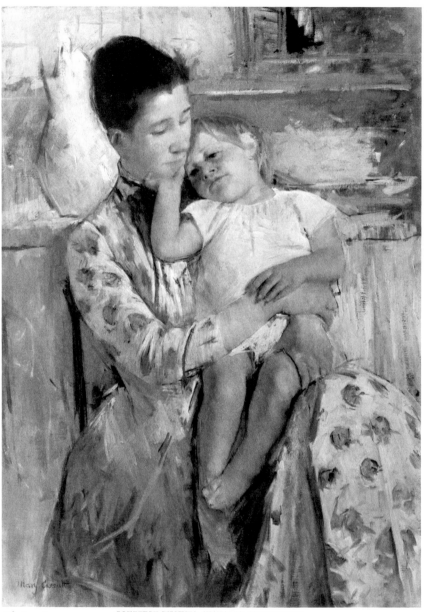

Plate 16

"Mother and Child" (*ca.* 1890)
(oil—35⅜" high, 25⅜" wide)

The furniture was a mixture of Louis XV, Louis XVI, Empire, and Second Empire, arranged with more of an eye to comfort than to forming a period setting. On the walls were the paintings of French Impressionists, Monet and Pissarro, and of Manet and Courbet, whom Mary Cassatt greatly admired. She once owned Manet's *"Tiges et Fleurs de Pivoines,"* now in the Louvre, and also collected Persian miniatures and Japanese prints, both of which had a strong influence on her style.

Mrs. Cameron Bradley, Mrs. J. Montgomery Sears's daughter, described the apartment vividly:

It was stuffy and old-fashioned, very French-Victorian— fringe on everything, lace curtains, heavy draperies with fringe, fringe on the lamps and tablecloths. There was a long hall, five little bedrooms, was on the top floor except for the servants' attic in the mansard. In the dining room was a round table with damask to the floor. They always had soup, fish, and often a favorite dish, *perdrix aux choux.* Mary Cassatt spoke German to Mathilde and called her Taudy.

Mrs. Hare spoke of their light and hot-water facilities:

"The apartment had a strange gas arrangement in the bathroom to heat the bath water and I think there may have been gas in the dining room, but the salon and bedrooms had lamps and candles. I am almost sure there was gas in the dining room; I remember the smell!"

Mr. Cassatt, as always, could be counted on to make pertinent and frank comments on the family's means:

<div align="right">

14 RUE PIERRE CHARRON
Friday, Feby 18, 87
</div>

MY DEAR SON: I suppose either your mother or Mame or both told you of the apartment we have taken. It is No. 10 rue Marignan and is owned by our present landlord. It is a half a mile nearer Paris than where we are now and in a quiet, fashionable street of nearly all private hôtels and good houses without

shops in front. The apartment is a larger and better one than this but we pay $140., 700 frcs. more rent than we do at present but the apartment is a deal cheaper than this one. As a matter of prudence I would have preferred remaining here for say six months longer until we could judge more certainly as to the chances of war or peace before entering into another lease, but Mame and her Mother poh! pohd! me. So we are in for a three year lease, war or no war. I feel curious to know how the rumors and chances of war will affect your plans for coming over. Of course it will be easy for you to "upsticks" and be off home if danger comes too near, but I look upon a residence in Paris, if war breaks, as not unlikely to be troubled by Communists in a case of any great disaster to the French Army as in 1870 for instance. The Communists are still a considerable party in Paris and their leaders are always threatening what they will do next time. However, this time the French know and feel that it is life or death and there won't be just a one-sided fight as in 1870 and, if the Germans reach Paris at all, it will be after having lost at least half their army en route.

I enclose a little sketch of the quarter in which our new house is situated with No. 10 marked on it. The house is built on part of what was formerly the Jardin Mabille of classic memory.

Once the ordeal of moving was over Mr. Cassatt calmed down:

No. 10 RUE DE MARIGNAN
Paris March 14, '87

My DEAR SON I date this from our new house though we are not yet in it. We have however commenced moving, that is to say carpets, curtains and some articles of furniture which need repair have been taken away and will be returned to new house. We expect to be reinstalled in a week or ten days at farthest. It will depend somewhat on the weather for we are not pressed for time, our present landlords owning both houses and this one not rented. So far we have been highly favored in weather dry, clear and cool, too cool in fact.

What is surprising is that we are all taking the moving very coolly, rather pleasantly in fact. Three years ago I was in purgatory all the time the moving was under way and for a good while before it commenced.

We are all quite well, I astonishingly so. I certainly am stronger on my pins than this time last year. Saturday I rode Mame's new horse, "Reddy" in the Bois for two hours and didn't lose my strength though he bucked once pretty badly and yesterday walked over six miles without feeling fatigue. Your mother too is very well and strong for her though she cannot make her six miles per diem on foot.

The war cloud, as you will have seen, has been blown out of sight and we hope now that there will be nothing to prevent your carrying out your programme for the summer.

In June, 1887, the Alexander Cassatt family went abroad for fifteen months, spent July at the Hotel Royal in Dieppe, near Arques-la-Bataille, where the elder Cassatts and Mary again spent the summer. Ed stayed with them to study for St. Cyr, the French military academy, which he hoped to enter. In the fall Alexander rented a private hôtel at 30, Avenue Montaigne and sent the girls to the *École Monceau*. While abroad the Cassatts bought as their Philadelphia town house, 202 West Rittenhouse Square, for which they paid $110,000 to the Fairman Rogers, furniture included.

Mary Cassatt was a superb horsewoman and had ridden since she was a child at Hardwick, their country place in Lancaster County. In the summer of 1888 she was out riding with her father and met with an accident which prevented her ever riding again. Degas describes the event in a letter to Henri Rouart:

⟳ ... Tillet must have written to you that poor Mlle Cassatt had a fall from her horse, broke the tibia of her right leg and dislocated her left shoulder. I met him two days later and told him the story; he was to have written to you the same evening. She is going on well, and here she is for a long time to come, first

of all immobilized for many long summer weeks and then deprived of her active life and perhaps also of her horsewoman's passion.

The horse must have put its foot in a hole made by the rain on soft earth. HE [Mary Cassatt's father] hides his daughter's *amour propre* and above all his own.

One of Mary Cassatt's close friends was George A. Lucas, of Baltimore. He was a witty bachelor, a collector, and an intimate friend of Whistler's. Like Whistler, he had been at West Point, but unlike his friend, he managed to graduate. In 1857 he went to Europe to do the Grand Tour. The ocean crossing was frightfully rough and he was so violently ill that he swore he would never set foot on a ship again, and he never did. Susceptibility to seasickness was indeed a bond which he and Mary Cassatt shared. In his diary (deposited in the Baltimore Museum of Art) he wrote on January 23, 1888: "At Mlle Cassatt to show her my Whistler."

In a letter to Mr. Lucas, Mary Cassatt recounts another one of her frequent accidents. Although undated, it was probably written in 1890:

September (SEINE ET OISE)

~~~ MY DEAR MR. LUCAS: You would have heard from me before now and I would have sent you the drawing for Mr. Avery if I had not another accident. I was thrown from my carriage on the stones at the corner of the rue Peirre Charron and the Place d'Iena and as I alighted on my forehead, I have had the blackest eye I suppose anyone was ever disfigured with. The carriage was kicked to pieces the coachman pitched out and even the dogs wounded, and all because a man driving a van thought he would amuse himself cracking his whip at my cobs' head, finding it frightened her. He leaned out of his wagon and continued his amusement until he drove her nearly mad with fright and drove off smiling.

Fortunately none of our wounds were very serious. I am well again but still with patches of red and blue on my forehead and around the eyes. As soon as the doctor would allow me we came

here where I am beginning to work and hope if nothing else happens to soon send you the drawing in question. Mr. Avery wrote me a very kind letter. Won't you, if you write to him, mention why I have not answered him. I was very sorry to hear of his bereavement, Mrs. Havemeyer told me of it.

Hoping that you are well and enjoying the sunshine as we are here, believe me, Very sincerely yours,

MARY CASSATT

In the fall of 1888, Edward Cassatt entered the French military academy at St. Cyr. He greatly enjoyed his experience there even though it meant, with a West Point career to follow, two additional years in his military training. He saw his grandparents frequently and dined out in French society. "As I told you," he wrote his father:

Captain Balloré dined with us last night. Aunt Mary had talked about him for a long time as eligible for Molle Riedner's hand and she said I'll just ask Molle Riedner tonight to see if he won't fall in love with her and as I was leaving she rushed after me saying, "It has taken! It has taken! He is head over heels in love with her." How is that for love at first sight.

To his Mother he wrote:

I dined in great state last night at the Vicomtesse de Trédern's, the mother of de Brissac[6] who is in my class. There were powdered footmen in livery everywhere and in the middle Mme. la Vicomtesse ate so fast she nearly killed herself, and held her fork in her fist as if she was afraid of its running away from her. I believe most of these French Swells eat like pigs.

After two years at St. Cyr, Ed returned to America and entered West Point. During these years and the previous ones at the *École Monge* he greatly endeared himself to his grandparents and his Aunt Mary. Despite this fact, in later years he was less close to Mary Cassatt than any of her other nephews and nieces.

6 François de Cossé, eleventh duc de Brissac, born February 12, 1868. His mother, Jeanne Say, born November 17, 1848, married in 1872 as her second husband Crétien-René-Marie, Vicomte de Trédern, whom she divorced in 1888.

During the summer of 1890 the Cassatts rented the Château of Septeuil, north of Paris in Seine-et-Oise in the area where they had summered before going to the vicinity of Dieppe. On June 21, Mr. Cassatt wrote to his son:

I need not say how delighted we shall be to see you. Tell Elsie, poor dear, that Grandfather felt "very cross" when he heard that she would not be coming. We are gratified to have such accounts of Ed. I suppose some of them have told you of Mame's second accident? She had a very narrow escape, but is now as well as ever with the exception of one of the blackest eyes I ever saw. Mame is hard at work getting up a new series of dry points. She has had her press brought out here and proposes doing a lot of work. I only hope she may be as successful as she was last year.

As Mrs. Alexander Cassatt remained home with Elsie, only Mr. Cassatt, Katherine, and Robbie went abroad on this trip.

CHAPTER VIII

Prints and Murals

O N JULY 8, 1853, Commodore Matthew Calbraith Perry steamed into Yedo harbor armed with an imposing array of United States naval vessels and a letter from President Fillmore to the Emperor of Japan. After refusing to see minor dignitaries and threatening to use force, he was finally received by two princes of the blood. At length on March 31, 1854, a peaceful commercial treaty was signed by the Emperor which opened up two ports for trading. This bold step on the part of an American naval officer had far-reaching effects in the relations of the Western World with the hitherto tightly closed Japan. Not the least of these was the discovery of Japanese art.

In 1856, Auguste Delâtre, the noted French engraver and printer, came across the *Manga*, a little volume of Hokusai woodcuts, which had been used as packing material for porcelain sent from the Orient. Two years later the Hokusai book was acquired by Félix Bracquemond, who showed it to several of his artist friends and thus set in motion an interest in Oriental art which was destined to have a wide influence. Further impetus was given in 1862 when Madame de Soye, who had lived in Japan and the East for ten years, opened a shop at 220, Rue de Rivoli in Paris called *La Porte Chinoise* or *Jonque Chinoise*. This is where Whistler bought Japanese prints, costumes, and blue-and-white porcelain, and also where Manet, Monet, Fantin-Latour, Baudel-

aire, the De Goncourts, and others eagerly sought color prints from Japan. Manet had painted Émile Zola in 1868 with a Japanese print and screen in the background, but one of the greatest enthusiasts for this newly discovered art was Degas, who in turn interested Mary Cassatt. In 1873, Théodore Duret went around the world and returned with greater enthusiasm than ever for the art of Japan. When the term "Impressionism" was coined the following year, Duret said that the Japanese were the first and finest Impressionists.

In April, 1890, Degas wrote to his friend Bartholomé:

⌒ Dinner at the Fleurys [the first Madame Bartholomé was a Fleury] Saturday with Mlle Cassatt. Japanese exhibition at the Beaux-Arts,

Berthe Morisot wrote Mallarmé:

⌒ I go on Wednesday to Miss Cassatt's to see with her these marvellous Japanese prints at the Beaux-Arts.

They were referring to the great exhibition of Japanese art held from April 25 to May 22 at the *École Nationale des Beaux-Arts*. There was an introduction in the catalogue by the well-known collector, S. Bing. In all there were 725 prints and 362 books, as well as other items, all lent by French collectors like Bing, De Boissy, Gillot, and Clemenceau. No one could have been more enthusiastic over the exhibition than Mary Cassatt and Degas. They had both been interested in Japanese prints for some time, but this emphasized the importance of that art, which was still something of a novelty to the general public. Mary Cassatt purchased figure prints by Kiyonaga, Shunjo, Haranobu, Utamaro, and Yeishi, as well as landscapes by Hiroshige and Hokusai, and she had an entire gallery of them at her château.

The prevalence of all-over floral patterns in her work of the 1890's is due in some measure to the influence of Indian and Persian art, no doubt stimulated by the *Exposition d'Art Musulman* held at the *Palais de l'Industrie* in 1893.

One of Mary Cassatt's greatest achievements was her work in

the field of prints. Her graphic work begins rather hesitatingly about 1879, progresses to a climax in the ten color prints of 1891, and then, after a few fine plates in the mid-nineties, her work coarsens and becomes monotonous until about 1911, when eye trouble caused her to give up printmaking. Although she gained technical knowledge from some of her contemporaries, her style was entirely her own—fresh, crisp, and completely free from the traditional etcher's approach. Except in two or three of her earliest prints, she never practiced straight etching, preferring soft ground, aquatint, and dry point. Her entire graphic output amounted to something over two hundred, more than one hundred of which were dry points. Two lithographs are also known, but these are rarities. Félix Bracquemond is supposed to have taught her print techniques, but, if that is true, it is curious that she had no interest in etching, which was, after all, his strong point. Paul Helleu, the great friend of John Singer Sargent, was also a friend of Mary Cassatt and may well have given her some hints on print techniques, especially dry point, at which he was most adept. Another who probably advised her was Marcellin Desboutin, a specialist in dry point, whose portrait she once painted. Mary Cassatt's success with prints was due to her own indefatigable approach. She felt that printmaking was good discipline, the best of training in helping draftsmanship. It is then first and foremost as a draftsman that she took up the print medium, and because of this attitude she was especially interested in dry point and soft ground. Rich effects are obtained, for the ink not only goes into the lines or grooves made by the dry point needle, but is also held by the burr which the needle throws up at the side like the earth thrown to either side of a furrow by a plow. "In dry point," she once said, "you are down to the bare bones, you can't cheat."

She was also greatly interested in soft-ground etching, another technique which requires direct and decisive draftsmanship. In this instance a plate is prepared as for a regular etching, but the ground must be a soft wax. A sheet of drawing paper is then placed over the wax ground and the design is drawn on the paper

117

with a pencil. On pulling the paper away, the ground adheres to the back of the paper in those places where the pressure of the pencil was applied and the copper plate will be exposed accordingly. The plate is then bitten in acid.

Aquatint, usually combined with one or both of the other techniques, was another medium which Mary Cassatt handled with great success. This required a more painterly approach. A ground of powdered resin is applied to the plate and then heated, giving an even, porous coating. Areas of the design which are to be blank are painted out with a brush and stopping-out varnish. The remaining areas are bitten in acid and, when printed, show up as gray tone. Linear elements of the design are usually put in beforehand in dry point, soft ground, or both.

Mary Cassatt's greatest contribution to printmaking took place in 1890–91, when she did a series of ten aquatints in color (Plates 23 and 24). The Japanese print show had made a profound impression on her and was in a large measure responsible for her attempting color prints. She admitted quite frankly that she was trying to get some of the same effects as the Japanese. Her technique was, of course, totally different, for they used a series of wood blocks, a different block for each color and one for the line, producing a polychrome woodcut.

In America, interest in Japanese prints had begun in the early 1880's[1] when William Sturgis Bigelow and Ernest Fenollosa began collecting in Japan. Charles Morse and others were stimulated by the World's Columbian Exposition in Chicago in 1893, where reproductions of Japanese prints were shown by the Kokka publishing house. American taste quickly took to the woodcuts of Japan and was equally appreciative of Mary Cassatt's color prints when they reached these shores in the early 1890's.

On January 23, 1891, Mrs. Cassatt wrote to Aleck about Mary's new venture:

[1] To be sure John Bancroft and John La Farge had imported Japanese prints in 1863 through A. A. Low, but what they got were mediocre landscapes chosen by ill-informed agents. In 1886, La Farge went to Japan with Henry Adams, but by then Bigelow and Fenollosa were in the field.

Mary has been quite as busy as she was last winter, but this time it is with colored "eaux fortes" and not with etching.[2] It is very troublesome, also expensive and after making the plates of which it takes 2 or 3 or 4 (according to the number of colors required) she has to help with the printing which is a slow proceeding and, if left to a printer, would not be at all what she wants. I am not sure they will be so much liked by the public as the drypoints, but that cannot be known until the exhibition takes place in the spring.

Camille Pissarro described Mary Cassatt's print techniques in a letter to his son:

PARIS, APRIL 5, 1891

My dear Lucien: It is absolutely necessary, while what I saw yesterday at Miss Cassatt's is still fresh in mind, to tell you about the colored engravings she is to show at Durand-Ruel's at the same time as I. We open Saturday, the same day as the patriots, who, between the two of us, are going to be furious when they discover right next to their exhibition a show of rare and exquisite works.

You remember the effects you strove for at Eragny? Well, Miss Cassatt has realized just such effects, and admirably: the tone even, subtle, delicate, without stains on seams, adorable blues, fresh rose, etc. Then what must we have to succeed? . . . Money, yes, just a little money. We had to have copper-plates, a *boite à grain*, this was a bit of a nuisance but it is absolutely necessary to have uniform and imperceptible grains and a good printer. But the result is admirable, as beautiful as Japanese work, and it's done with printer's ink! When I get some prints I will send you some; incidentally I have agreed to do a series with Miss Cassatt; I will do some Markets, Peasant Women in the Fields, and—this is really wonderful—I will be able to try to put to the proof some

2 The terminology here is somewhat confusing, for Mrs. Cassatt uses "*eaux-fortes*" which of course means etching, and Mary Cassatt refers to "colored etchings," but goes on to explain that they are dry points.

of the principles of neo-impressionism. What do you think? If we could make some beautiful engravings, that would really be something.

I have seen attempts at color engraving which will appear in the exhibition of the patriots, but the work is ugly, heavy, lusterless and commercial. I am certain that Miss Cassatt's effort will be taken up by all the tricksters who will make empty and pretty things. We have to act before the idea is seized by people without aesthetic principle.

This is a bad moment for me, Durand doesn't take my paintings. Miss Cassatt was much surprised to hear that he no longer buys my work, it seems that he sells a great deal. But for the moment people want nothing but Monets, apparently he can't paint enough pictures to meet the demand. Worst of all they all want *Sheaves in the Setting Sun*! always the same story, everything he does goes to America at prices of four, five and six thousand francs. All this comes, as Durand remarked to me, from not shocking the collectors! True enough! What do you want, I replied, one has to be built that way, advice is useless. But while waiting we have to eat and pay our debts. Life is hard!

A more detailed account of Mary Cassatt's methods is contained in the now famous letter of January 9, 1903, to Mr. Samuel P. Avery, president of the Metropolitan Museum's trustees:

My dear Mr. Avery:

I thank you very much for your very kind letter. It is delightful to think that you take an interest in my work. I have sent with the set of my coloured etchings all the "states" I had. I wish I could have had more but I had to hurry on and be ready for my printer [M. Leroy], when I could get him. The printing is a great work; sometimes we worked all day (eight hours) both as hard as we could work and only printed eight or ten proofs in the day. My method is very simple. I drew an outline in drypoint and transferred this to two other plates, making in all three plates, never more, for each proof. Then I put an aquatint wherever the color was to be printed; the color was painted on the plate as it was to

appear in the proof. I tell you this because Mr. Lucas thought it might interest you, and if any of the etchers in New York care to try the method, you can tell them how it is done. I am very anxious to know what you think of these new etchings. It amused me very much to do them although it was hard work.

Mr. Durand-Ruel is going to have an exhibition of my work, pictures, pastels and etchings in the fall in New York. Will you be so kind as to lend him some of my early etchings? You are the only person who has everything I have done in that line.

I received the Annual Report of the Metropolitan Museum you were so kind as to send me. I should like very much to give something to the Museum, but I don't feel as if I were well enough known yet at home to make it worthwhile. After my exhibition, if I have any success with the artists and amateurs I will certainly present something to the Museum if you think they would care to have it.

Again thanking my dear Mr. Avery for your kind sympathy believe me.

<div style="text-align:right">

Very sincerely yours,
MARY CASSATT
</div>

Frank Weitenkampf, print curator of the New York Public Library, commented:

Miss Cassatt's work shows a wise reticence in linear expression, the "tact of omission" as Walter Pater, speaking of Watteau, happily characterizes it in his Imaginary Portraits. The secret of compressed statement is here, of condensed significance. . . . She reveals the beauty of the relation between Mother and child without calling in the aid of superficial prettiness which, after all, has nothing to do with the matter.

Mary Cassatt further described her methods to Mr. Weitenkampf in a letter dated May 18, 1906:

In reply to your's of May the 9th asking about the printing of my colored etchings, my system was as follows: I drew the outlines in drypoint and laid on a grain where color was to be

applied, then colored "à la poupée." I was entirely ignorant of the method when I began, and as all the plates were colored by me, I varied sometimes the manner of applying the color. The set of ten plates was done with the intention of attempting an imitation of Japanese methods; of course I abandoned that somewhat after the first plate, and tried more for atmosphere.

After 1886 there were no more exhibitions of the Impressionist group, but a new organization was formed which included many of the same people. Now calling themselves the *Société des Peintres-Graveurs Français*, they made plans in 1891 for an exhibition at the galleries of Durand-Ruel. One of their rules proved something of a bombshell, for they admitted no foreign-born artists. This not only excluded Mary Cassatt, but also Camille Pissarro, who had been born in the Danish West Indies. These two "foreigners" now proceeded to take action and ended by turning matters very much to their own benefit. Pissarro has a good deal to say about this in letters to his son, Lucien:

PARIS, January 10, 1891

MY DEAR LUCIEN:

The group of painter-engravers is going to form an organization which will be known as the *Société des Peintres-Graveurs Français*. It seems that I can't be a member because I am an alien! They intend to invite foreign-born artists, but I will not accept any invitation from them. How officious they are.

Mary Cassatt's exclusion from the new group brought about her first one-man show. She had always felt that she was not quite ready, but this occasion proved that she was most certainly worthy of an exhibition. It was in any case a fairly modest showing—twelve prints and only five paintings—but it gave her courage to plan something more ambitious two years later.

The day after the opening of the Durand-Ruel exhibition, the members of the *Peintres-Graveurs* gave a dinner at Albert Bartholomé's (1848–1928) to which Mary Cassatt was asked, but they teased her unmercifully for her retaliation.

Tandis que la Société des peintres-graveurs français exposera dans la grande salle des Galeries Durand-Ruel, Pissarro et Mary Cassatt auront des expositions particulières dans deux petites salles voisines. Le lendemain de l'ouverture, un diner eut lieu chez le peintre-statuaire Bartholomé ami de Degas. Les convives plaisantèrent Mary Cassatt et parfois si malignement qu'elle sortit de cette réunion toute bouleversée, presque en larmes.[3]

After the excitement of the Paris art season, Mary Cassatt went to the country with her family for a summer of hard work free from distractions. They rented Château Bachivillers, a moderate-sized late-eighteenth-century house, four miles from the charming small village of Chaumont-en-Vexin, some fifty miles north of Paris. They had two salons, a billiard room, dining room, and upstairs more bedrooms than they could use. Ample space was available for a studio. The house, which was red brick with gray stone trim, had a three-story central block with dormers on the third floor and a two-story wing at each side. Back of the château were five linden trees and a charming garden beyond which the estate extended over a considerable territory, some 1,500 acres. At the front was a large forecourt and a gatehouse in which the owner, a wealthy farmer by the name of Crèvecoeur, lived with his mother. They were given all the fruit and vegetables they could eat, milk at three sous a liter, and the rent was 2,300 francs for the season.

Mary Cassatt and her mother drove out in their carriage, leaving Paris on the second of May and spending a night en route at Pontoise. Mr. Cassatt came the next day by train.

The exhibition at Durand-Ruel's had been a great stimulus to Mary Cassatt, and gave her more of a feeling of self-importance than she had ever had before. Her greatest thrill had been a compliment from Degas, who admired her work and said that she had greatly improved in drawing. After the exhibition she

[3] This footnote appears only in the French version of the Pissarro letters; also in Segard.

sent off through Portier, Durand-Ruel's packer, sets of her dry points to both of her brothers. These are scattered among their descendants today.

On July 23, Mrs. Cassatt wrote to Aleck:

⟍⟍⟍ Mary is at work again, intent on fame and money she says, and counts on her fellow countrymen now that she has made a reputation here. I hope she will be more lucky than she is in horseflesh. Her new horse has been down, this time when driving him. We thought he was perfectly surefooted but he has a thin skin and the flies set him crazy so that in knocking his head about and tossing about to bite them he came down, one knee is sure to be marked and of course his value if sold greatly diminished. Mary firmly believes she has bad luck and it looks like it. Happily for her she is immensely interested in her painting and bent on doing something on a large canvas as good as her pictures last summer which were considered very fine by critics and amateurs. One of them could have been sold ten times but Durand-Ruel said he bought it for himself. You will probably see that one in New York next fall or winter. After all a woman who is not married is lucky if she has a decided love for work of any kind and the more absorbing it is the better.

Robert Cassatt complained during the summer of swollen legs, as well as of disorders of the heart, lungs, and stomach. After their return to Paris, he grew worse and finally died on December 9. This reduced the family's number to Mary Cassatt and her mother. Early in December, Jennie and little Gardner Cassatt arrived for a visit, and after Christmas they accompanied Mary Cassatt and her mother to Cap d'Antibes.

Five miles from Château Bachivillers at Mesnil-Théribus, Mary Cassatt purchased Château de Beaufresne (Plate 2a), a seventeenth-century manor house, but so much repair work was necessary that she and her mother were not able to occupy it until 1893. That being the case, they spent a second summer at Château Bachivillers. The purchase of Beaufresne gave her a

great sense of independence, as it was paid for entirely with money she earned from the sale of her work.

In 1892, Mary Cassatt carried out her latest project, a mural for the south tympanum of the Woman's Building for the World's Columbian Exposition at Chicago. Only women artists were to be employed: Sophia B. Hayden, a twenty-one-year-old Bostonian was the architect; Lucia Fairchild, Amanda Brewster Sewell, Rosina Emmet Sherwood, and Lydia Emmet did murals for the side walls of the Hall of Honor; and Mrs. Mary Fairchild Mac-Monnies, wife of the sculptor Frederick MacMonnies and a noted painter in her own right, and Mary Cassatt each did a tympanum. Mrs. Potter Palmer, Chicago's distinguished social leader and the real power behind the Exposition, had commissioned them while in Europe the previous summer. She took houses in Paris and Rome, lavishly entertained diplomats, high government officials, and influential peeresses, convinced them of the great significance of the Chicago fair, and induced them to participate on a much more impressive scale than they had originally intended.

Mrs. Palmer, who was president of the Board of Lady Managers, in a report to the members of her board, October 18, 1892, indicated that after "exhaustive investigation" Miss Cassatt and Mrs. MacMonnies had been selected. She applauded the fact that Miss Cassatt had chosen Degas as her master, but regretted that, because of her prejudice against exhibitions, her name was unknown in her native country despite her great reputation among the artists of Paris. In speaking of her work on the mural, she said, "Miss Cassatt had to build an immense glass-roofed building at her summer home, where, rather than work on a ladder, she arranged to have the canvas lowered into an excavation in the ground when she wished to work on the upper part of its surface."

Mary Cassatt's relationships with the Chicago world's fair are described in a series of letters to Mrs. MacMonnies, Mrs. Potter Palmer, and Miss Sara Hallowell, who was a leading light on the art committee of the fair and the Paris representative of several American museums.

BACHIVILLERS
PAR CHAUMONT-EN-VEXIN
(OISE)
Wednesday [early summer 1892]

My DEAR MRS. McMONNIES,

I hasten to answer your note at once, certainly Chicago seems to reserve endless surprises for us. I should fancy from what you told me of your design and from what Miss Hallowell said your intention was, as regards the size of your figures it would be quite impossible for you to put a border of the width of mine around your composition. My object was to reduce the huge space as much as possible by a border in such a way as to enable me to paint a picture in each of the spaces left where the figures would be rather under life size. Therefore, I designed a border of one metre in depth to run along the whole base of the decoration consisting of bands of color with designs and divided by lines of gold, and in this I have introduced at intervals circles in which naked babies are tossing fruit, etc. The upper border is narrower about 75 centimetres wide repeating the colors and design of the lower border.

You will perceive that I went to the East for the foundation of the idea. I have divided the length into three by two panels of 80 centimetres wide. You may remember that I told Mrs. Palmer I intended doing so. The border is the only attempt I have made at decoration pure and simple.

Considering the immense height at which the pictures will be placed and the distance apart they will be, we agreed that unity of any kind was not necessary.

I think they will be placed much higher than Baudry's[4] fine decorations at the Grand Opera and yet they are quite out of sight. When Miss Hallowell was here we thought the height would be at the top of the chimneys of this house, or about the fourth floor of the large apartment houses in Paris. I think, if Mrs. Palmer realized this, she would see that there could be no necessity for unity; if such a thing was in the scheme it is too late now.

4 Paul Baudry (1828–86).

I hope you won't have left for Chicago before we return to Paris. By the way, I had the *rentoileur* of the Musée du Louvre here the other day, he thinks it will be impossible to place the decorations otherwise than on stretchers on account of the rounding top which would make it impossible to stretch properly on a flat wall.

<div style="text-align:right">

Yours sincerely,
MARY CASSATT

BACHIVILLERS
Friday [July, 1892]

</div>

My DEAR MISS HALLOWELL,

Your letter reached me this morning, thank you for cabling to Mrs. Palmer. I sent my cable after leaving you on Wednesday. "Contract received, conditions impossible, if maintained I must resign." I see by your letter that the stumbling block will be my not sending a sketch and, as I don't know why they should make an exception in my favor, I will wait a few days for Mrs. Palmer's answer to my cable and then resign. I saw M. Ch. Durand Ruel and asked him to forward the answer from Chicago as soon as received by mail. At the same time I told him that I would cut down my canvas for my exhibition in New York. He told me that he had just sold one of my pictures in Montreal, the purchaser saw the photograph. The fact is if I don't paint something for New York, I won't be able to have an exhibition there. I won't have anything to show if my pictures are to travel so far. I am very sorry for all this misunderstanding, but now that I am thrown off the track, I hardly feel as if I could get back on to it again. I am infinitely obliged to you for your sympathy and kindness in the matter.

My Mother joins me in kindest regards.

<div style="text-align:right">

Ever yours most sincerely
MARY CASSATT

</div>

P.S. I think Mrs. McMonnies quite right about the payments, why should she advance all the money? I had to pay cash as I went along.

A note on the back page says:

⟋⟍ DEAR MRS. PALMER,

That you may be *fully* informed on this subject, I conclude to send you Miss Cassatt's second letter on the subject.

Yours always,
SARA HALLOWELL
PARIS, July 24th

The reason the conditions were impossible was that the artists were not to be paid until the work was complete and were to install the murals at their own expense. Records of the Exposition indicate that expenses for Mary Cassatt's mural were $3,000. Presumably this was her fee, plus transportation and installation charges.

Mrs. MacMonnies made the case clear in her letter of August 22, 1892, to Mrs. Potter Palmer:

⟋⟍ I thank you very much for your prompt and kind reply concerning the contracts. The date February 15th, though it will hurry me a little more than I like, is still possible and I will deliver my work in Chicago by that time. As far as I know Miss Cassatt's objections to the contract were identical with mine. I am surprised that there should be any question about acceding to our wishes in arranging payments and in placing the decorations at the expense of the Exposition, and still more surprised at Mr. Millet's statements concerning these matters.

With the difficulties satisfactorily settled, Mary Cassatt expressed her thanks to Mrs. Palmer.

CHATEAU DE BACHIVILLERS
PAR CHAUMONT-EN-VEXIN
(OISE) Sept. 10th [1892]

⟋⟍ DEAR MRS. PALMER.

I received your most kind letter with great pleasure; knowing what your correspondence must be I hesitate even in sending you a line of thanks; you certainly must be the most written to woman in the world at present.

Thanks to your kind offices all my difficulties with the board of construction seem to be arranged, and my contract is here although not yet in my hands, as it was sent by mistake to Mrs. MacMonnies and hers to me. I sent her hers but she has not yet sent me mine having heard at Durand-Ruels that I had already received one! However I suppose I shall get it sometime. Between you and me I hardly think women could be more unbusinesslike than some of the men are. Here is Mr. Millet sending me "the exact size of those tympana" at this hour of the day. It will entail on me a good deal of extra work which he might just as well have spared me by sending the exact size at first.

However, it would be ungracious to grumble for really I have enjoyed these new experiences in art immensely and am infinitely obliged to you for the opportunity you have given me, all I could wish would be a little more time. I am afraid my work will show signs of hurry and it would have been better if we could have had two long summers instead of one.

And as if by a *fait exprès* all my relations[5] seem to have given each other rendezvous in Paris this summer and one cannot exactly refuse to see them.

Yesterday we had a visit from a cousin who spoke of having been so charmed to meet you, Mrs. Sloan,[6] her husband is professor at Princeton.

I hope Miss Hallowell will have arrived safely before you receive this and that she was not quarantined, the last news here is that the cholera may put off the exhibition a year.

Again thanking you my dear Mrs. Palmer and wishing you all success in your great work, I remain, Most sincerely yours,

MARY CASSATT

Mrs. Cassatt commented to her daughter-in-law about the mural:

[5] All the Alexander Cassatt family went abroad the summer of 1892, except Ed, who was at West Point. The Gardner Cassatts were also there with their son. In September, while in England, Alexander bought his famous race horse, Cadet, for £3,000.

[6] Mrs. William Milligan Sloane. They lived in Paris while Professor Sloane wrote a life of Napoleon, and had an adventurous trip to Moscow.

BACHIVILLERS
PAR CHAUMONT-EN-VEXIN, OISE
[1892]

〰 MY DEAR LOIS,

Mary's help in the shape of a young Hebrew came out on Tuesday to work on the border of her decoration; such a slow creature you never saw. Mary got out of patience when he said it would take six weeks to do what he had to do, so yesterday she left her models to get at the border hammer and tongs and when the day was over she said his part would be done in six days instead of weeks to which he replies, "well, yes we have worked!" All that he does is of the simplest and then a gilder will have come to put in the gold required which won't take very long but will cost like the mischief Mary says.

A detailed description of the mural was given in letters to Mrs. Palmer.

BACHIVILLERS
PAR CHAUMONT-EN-VEXIN
(OISE)
Oct. 11th [1892]

〰 MY DEAR MRS. PALMER,

Your letter of Sept. 27th only arrived this morning, so unfortunately this will not reach you by the 18th as you desired. Notwithstanding that my letter will be too late for the ladies of the committee, I should like very much to give you some account of the manner [in which] I have tried to carry out my idea of the decoration.

Mr. Avery sent me an article from one of the New York papers this summer in which the writer, referring to the order given to me, said my subject was to be "The Modern Woman as glorified by Worth!" That would hardly describe my idea of course. I have tried to express the modern woman in the fashions of our day and have tried to represent those fashions as accurately and as much in detail as possible. I took for the subject of the center and largest composition Young women plucking the fruits of Knowl-

edge and Science. That enabled me to place my figures out of doors and allowed of brilliancy of color. I have tried to make the general effect as bright, as gay, as amusing as possible. The occasion is one of rejoicing, a great national fete. I reserved all the seriousness for the execution, for the drawing and painting. My ideal would have been one of those admirable old tapestries brilliant yet soft. My figures are rather under life size although they seem as large as life. I could not manage women in modern dress eight or nine feet high. An American friend asked me in rather a huffy tone the other day, "Then this is woman apart from her relations to man?" I told him it was. Men I have no doubt are painted in all their vigor on the walls of the other buildings; to us the sweetness of childhood, the charm of womanhood, if I have not conveyed some sense of that charm, in one word if I have not been absolutely feminine, then I have failed. My central canvas I hope to finish in a few days. I shall have some photographs taken and sent to you. I will still have place on the side panels for two compositions, one which I shall begin immediately is Young Girls Pursuing Fame. This seems to me very modern and besides will give me an opportunity for some figures in clinging draperies. The other panel will represent the Arts, Music (nothing of St. Cecelia) Dancing and all treated in the most modern way. The whole is surrounded by a border, wide below, narrow above, bands of color, the lower cut with circles containing naked babies tossing fruit, etc. I think my dear Mrs. Palmer that if you were here and I could take you out to my studio and show you what I have done that you would be pleased indeed without too much vanity. I may say I am almost sure you would.

When the work reaches Chicago, when it is dragged up 48 feet and you will have to stretch your neck to get sight of it at all, whether you will like it then, is another question. Hillman in a recent article declares his belief that in the evolution of the race painting is no longer needed, the architects evidently are of that opinion. Painting was never intended to be put out of sight. This idea however has not troubled me too much, for I have passed a most enjoyable summer of hard work. If painting is no longer

needed, it seems a pity that some of us are born into the world with such a passion for line and color. Better painters than I am have been put out of sight. Baudry spent years on *his* decorations. The only time we saw them was when they were exhibited in the Beaux-Arts, then they were buried in the ceiling of the Grand Opera. After this grumbling I must get back to my work knowing that the sooner we get to Chicago the better.

You will be pleased, believe me, my dear Mrs. Palmer

Most sincerely yours,

MARY CASSATT

BACHIVILLERS
PAR CHAUMONT-EN-VEXIN
(OISE)
Dec. 1st [1892]

MY DEAR MRS. PALMER

Your telegram received today gave me the greatest pleasure. I am infinitely obliged to you for the kind thought which prompted you to send it.

The fact is I am beginning to feel the strain a little and am apt to get a little blue and despondent. Your cable came just at the right moment to act as a stimulant. I have been shut up here so long now with one idea, that I am no longer capable of judging what I have done. I have been half a dozen times on the point of asking Degas to come and see my work, but if he happens to be in the mood he would demolish me so completely that I could never pick myself up in time to finish for the exposition. Still he is the only man I know whose judgment would be a help to me. M. Durand-Ruel poor man was here with his daughter a week ago, it was most kind of him to come, they are all broken-hearted over the death of poor Charles. M. Durand was very kind and encouraging, said he would buy it if it were for sale, and of course from his point of view that was very complimentary but it was not what I wanted. He seemed to be amazed at my thinking it necessary to strike for a high degree of finish; but I found that he had never seen the frescoes of the early Italian masters, in

fact he has never been to Italy except to Florence for a day or two on business. I asked him if the border shocked him, he said not at all, so it may not look eccentric and, at the height it is to be placed, vivid coloring seems to me necessary.

I have one of the sides well under way and I hope to have the whole finished in time for you to have it up and out of the way by the end of February.

You must be feeling the strain, too, with all the responsibility on your shoulders. I hope you will have strength and health to bear you through. With kindest regards and renewed thanks my dear Mrs. Palmer

<div align="right">Sincerely yours,
MARY CASSATT</div>

Pissarro mentioned the mural to his son:

⤳ Speaking about Miss Cassatt's decoration, I wish you could have heard the conversation I had with Degas on what is known as "decoration." I am wholly of his opinion; for him it is an ornament that should be made with a view to its place in an ensemble, it requires the collaboration of architect and painter. The decorative picture is an absurdity, a picture complete in itself is not a decoration. It seems that even the [decorative paintings of] Puvis de Chavannes don't go well in Lyon, etc. etc.

The official publication of the Exposition said:

Miss Cassatt's large painting for the decoration of the south tympanum of the Woman's Building at Chicago, two years ago, will be remembered by many visitors notwithstanding the very inconvenient height at which it was placed. . . . It may also be remembered that some of the Western "Lady Managers" thought this conception of "Modern Woman"—her theme—somewhat inaccurate.

In *Art and Handicraft in the Woman's Building of the World's Columbian Exposition*,[7] Miss Sara Hallowell wrote:

[7] Edited by Maud Howe Elliott (Chicago, 1893), from "Women in Art," pp. 56–57.

Two women have been chosen to paint each a very important decoration for the Woman's Building at Chicago—Miss Cassatt and Mrs. MacMonnies. Miss Cassatt is easily the best of our women painters. Her work is probably better known to those intimately connected with art than to the general public. She is of the school of Degas, Whistler, and Monet, and holds that a ballet-girl by Degas may be as religious as a saint by Puvis de Chavannes. She would call Degas master, but that her manner of expression has been arrived at independently of him. A set of her etchings has been purchased for the Luxembourg, and the French Government invited her to present it with a picture, an honor which falls to few, and which it was characteristic of Miss Cassatt to decline. Her "Essais Japonais" are what their title indicates, and are a revelation of strong line and exquisite color. Her decoration in Chicago will no doubt be *caviar* to those who may not see the religion in Degas, but to the catholic lover of art it appeals strongly.

Maud Howe Elliott commented further on the mural:

The North tympanum of the hall is enriched by a decorative painting by Mrs. Frederick MacMonnies, representing the Primitive Woman. At the other end Miss Mary Cassatt presents her conception of Modern Woman. Mrs. MacMonnies' subject is well chosen and ably treated. . . .

The central portion of Miss Cassatt's panel shows us a group of young women gathering apples in a pleasant orchard. On the right is a band of ladies variously engaged. One is playing upon a stringed instrument, while another poses in one of the attitudes of the modern skirt-dance. On the left we have Fame, a flying figure, pursued by a flock of ducks and women. The border of the tympanum is very charming; the children quite beautifully painted. Both Mrs. MacMonnies and Miss Cassatt received orders for their work from the Executive Board of the Woman's Building. The two decorations were executed in Paris and sent to Chicago.

Mary Cassatt's Chicago mural certainly brought out aspects of her style, or new developments in her style, that were not apparent before. In 1891 a very strong Japanese influence came into

her prints as a result of the impact of the great Japanese exhibition of the previous year. We note emphasis on line, flat pattern, flowered dresses or wallpapers contrasting with simple areas, and the introduction of subtle color harmonies. While the mural contains certain of these elements, such as flowered dresses and a strongly linear concept, they produce merely a decorative effect without any relation to the quasi-Japanese manner in which they are employed in the prints. Some of the figures in the mural, especially those in the left portion, women pursuing Fame, have a simple, naïve charm which results in being a sort of adult version of Kate Greenaway, whose children's books had been enormously popular from the time *Under the Window* was published in 1879. *Mother Goose, Kate Greenaway's Birthday Book*, and other books of the 1880's showed that Kate Greenaway was an illustrator of rare enchantment who recreated a sort of 1820 costume which has ever since gone by her name. But she was more than just an illustrator of children's books; she was a timid, sensitive person who had a great understanding of line and pattern and, at least in her early work, retained a freshness, crispness, and simplicity which captivated a large number of people of widely divergent tastes. Paul Gauguin was influenced by her in the 1880's in his Brittany period and in these early canvases peopled the countryside with Kate Greenaway figures, albeit somewhat transformed. Mary Cassatt, without having any of the quaintness of Kate Greenaway, recalls at this period something of her sense of pattern and line and her simple freshness.

As we have learned from the letters of Mrs. Potter Palmer, Mary Cassatt considered that her mural was very contemporary, very "modern." In a sense she was modern in that her symbolism was not cloaked in classical allegories, there were no Greek and Roman matrons, none of the trappings of academic, historical, or mythological pieces. At the same time her mural had none of the verve of Degas or even of her Impressionist contemporaries. It was at best a fairly fresh, decorative piece, lacking the finer elements of design and decisive draftsmanship which she put into her prints of the period. Certainly Mary Cassatt's forte lay in a

smaller, more articulate scale; as a muralist she produced one of her least notable efforts. She had worked hard, but under great pressure, for a setting that was far away and in a sphere in which she had neither experience nor any very special interest. As a woman and something of a feminist she was proud to have been asked to participate, but the result, though as competent as the other decorations in the Woman's Building, was nothing of exceptional merit.

After the fair was over, February, 1894, Sara Hallowell wrote Mrs. Palmer that she had been resting in Philadelphia, and that she had had to give up her plans of going to the Riviera to visit Miss Cassatt, who had sent such a "delightfully urgent letter," and mentioned that the Luxembourg was "in treaty for one of her pictures." "After all," Miss Cassatt said, "give me France. Women do not have to fight for recognition here if they do serious work. I suppose it is Mrs. Palmer's French blood which gives her organizing powers and her determination that women should be *someone* and not *something*." Two days later Miss Hallowell wrote Mrs. Palmer again to say that she had finally secured passage and would go "direct to Miss Cassatt at her mother's villa at Cap d'Antibes, the loveliest spot on the Riviera."

The Gardner Cassatts joined them at the villa at Cap d'Antibes and at this time Mary Cassatt did young Gardner as the "Boy in the Sailor Suit," but while posing, he got bored and spat in his aunt's face. His mother was humiliated and locked him in a closet, but Mary Cassatt felt sorry for him, got her carriage and went to town to buy him a box of chocolates, let him out, and gave him the candy.

No sooner had Mary Cassatt dispatched her mural to Chicago than she began assembling material for her second exhibition at Durand-Ruel. Held during November and December, 1893, it contained ninety-eight items, a far larger group than her modest showing two years earlier. There were seventeen paintings, fourteen pastels and sixty odd prints of various types. André Mellario ended his introduction to the catalogue with a fine tribute:

Il faut le dire, en toute sincérité, Miss Cassatt est peutêtre, à côté de Whistler, la seule artiste d'un talent élevé, personnel et distingué, que possède actuellement l'Amérique.

To have the French accord her such praise was now rewarding, but she regretted very much that so few people in her native country had a comparable appreciation of her work. Mrs. Potter Palmer had said in fact that her name was unknown in America, yet in France she had arrived at the peak of her career, widely acclaimed and accepted by the most discerning artists, critics, and collectors as an artist of the first rank.

Fortunately, both descriptions and measurements are given of the pictures exhibited in 1893, with the result that the majority can be identified. Two paintings in the Boston Museum of Fine Arts ("A Cup of Tea" and "At the Opera"), one in the Metropolitan ("The Cup of Tea"), and one belonging to Marcel Midy (*"La Loge"*) were among them. Another was the "Morning Toilet," shown at the last Impressionist Exhibition of 1886 and lent to the exhibition by Degas. Number one in the catalogue, called *"La Toilette d'Enfant"* ("The Bath") (Color Plate VI) is now in the Art Institute of Chicago. Here can be seen the influence of Japanese prints in the clear-cut, compartmented design, the distorted perspective giving the effect of looking down into the picture. By placing the mother and child on opposing diagonals, a closely knit, interlocked composition is achieved. Effective contrast is set up between the round basin and jug and the geometric pattern of the rug, while the muted green, mauve, and off-white stripes in the mother's dress form a most subtle color harmony. Despite the importance of pattern and color there is a strong feeling of structure in the picture, especially in the firm, fully rounded modeling of the child's body. Here, in what is her most outstanding achievement of the early 1890's, Mary Cassatt has arrived at supreme clarity of design but at the same time has fully mastered the rendering of form.

A painting done at Antibes in 1893 (not in the exhibition)

was "The Boating Party" (National Gallery, Chester Dale Collection) (Color Plate VII), which is one of the most ambitious pictures she ever attempted. Off center to the right is the powerful dark silhouette of the boatman seen from the back. His left arm and the handle of the oar form an angle which thrusts powerfully into the center of the composition towards the mother and child seated in the stern of the boat. Horizontal accents are formed by the thwarts, while the bold curve of the sail, following the curve of the boat, introduces a sense of graceful movement. Powerful elements are subtly balanced with delicate, feminine ones. The idea was perhaps suggested by Manet's "In the Boat," of 1879, although the composition is entirely different.

One of Mary Cassatt's major achievements of the early 1890's was a "Mother and Child," acquired by Mrs. J. Montgomery Sears, and later sold by the family to the Wichita Art Museum (Plate 16). In this the two heads form a closely knit design, made the more compact by the water pitcher, which fits snugly at the left of the mother's head—almost sharing a common outline. Over a dark underpaint, parchment yellows and muted reds form a subtle harmony, and elimination of detail with some areas very summarily treated gives the effect of vigor and freshness.

"Young Women Picking Fruit" (Carnegie Institute, Pittsburgh) (Plate 17)—so closely connected with the Chicago mural and with a colored dry point and aquatint, "Gathering Fruit"— shows a seated woman in a flowered dress and hat looking up at another woman, who is reaching up to pick a pear. The composition is organized on the principal of a sweeping S-curve formed by the position of the arms. These rather stout, blowsy, country women treated with such utter lack of flattery have an honest, robust, almost American quality, completely opposed to the refinements of French taste. Yet about the same time Mary Cassatt did a pastel, "Woman Arranging Her Veil," which has all the dash and elegance worthy of Degas and is truly French in its distinction and style.

After the turn of the century Mary Cassatt's work was more freely brushed and less compactly organized. In this final decade,

before blindness restricted her activities, she produced some of the freshest compositions of her career. As an example in "Women and Child" (Detroit Institute of Arts) there is an enchanting interplay as the woman on the right greets the child, taking both of her hands. By turning the mother's head into the composition, attention is directed to the theme itself. It is as if we had come suddenly upon a moment in life which is completely natural and unself-conscious.

On the other hand, in "Mother Sewing" (Metropolitan Museum, Havemeyer Collection), the child gazes wistfully out of the picture as if to invite the observer to participate while the mother is detached, wholly absorbed in her work.

An enchanting interplay of irregular rounded shapes is emphasized in the two straw hats of the mother and daughter called "Young Girl in Large Hat" (Mrs. J. Lee Johnson III Collection, Fort Worth) (Plate 21). An effective contrast is set up between the severe dark band of the child's hat and the confection of bright red nasturtiums on the mother's modish summer model. Clear blue, pink, and white areas devoid of pattern make a good foil for the dominant motifs of the hats.

Looseness of structure and extension of space is even more apparent in the "Family Group Reading" (Philadelphia Museum), where the figures are somewhat casually placed in an outdoor setting. These later paintings are more naturalistic and less subject to any formula or set theory than her earlier work.

From the 1870's until the end of her career at the time of World War I, she worked in pastel and was almost as much of an enthusiast for the medium as Degas himself. She did a few drawings[8] (Plate 22) and a handful of water colors and *gouaches*, but it was in pastel that she produced some of her most sensitive work. Quentin de la Tour, the great eighteenth-century pastelist, was her god, and she felt that all young artists should study his portraits. "In the Garden" (Baltimore Museum) (Plate 18), done in

[8] There was a pen drawing in the Degas sale, and Sarah Bernhardt owned a charcoal drawing. Of the drawings she has left, several have a wax coating on the back, indicating that they were used in preparation of soft ground etchings. On the back of some of these she took a trial proof of the etching.

1893, displays a riot of pattern which almost overwhelms the mother and child theme and may be a momentary influence of Near Eastern design much in vogue in Paris at the time. During the following decade she produced many of her most notable pastels with a transparent luminosity of flesh and often daring use of color. With "Madame Aude and Her Two Daughters" (Charles Durand-Ruel Collection, Paris) (Plate 20), shown as a closely knit group, she made effective use of their dark hair contrasting with the bright blue and bright pink of the dresses. In another, "Mrs. Havemeyer and Her Daughter Electra" (Mrs. Electra B. McDowell Collection, New York) (Plate 19), sympathetically placed on a sofa, an introspective mood is enlivened by the pink candy-striped dress of the girl. "After the Bath" (Cleveland Museum) (Color Plate VIII) is daringly composed of warm flesh tones and a brilliant red-orange dress against a background of yellow-green and blue. One of the most sensitive is a "Mother and Child" (Dr. John J. Ireland Collection, Chicago) in which a luminous tone is so successfully achieved.

Although Mary Cassatt made constant use of the maternal theme in her later work, she varied her interpretation constantly and through change in scale, mood, and tone avoided monotony. At times the sense of tender rapport between mother and infant becomes dominant over the pictorial concept, with the result that the work is weak and indecisive. Unresolved as these are, they represent her less felicitous side. In this category must be placed some of her pastel sketches of children, many of which were no doubt first trials and were probably not intended to be preserved. "A Mother and Child" in pastel, which was formerly in the collection of the Art Institute, indicates that the artist was so intent in catching the child's exuberant expression that she failed in any convincing realization of the figure of the mother or in the organization of the design. Such failures were not many, but were sufficiently frequent to make one wish that Mary Cassatt had been even more rigorous in destroying her studio scrapings. She did clean house more than once, and it is to be hoped that her judgment was sound in regard to what she did destroy.

A Château in the Country

IN 1893 MARY CASSATT and her mother moved into Château de Beaufresne, which had taken a long time to do over but was at last ready for them, and continued to be a much beloved country house until Mary Cassatt died there in 1926. Beaufresne was a seventeenth-century manor house, furnished in a livable way with a mixture of old furniture and more modern upholstered pieces. Mary Cassatt appreciated fine antiques but never at Beaufresne nor in the Paris apartment on the Rue de Marignan was she at all interested in a period salon. A perfectly appointed Louis XVI drawing room would have been completely artificial to her way of thinking. She had around her the things she liked, and hung on the walls the pictures she liked—Impressionist canvases by Monet (including "Springtime," now in the Walters Art Gallery, Baltimore), Pissarro, and Degas, as well as a Cézanne, and Japanese prints, perhaps a hundred of them, chosen for their pictorial interest and not because they were rare items or in perfect condition. There were also Persian minatures in her collection, and her taste was so advanced that she had an appreciation for the extravagance of the Baroque and owned a notable canvas, "The Toilet of Venus," by Simon Vouet (1590–1649) (Carnegie Institute), which she bought in Paris in 1904.

From the road, Beaufresne is seen across a long grassy forecourt on either side of which is a driveway and masses of trees. Built

of mellowed pinkish-red brick, the house has three stories, each of which is separated by a band of chalky-white marble. The façade has a pediment spanning the central three windows, and at each side are hexagonal towers surmounted by open belfries. All the windows in the first two stories have gray-white blinds. This was once a hunting lodge, a dependency of a much larger establishment in the neighborhood, and was built at the time of Louis XIII, but the left tower is said to be even older. The entrance is not, as one would expect, in the center of the symmetrical façade but towards the left, leading to a rather small stair hall, with the kitchen to the left, and at the right a large dining room, with a circular drawing room beyond, and at the end of the house what Mary Cassatt called her "painting room." Across the garden side a nineteenth-century addition with a glassed-in gallery served as an informal living room and had a beautiful view out over the wide lawn. Here Mary Cassatt used to serve coffee after lunch and enjoyed discussing art and politics with her frequent guests. Along the inner wall of the gallery were massed many of her Japanese prints and on tables were pieces of Venetian glass. Upstairs there are six bedrooms—one of the smallest of which was Miss Cassatt's—and two primitive bathrooms with tin tubs. The servants had rooms under the third-floor mansard roof. Much of the furniture, especially in the drawing room and bedrooms was Empire, left there by the De Grasse family,[1] from whom Mary Cassatt bought Beaufresne. The simple lines of this style, very unfashionable at the time, appealed to her taste and she liked to paint the bedroom pieces apple-green. Furniture held in such general disfavor was most inexpensive; therefore, in painting it, there was no thought that valuable antiques were being defaced.

There were about forty-five acres in the estate, much of it in the wide expanse of garden and lawns. Great chestnut trees grew about the grounds, and Lombardy poplars bordered the long, narrow pool. Outside the gallery were enormous rosebushes.

1 Comte de Grasse of Revolutionary fame was a relative.

There were fruit trees and a vegetable garden where Mary Cassatt enjoyed growing unusual things such as American corn and eggplant. At one side of the house and scarcely visible were the farm buildings, hot frames for tomatoes and strawberries, stables, a carriage house, and, after 1906, a garage for the Renault limousine.

Whether Mary Cassatt was in the "gallerie" of Beaufresne or in her salon on the Rue de Marignan, she enjoyed brilliant conversation and knew many people who were good foils for her. Although she was capable of annihilating argument, she could not stand up to Degas, who did at times, she said, "demolish" her. He was the most intellectual of the painters she knew and, despite their many tiffs, offered her the greatest stimulation. She entertained Clemenceau, Marcel Cachin, Jacques-Émile Blanche, George Moore, Stéphane Mallarmé, Ambrose Vollard, Berthe Morisot, who was a sort of friendly rival, and Violet Paget, the English friend of Sargent who wrote under the pseudonym Vernon Lee.

After a visit to Beaufresne, Vernon Lee wrote to her friend Kit Anstruther-Thomson, July 28, 1895:

... I liked immensely being at Mesnil. That high-lying, monotonous, not at all beautiful French country, crude or dingy in colour, composed of blunt lines, without romance or suavity of village or old house, moreover apparently depopulate, has yet a charm of breadth, of belonging to an endless continent—no island or semi-island like England or Italy—there being *enough land*, and enough sky especially, leagues of cloud and air; a certain charm to me, of unusualness, of a back of beyond, due to its lines *leading nowhere* (do you know what I mean?). The complete scheme of the eternal story told by mountains and rivers, the story of watersheds and sea, of perpetually becoming and going. And I liked the Louis XVI Château and the sort of white bareness of the rooms, making me feel almost like Corobbia. Poor old Mrs. Cassatt is, I fear, slowly dying. Her daughter will probably write to you to find her an English nurse for she seems to know no one in London, and I ventured to tell her she might.

Miss Cassatt is very nice, simple, an odd mixture of a self-recognising artist, with passionate appreciation in literature, and the almost childish garrulous American provincial. She wants to make art cheap, to bring it within reach of the comparatively poor, and projects a series of coloured etchings, for which she wants me to write a little preface. She wants other artists to do something similar, suggested Sargent—do you think he would? She has most generously given me one of her new and most beautiful etchings, a mother and baby, green on green, quite lovely.

Various other artists came to Mary Cassatt's in small informal groups, but it is a mistake to think that she in any sense conducted a salon. Being extremely interested in politics, she frequently held sessions at Beaufresne when a local election was coming up, and she indicated in no uncertain terms what policies should be adopted and who should be elected. Her influence in local affairs was considerable. She was very much respected in the community and looked up to as the "lady of the manor." Mary Cassatt's growing reputation as an artist was fully appreciated by her country neighbors, and they realized that the same determination and purposefulness that she applied to her art was also applied to the organization of her household and, so far as possible, to directing the political tenure of her domain.

Feeling ran high in France during the 1890's over the Dreyfus case, which had reverberations all over the world. Both political and racial problems were involved, and all France was divided into anti-Dreyfus or those on his side, the Dreyfusards. Alfred Dreyfus (1859–1935), an army officer, was appointed in 1894 to the Ministry of War, but soon after was arrested on the charge of betraying military secrets, was tried, and was sentenced to life imprisonment on Devil's Island. His guilt was based on a compromising letter, supposedly in his handwriting but later proved to have been written by another officer, Major Esterhazy, who was tried, but acquitted because high officials did not wish to acknowledge their error. Émile Zola then wrote his famous

J'accuse, an open letter to the president of the French Republic denouncing this action and demanding the release of the falsely accused Dreyfus. Public opinion was raised to fever pitch and no one was more militantly in favor of Dreyfus' release than Mary Cassatt. Her great sense of justice was aroused. Degas, on the other hand, took the opposite view, that held generally by the old-line French aristocracy, thus setting up a great bone of contention between himself and Mary Cassatt. Not until 1906 was Dreyfus completely cleared and all honors restored to him.

Mary Cassatt had a love of animals and kept a horse until her vision became impaired, around 1914. Although not able to ride after her accident in 1888, she continued to drive horses and retained her devoted coachman, Pierre. She had a passion for small dogs and raised Belgian griffons, some of which she brought to America to present to relatives. Mary Cassatt's last photograph, taken in the gallery at Château de Beaufresne at eighty-one, shows her holding her favorite griffon, Gamin.

Her first experience with these tiny dogs had been somewhat dismaying. In Brussels she purchased from a famous kennel a puppy purporting to be a prize griffon, but as time went on it grew to strange proportions and turned out to be a King Charles spaniel. Undaunted, she tried again with more success, for to appease her, the kennel sent a truly choice griffon with his own brush and comb, a raincoat, an overcoat, and a pocket handkerchief. She later gave this elegantly equipped specimen, Nippo or Napoleon Bonaparte, to her young niece, Ellen Mary, daughter of her brother Gardner.

Miss Cassatt lived comfortably in a well-staffed house, and yet for that day her retinue was modest according to those of big French houses or to those of her two brothers in Philadelphia. Mathilde did her hair every morning and helped her dress; Mathilde was also the general supervisor of the household, what the French call the *"gouvernante."* There were also a cook, a housemaid, a chambermaid, three gardeners, and the coachman, Pierre, who after 1906 became chauffeur. For all her comforts and service, Mary Cassatt never allowed her devotion to her art

to lag, working eight hours a day in her studio and spending many evenings at drawing. Although she could not paint by artificial light, much of her finest draftsmanship was achieved in the evening, as one can see from the many prints which show people under lamplight. Her ability to accomplish the seemingly impossible was due to the fact that she was truly dedicated to the work of a serious artist, and yet lived the life of a well-to-do, cultivated American and kept up all the appurtenances of gracious living. George Biddle, the well-known Philadelphia painter, who was a close, yet much younger friend, said of her, "She drew that almost impossible line between her social life and her art, and never sacrificed an iota to either. Socially and emotionally she remained the prim Philadelphia spinster of her generation." Any deviation from good manners or the slightest failure to meet her standards aroused her indignation, yet on growing older she became more and more opinionated and was capable of the broadest profanity when certain subjects were mentioned. One of these was Woodrow Wilson, whom she would, in any case, have disliked for his being a Democrat, as she adhered strictly to a Philadelphia "Main Line" Republican point of view. George Biddle also remarked, "She was one of the most vital, high-minded, dedicated and prejudiced human beings I have ever known, and had a strong influence on me as a student."

Mary Cassatt enjoyed good food and served the best of wines. In the country she kept trout in the pond and guests fished for those that would be served to them. While in Paris she enjoyed fine restaurants, and when she discovered an especially pleasing dish, sent Mathilde to the restaurant to sample the speciality and had her teach the cook how to make it. She held her servants to a strict routine and was easily angered by any lapse. She never smoked and no women ever smoked in her house.

Home remedies and odd cures fascinated her, and in this she was like an old-fashioned country woman. Mallarmé wrote to Berthe Morisot in 1891:

If either one of you has hayfever, I recommend that you

have M. Dejouy[2] bring you the "Corbelic smoke ball," of Miss Cassatt (whatever that is, I can hear him say), Geneviève finds it a marvel.

She dressed extremely well in a tailored manner (Plate 4), went to the best Paris dressmakers, such as Doucet, Redfern, or La Ferrière, and to Reboux for big hats with plumes and aigrettes (Plate 5), and often bought dresses at Paquin sales for her models, as she liked the flowing lines. William Ivins recalled that she both stood and sat very erect and that she was no doubt well corseted. Her shoes were made in England since she considered French footgear too frivolous. She liked to wear long amethyst chains with a lorgnette and had a passion for old jewelry. Very aristocratic in bearing, she was once mistaken by two young Royalists for the Comtesse de Paris.

Armand Delaporte, her chauffeur in later years, said of her:

Mlle. Cassatt was strong willed in character, voice strong, dry and at the same time sympathetic. In manner very very elegant and distinguished, impeccable in dress and in the best taste, very charitable, kind hearted, one never extended a hand to her in vain, especially for the blind to whom she gave a great deal. I myself distributed a great deal of money on her behalf to the blind. The poor and beggars of whom there were a lot at that time were lavishly fed at Miss Cassatt's at her Château de Beaufresne. The servants both indoor and outdoor were happy with her and all loved her. Mlle. was very fond of animals, especially horses. Mlle. never drove a car but on the other hand in the period of horses she always drove her horse or her two horses in tandem, having with her her old coachman Pierre. She also loved flowers, above all roses. She always had two massive bushes in front of the Château of which she was very proud. No one ever had the right to cut a rose. She did this herself when she wished to make a gift and even though blind she knew the color.

Mary Cassatt had several neighbors in the country of whom

2 Jules Dejouy, a lawyer, cousin of the Manets.

she was especially fond. About three miles away was Villotran, an eighteenth-century château and beautiful park belonging to a French family, the Mellons. She used to take her nieces there in summer to tea, which was put in a donkey cart, escorted through the gardens, and served by two footmen in a *temple d'amour.* Another close friend was Octave de Sailly, who lived in Château de Pouilly, a short distance from Beaufresne. His children, Agnes and Jean de Sailly, posed for Mary Cassatt as children. They recall that, when she came to call on their parents, she insisted upon remaining in her car, which meant that they all had to stand around, but they were so fascinated by her personality that they did not mind. Posing for Mary Cassatt, they said, was fun as she kept them amused with books and toys, but they were driven to distraction by her Belgian griffons nipping at their ankles.

One of the village women, Mme Pinault (Reine Lefebvre), also recalls posing for Mary Cassatt from 1901 to 1903, when she was sixteen and seventeen. "*Notre Mademoiselle,*" as they all called her, "always wore a white blouse while painting. She was serious but not severe, though I must say at times she was difficult. It was hard to pose at first but became easier when I got used to it."

From their earliest days in Paris the Cassatts had seen a great deal of their cousin Mrs. Riddle, her daughter, Mrs. Thomas Scott, and her grandson, Edgar Scott. In 1899, Edgar, by then a mature man, was at the American Embassy in Paris and lived on the Avenue du Bois de Boulogne, where his son Edgar was born. Mary Cassatt came to see the baby and completely terrified young Mrs. Scott, who was scared to death of the austere "old" woman who looked the baby over carefully and said nothing until she was on her way out, when she remarked: "I'll write his grandmother that he has beautiful ears."

Mary Cassatt's mother, who had for so long been an invalid and caused the family such anxiety, died at Château de Beaufresne on October 21, 1895, at seventy-nine. For virtually eighteen years, ever since her parents and Lydia first came to live in Paris, Mary Cassatt had been restricted by the demands and the needs of a

semi-invalid family. In retrospect, it is extraordinary to realize the body of work she accomplished in this household. Months of her time were spent in Divonne, southern France, Spain, or the Isle of Wight in the interests of her family's health, periods during which she could not work, and weeks at a time were used up in exhaustive searches for new apartments or for summer villas during their frequent moves, which were undertaken in the interests of better living conditions or better climate for the invalids, Mrs. Cassatt and Lydia.

Even though her two brothers and their families came abroad frequently, she no longer had relatives in France. Not by nature gregarious, she had a rather limited circle of friends and was very much by herself, and by now, just past fifty, was very much of a confirmed spinster, set in her ways, and with no one to think about but herself. As a result she spent more time in travel.

In the fall of 1895, at the time of Mrs. Cassatt's death, the Gardner Cassatts came to Europe for two years. Young Gardner was then nine, his sister Ellen Mary one and one-half years old. Mary Cassatt spent part of the winter with her brother and family on the Rue de Marignan and enjoyed doing pastels of the children; two of Ellen Mary were done at this time. She loved little children and especially her young relatives, but, as she got older, she tired more easily and was glad to have the visit end.

During the season of 1897–98, the Gardner Cassatts had a yacht, *Eugenia*, and started out on a Mediterranean cruise. Their sister Mary came aboard equipped with a whole new wardrobe for yachting, accompanied by Mathilde, who always went with her as lady's maid. Miss Cassatt became so violently seasick when they were only a few miles out that they had to put in at Toulon and let her off. While the yacht was anchored off Marseilles, the British royal yacht was anchored beside them. Queen Victoria arrived and set out to find out what the erring Edward Prince of Wales was up to.

In the meantime, in the summer of 1895, the Alexander Cassatts had taken a North Cape cruise on the chartered yacht, *Star*, and in January, 1896, abroad again, they rented a dahabeah for

a trip up the Nile, traveling back through Italy, Germany, France, and England and returning to America in May.

With these constant trips of her brothers, Mary Cassatt had been able to see one or the other of them every year since her mother's death, but in 1898–99 she decided to visit America, her first trip home since the Franco-Prussian War. From a note in the Philadelphia *Ledger,* the extent of appreciation of Mary Cassatt in America as an artist was well confirmed.

> Mary Cassatt, sister of Mr. Cassatt president of the Pennsylvania Railroad, returned from Europe yesterday. She has been studying painting in France and owns the smallest Pekingese dog in the world.

She stayed with her brother Gardner in his town house and did pastels of two of his children, Ellen Mary and Gardner.

During the time Mary Cassatt was visiting America, Mr. and Mrs. Gardiner Greene Hammond of Boston commissioned her to paint their children. Mrs. Hammond had asked John Singer Sargent whom he would suggest to do portraits of the children, and Sargent replied that Miss Cassatt, who by chance was visiting in America, would be the best person. Sargent had painted Mr. Hammond in 1895 and was to do his wife eight years later. At length Mary Cassatt agreed to go to Boston during the fall, where she stayed at the Vendome and went every day with her dog to the Hammond house at 261 Clarendon Street. A temporary studio was set up in one of the parlors, from which the parents were rigorously excluded. Frances Lathrop Hammond, age four (Mrs. McKinley Helm), posed first, and was followed by her two brothers, Gardiner Greene Hammond III and George Fiske Hammond, who posed together. After completing these two commissioned portraits, Miss Cassatt saw Gardiner coming down the staircase one day with his nurse on the way to the Public Garden, dressed in a green caped coat and a George Washington tricorn hat. She was so enchanted by his costume that she asked him to pose in it and gave the portrait to his parents.

While in Boston Mary Cassatt spread the word about the Im-

pressionist painters, or our "little band of Independents," as she called their group. At a series of dinner parties the Hammonds gave for her, she urged the collecting of French art. Questioned about Sargent, who had just preceded her in Boston, where he was such a god, she said, "What Sargent wants is fame and great reputation."

Her opinions on cultural conditions there are given in a letter to Miss Pope:

I assure you when I was in Boston and they took me to the library and pointed with pride to all the young ones devouring books, and that without guidance taking up all sorts of ideas of other people, I thought how much more stimulating a fine museum would be. It would teach all those little boys who had to work for a living to admire good work and give the desire to be perfect in some one thing. I used to protest that all the wisdom of the world is not between the pages of books and never did I meet anyone in the Boston Museum[3] where the state the pictures are in is a disgrace to the Directors.

As to the Havemeyer's collection about which you feel so strongly, I consider they are doing a great work for the country in spending so much time and money in bringing together such works of art; all the great public collections were founded by private individuals.

In March, Mary Cassatt went to Naugatuck, Connecticut, to visit the Whittemores, who had commissioned her to do portraits of various members of their family. The finest portrait was of the elderly Mrs. John Howard Whittemore, which Mary Cassatt called "Portrait of a Grand Old Lady." It is done in pastel in various tones of gray and is both well organized and distinguished. She also did Mrs. Harris Whittemore with her daughter Helen and the "Boy with Golden Curls" (Harris Whittemore, Jr.). John Howard Whittemore had met Mary Cassatt in Paris in 1892, in-

[3] The Museum of Fine Arts was at this time still in its antiquated quarters on Copley Square. This was abandoned in 1908, and the museum was moved into the new building being erected on Huntington Avenue, and the old building was torn down to make way for the Copley Plaza Hotel.

troduced by his first cousin, Mrs. Clinton Peters (Adele Bacon), whose husband was an artist. He had gone to Paris to study with Gérôme and Lefebvre and later conducted art classes in New York. In Naugatuck, Mary Cassatt met the Pope family, whose daughter Theodate became perhaps her most intimate younger friend. During her visit she became fascinated by the beautiful setting of a shutdown factory at Beacon Falls and urged the Whittemores to acquire it and transform it into a unique sort of country house. The distressing fact that the factory was closed on account of the depression seems not to have impressed her.[4]

While in America Mary Cassatt visited her various relatives in Philadelphia. On one occasion she went to the house of her cousin Mrs. Fisher and scoffed at a painting hanging in the drawing room, which the family had confidently believed was a Poussin. Mary Cassatt indicated in no uncertain terms that it was *not*.

After returning to France, she went to Château de Beaufresne and spent the winter there, as she had undertaken a considerable amount of renovation. "You would not know Beaufresne again," she wrote to Mrs. Pope, April 7, 1900:

I have done more plumbing, another bathroom, I hope I am now nearly up to the American standard. I need not say that I am so far beyond my French neighbors that they think I am demented. Now that my lawns have all been properly turned over and leveled and walks designed and made, I have gone into roses. I have over a thousand planted. There is nothing like making pictures with real things.

Paris has changed, the fine opening from the Champs-Elysée through the Invalides [Avenue Alexandre III] and the new bridge add much to our part of the town and the exhibition is going to be very fine.[5]

[4] While Mary Cassatt did not as a rule paint commissioned portraits, she was willing to do the Whittemores since they were personal friends. Her love of children allowed her to be tempted by the Hammonds' request, but this was a rare exception.

[5] Paris Exposition of 1900. The Avenue Alexandre III gave access to the Grand Palais and Petit Palais, both of which were constructed for this occasion.

In 1900 all the Gardner Cassatts went abroad for the summer and visited Mary Cassatt at Château de Beaufresne. Ellen Mary, then six, fell into the pool the moment they got there. The Alexander Cassatts were also abroad again, and went to Bad Homburg for Aleck's health. In July, Ed Cassatt was made military attaché in London, and his daughter Lois visited Beaufresne in September just at the age of six. While she was at Beaufresne, Ed and Emily were at the Meurice in Paris, and his parents stopped on their way back from Germany at the Castiglione. Since the Havemeyers were also in Paris in 1900, Mary Cassatt had a great visitation of friends and relatives.

CHAPTER X

Adviser on Art and Recipient of Honors

MARY CASSATT was given wider scope for her advice to art collectors after 1889, when the H. O. Havemeyers moved into their big house at 1 East Sixty-Sixth Street, at the corner of Fifth Avenue. The house was decorated by Samuel Colman and Louis Tiffany, who had found inspiration at Ravenna for the mosaic hall and ten mosaic pillars at the entrance to the gallery. This house became a veritable museum, the most important private collection in America.

Not much interested in formal society, the Havemeyers were devoted to their children and family life. Their entertaining was largely centered in their notable Sunday musicals where some hundred people—artists, musicians, and distinguished figures in many different fields—gathered to listen to fine music, then to see the paintings.

> "When I was a small boy," Homer Saint-Gaudens recalled, "I remember going with my father and mother to hear chamber music by the Kneisel Quartet at the Havemeyers in their Rembrandt Room on Sunday afternoons. There was a mingling of artists and men of both means and understanding of the aesthetics that I have failed to come across these days. There were painters like Thomas Dewing, architects like Stanford White, sculptors like William MacMonnies, editors like Richard Watson Gilder."

Most people were grateful for the privilege of seeing the treasures of this extraordinary house, but occasionally a guest was not so gracious. One Sunday the Swedish painter, Anders Zorn, was being conducted through the house by Mr. Havemeyer. Zorn stopped in front of a fine Dutch picture and said, "Do you call that a Rembrandt?" Mr. Havemeyer replied quietly, "No, I did not call it a Rembrandt, do you?"

Since the house was usually open on Sundays for musicals, Saturdays of necessity were devoted to cleaning. Mrs. Jack Gardner came to New York, eager to see this collection about which she had heard so much, and asked to be admitted on a Saturday. Even though it was most inconvenient, Mrs. Havemeyer was kind enough to receive her. Mrs. "Jack" looked everything over with care, was noncommittal, but urged them to come to Boston to see her collection at Fenway Court. Sometime later the Havemeyers were in Boston and called on Mrs. Gardner, but she refused to see them or admit them. She felt, of course, a keen sense of rivalry and did not wish to give the Havemeyers an opportunity of judging her collection in relation to their own.

Mrs. Theodore Roosevelt came one Sunday, but she annoyed Mrs. Havemeyer because she seemed to expect to be treated like royalty and bow only to those whom she cared to recognize. The Havemeyers disliked such pretentiousness and did not accord her any special deference, with the result that Mrs. Roosevelt haughtily left without thanking them.

One of the Havemeyer's favorite guests was Helen Keller, who, despite being deaf and blind, had completed her degree at Radcliffe in 1904 and given much courage to others similarly afflicted. Mrs. Havemeyer and her sister, Mrs. Peters, who was often present at the Sunday musicals, were much alike in manner, yet Helen Keller could tell the sisters apart instantly just from a touch of the hand.

Mrs. Havemeyer liked nice clothes and always wore Worth gowns, but in general she was very thrifty about everything except art purchases. She kept few servants, considering the size of the house, and would not have a butler and footmen after once

going into her kitchen and finding the butler boiling his socks in a saucepan. She turned every manservant out of the house and had only women after that. Often after Sunday lunch she put her daughters to work making tea sandwiches to be served later in the afternoon at the musical.

Once Mrs. Peters complained of her sister's penuriousness in taking a Madison Avenue streetcar to an auction instead of ordering her carriage. At the sale Mrs. Havemeyer paid $40,000 for a picture—explaining that she could afford to do this only by being careful about other expenses. She was not for the most part very congenial with other women, the great exception being Mary Cassatt. They often traveled together during the eighties and nineties, but one of the most significant trips occurred just after the turn of the century.

On January 30, 1901, Mr. and Mrs. Havemeyer and Mrs. Peters, sailed from New York on the *Kaiserin Augusta Victoria* for Genoa, where they were met by Mary Cassatt. This was a most important venture, for under the guidance of Mary Cassatt, the Havemeyers at this time bought many of the greatest pictures in their collection. The account of the trip is vividly recorded in Mrs. Havemeyer's memoirs.

In Genoa they set out to see paintings by Van Dyck, many of which eventually found their way into American collections. Despite the cold, they went to Turin, where they admired the famous "Black Rameses," a splendid example of Egyptian diorite sculpture dating from 1,400 B.C. Mary Cassatt induced them to stop in Milan to see the Luinis, Veroneses, and Moronis before going south to the warmer climate of Naples and on across the Strait of Messina to Taormina. Much impressed by the theater, she urged them to read the work of the French encyclopedist, Denis Diderot (1713–84), who thought that we might still have an art comparable to that of the Greeks had it not been for Christianity with its draped angels and martyred saints. Syracuse they found depressing and dirty, but Girgenti proved a thrilling experience even though they could not venture beyond the protecting walls of the hotel without armed guards because of the

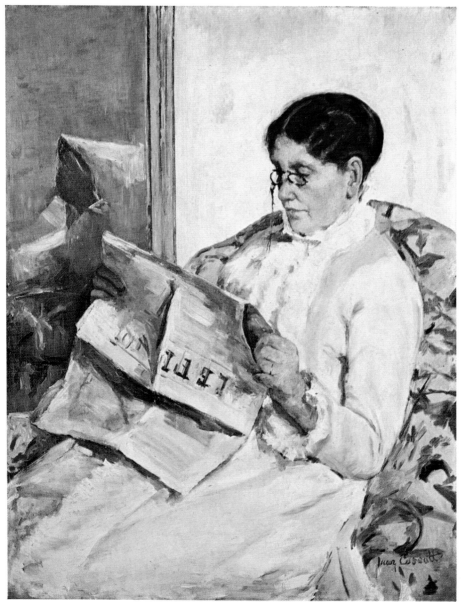

Color Plate V

"Reading *Le Figaro*" (*ca.* 1882)
(oil—41″ high, 33″ wide)

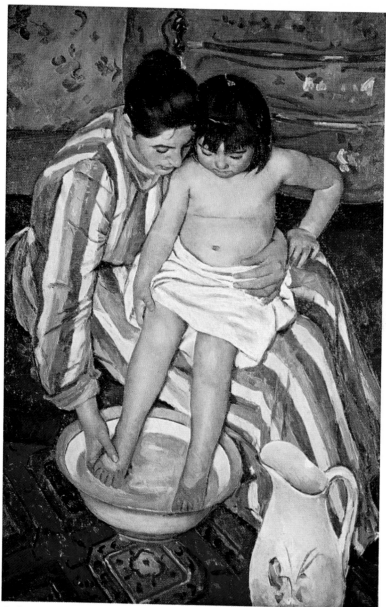

Color Plate VI COURTESY THE ART INSTITUTE OF CHICAGO
(ROBERT A. WALLER FUND)

"The Bath" (1891–92)
(oil—39½″ high, 26″ wide)

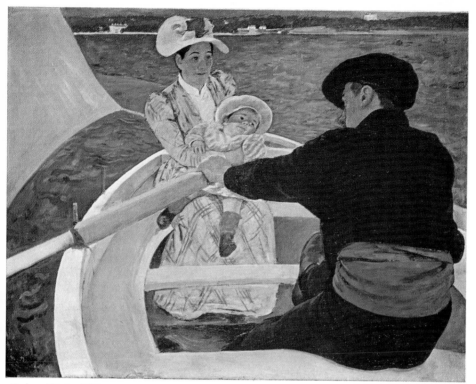

Color Plate VII

"The Boating Party" (1893)
(oil—35½″ high, 46⅛″ wide)

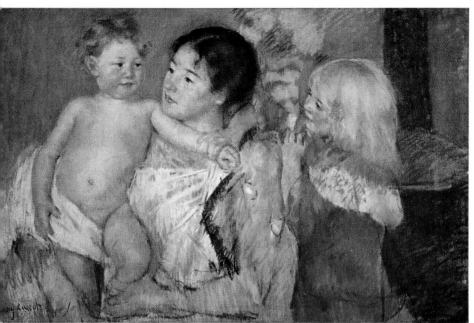

Color Plate VIII

"After the Bath" (*ca.* 1901)
(pastel—25¾" high, 39¼" wide)

prevalence of bandits. In the temples they felt that they were seeing something as fine as anything that could be found in Greece. At night the Temple of Concord looked majestic in the solemn white moonlight.

In Palermo they relived the time of Roger of Sicily and read *La Grande Grèce* by the well-known French archaeologist, François Lenormant (1837–83). They had hoped that it might be possible to motor in Sicily and Calabria, but Marion Crawford, who had lived many years in southern Italy, said that conditions would be impossible and that the bridges would be unsafe for an automobile.

At Reggio they looked across the Straits to Mount Etna, which was smoking ominously. Mary Cassatt felt that disaster was impending and remembered Lenormant's terrifying description of the Calabrian earthquake of 1663. A few years later, in 1908, during the dreadful Messina earthquake she recalled this prophetic moment.

Mrs. Havemeyer and Mary Cassatt were both carsick on the way to Rome but soon recovered and were off to see Velázquez' portrait of Pope Innocent X, which Miss Cassatt said did not impress her as it once had. They visited many dealers but found nothing of interest.

At Bologna they looked chiefly at paintings by Domenichino, who, Mary Cassatt told them, was much admired by Degas. She regretted that such a great artist was so little known. Although Degas greatly appreciated the early Italians, as well as Raphael and Michelangelo, his admiration for Domenichino has not been noted before. His taste in this instance had no doubt stimulated Mary Cassatt's interest.

As a young girl Mrs. Havemeyer had visited Ravenna heavily guarded against bandits. On returning there, they found no such hazards and could visit the Mausoleum of Theodoric and San Vitale at their leisure. Observing the Byzantine style of the Ravenna mosaics brought many artistic problems to mind. Did art find its origins in Egypt, Persia, or the Yangtze, Miss Cassatt wondered. Did the caravans carry the Chinese fret to Greece and

the grapevine back to China? Shall it be proven that Homer sang of real mortals?[1]

In Venice, San Marco and the Palazzo Ducale occupied a great deal of their time; they admired the Colleoni and Carpaccio's women feeding their dogs and bleaching their hair.

Donatello's sculpture at the Church of Saint Anthony was of the greatest interest to them in Padua. Mary Cassatt believed that Donatello had absorbed the best of classic art and had added to it a note of the Renaissance. Original European art ended, she felt, with the Gothic. Giotto's frescoes in the Arena Chapel appear not to have attracted their attention.

Arturo Harmisch, long known to Mary Cassatt, was engaged as a full-time scout in Florence. He and his wife knew everyone and gained access to all sorts of out-of-the-way places. In a dark room in a remote *palazzo* they were shown a Veronese portrait of his wife. Mary Cassatt sensed the great quality of the picture and finally prevailed upon the dubious Havemeyers to buy it when she threatened to sell something and buy it herself. They bought the Veronese as well as a Mino da Fiesole and, in an obscure hill town, a Madonna by Filippo Lippi. Many of Harmisch's connections were decidedly dubious and most of his great "finds" turned out to be of no great importance.

They returned to Paris, left Mrs. Peters in Mary Cassatt's apartment, then set out for Spain. The Havemeyers were most excited over the Prado, and a new discovery, at least for Mr. Havemeyer, was El Greco. In a little shop Mary Cassatt found an El Greco, "Christ Bearing the Cross," which they bought for $250. Goya's "Portrait of Wellington" was secured for $4,000, and the pair of Sureda portraits by Goya for less than $10,000.

While Mr. and Mrs. Havemeyer went on to southern Spain, Mary Cassatt remained in Madrid to search for pictures. When they returned, she had lined up for their consideration El Greco's

[1] A curious question in view of the fact that Heinrich Schliemann (1822–90) in 1870–74 excavated Hissarlik and uncovered what he believed to be Homeric Troy, publishing *Troy and its Remains*. Wilhelm Dörpfeld in 1891–94 confirmed Schliemann's findings and established the sixth of nine superimposed levels as the Troy about which Homer wrote (or VIIa, according to recent chronology).

"View of Toledo," "Cardinal Guevara," and the "Assumption," and Goya's "Majas on the Balcony." It took three years to negotiate for the Majas, four years to secure the Cardinal. They paid $17,000 for the "Assumption," but, as it would be too big for their New York house, they turned it over to Durand-Ruel, after having their offer to sell it to the Metropolitan Museum refused. Mary Cassatt wrote to the Art Institute of Chicago, which ultimately purchased the picture.

In Madrid they were taken to see the Marquis de Heredias, who offered for sale Goya's "Bella Librera." Mary Cassatt examined it carefully then discreetly indicated to the Havemeyers that she did not think that it was a Goya. Later they found that it was a copy when they bought the real "Bella Librera" in France, proving once more the keenness of Mary Cassatt's eye and unfailing judgment.

Apropos of Mary Cassatt's sense of quality in pictures, Mrs. Havemeyer commented:

> As the French say, Miss Cassatt had the "flair" of an old hunter, and her experience had made her as patient as Job and as wise as Solomon in art matters.

By 1903 the Havemeyers were in Europe again, for Mary Cassatt wrote Mrs. Pope in March that Mr. and Mrs. Havemeyer were landing on the *Oceanic* the next day. They tried to take her along on a trip, but she was too busy to leave since she was getting ready for a show. "There is to be an exhibition," she wrote:

> opening April 2nd at the Bernheim Gallery of all our set, including Manet, Degas, Monet, Sisley, Berthe Morisot and myself. I think there will be some interest excited, it is so long since anything of the kind has been done.

About this time Mary Cassatt experimented with painting floral decorations on vases. In a letter to Vollard she mentions her dissatisfaction with the results:

━━ I am thinking of the vases I saw at your place and I see I am mistaken. I am almost tempted to efface the one that was fired as I am sure that this would give me nothing. One must serve an apprenticeship for that as for anything else. I am going to see if I can do something with the other one as the crown of flowers doesn't seem sufficient to me.

I count on returning to Paris in a week and if you wish I will look over the things which you took here and also I will sign the two which you took yesterday.

To return to the vases I can make them even in Paris but on the other hand I have models of flowers here in abundance, when it rains I can't work outside.

Please accept my cordial greetings,

MARY CASSATT

Vollard had the most profound respect for her and referred to her as "that generous Mary Cassatt" who "labored with frenzy" for her Impressionist friends, but who never pushed herself. In his early days as a dealer, when things were at times not going so well, he was more than once reassured by the arrival of Mary Cassatt saying, "Have you a picture for the Havemeyers?" Once an argument took place at an Impressionist exhibition of which Vollard commented:

━━ "But," said someone speaking to Mary Cassatt without knowing who she was, "You are forgetting a foreign painter that Degas ranks very high."

"Who is that?" she asked in astonishment.

"Mary Cassatt."

Without false modesty, quite naturally, she exclaimed, "Oh, nonsense!"

"She is jealous," murmured the other turning away.

Mary Cassatt accepted the honorary presidency of the Art League in Paris in connection with the hostel for American students, which was established by Mrs. John Hoff. Occasionally she went to talk to the girls on "Art for Art's Sake," and in her

simple and direct manner was a great inspiration to others. She offered scholarships to the two most deserving students, but made the provision that they must spend a year in Saint Quentin studying the great French pastelists of the seventeenth and eighteenth centuries who had been so inspiring to her.

In her letters to Carroll Tyson, a young Philadelphia painter, she was most revealing in her attitude about collecting, and was especially vitriolic about the apathy both of American museums and collectors:

10, RUE DE MARIGNAN, PARIS
April 28, 1904

My DEAR MR. TYSON:

I gave your name to Mr. Joseph Durand-Ruel with a request that he would facilitate your efforts to see Manet's and Degas' pictures, so if you will see him when you go to the rue Lafitte he will tell you what can be done. Faure[2] the former baritone of the Opera and a friend of Manet's has still some fine pictures of his, and also some of Degas though he sold his finest Degas to Col. Paine of New York [who lived next door to the Havemeyers], you see everything is fast going our way; unfortunately not yet to our public galleries, several people must disappear before we can hope for any change there.

I will probably see M. Roger Marx before you return to Paris and will ask him to allow you to see his collection, there you can judge of some of the later work; he has not a great many things but what he has is good.

I may still be here when you return if not I hope you will come and see me in the country. If you don't know French country, you will find it interesting.

Please believe that I will do all in my power to help you. I have lived so long in the intimacy of artists now so celebrated, but when I first knew them so neglected, and as far as Degas is concerned I know so well the sort of advice he gave. I feel it my duty to pass it on.

2 Jean Baptiste Faure, noted opera singer, who once owned forty-three Manets.

Hoping you will let me know when you return believe me,
Very sincerely yours,
MARY CASSATT

July 11, 1904 MESNIL-BEAUFRESNE
Monday FRESNEAUX-MONTCHEVREUIL
 MESNIL-THÉRIBUS (OISE)

DEAR MR. TYSON

I hope the train was all right and the return to Paris not so uncomfortable as the journey here. I have been thinking of you and your friends and your efforts, your future efforts to obtain recognition. Where the real trouble lies I think is in not having a good intelligent dealer in Philadelphia. If there is such a man he must be a recent acquisition. In these days of commercial supremacy artists need a "middle man," one who can explain the merits of a picture or etching, "work of art" in fact, to a possible buyer. One who can point to the fact that there is no better investment than "a work of art." If an intelligent young man with some knowledge, some enthusiasm, and a good deal of tact would arrive in Philadelphia he would do much to create a race of *buyers*. If I had the doing of it my shop would be near the commercial element, and I would turn my back on the society side, for in that set pictures are mostly bought from motives of vanity. Once a cousin, (N.Y.) said to a member of my family that she much regretted not being rich enough to buy pictures—she had $70,000 a year! Let the dealer take for motto Degas' answer to Vibert anent pictures being articles of luxury. "Yours may be, *ours* are of first necessity." You will think me absurd perhaps, but the question interests me beyond others, and I half wish myself young again to take part in the battle. If a man like Vollard for instance was in Philadelphia your friend Mr. Ullman would have sold pictures ere this.

Wishing you the smoothest of seas and a hard working summer and loads of amateurs[3] believe me always

Very sincerely yours,
MARY CASSATT

[3] *Amateur* in the French sense of a collector, one interested in the arts.

Mary Cassatt also commented on Mr. Tyson's visit in a letter to her niece, Minnie, July 14, 1904:

⟳ The other day young Carroll Tyson appeared by Meru and the village bus. Such a nice young fellow and great artistic feeling—Young Tyson tells me great things of your father-in-law's place in Bar Harbor [Four Acres, Alexander Cassatt's summer home at Mt. Desert].

Six months later she wrote to Mr. Tyson:

January 23, 1905

⟳ MY DEAR MR. TYSON

I have already announced your visit to my friend Mrs. Havemeyer, No. 1 East 66th Street, N.Y. Do go and see this collection, take a friend with you, an artist, write to her telling her I want you to see the gallery. If she is there herself I think you will doubly enjoy your visit and you will find one woman in America who loves art and knows what it means in a nation's life.

I hope you carried out your plans and are going to have your exhibition of your group.

I wish I could hear that you had a young and active dealer in Philadelphia it might *wake* them up.

I am still lingering here, there are fogs and dark days in Paris, but here we are having our usual mild and dry, ever dry winter. Our little railroad opened on Jan. 10th and I have a station within ten minutes of the place, a great improvement. I hope you will find it so when next you come to see me, then my horses can be used for excursions and I will drive you to Beauvais and show you the spot Turner chose to take his view of the cathedral. With best wishes for your success in this coming year, ever sincerely yours,

MARY CASSATT

In the spring of 1904 Mary Cassatt was awarded the Lippincott Prize of $300 at the Pennsylvania Academy in their Seventy-third Annual Exhibition for a painting called "Caress" (National Collection of Fine Arts, Smithsonian Institution).

February 15 [1904]

~~~ MY DEAR MISS CASSATT:

It has been our pleasure to inform Messrs Durand-Ruel of the award to you of the Walter Lippincott Prize of $300.00 for the best figure picture available for purchase in the 73rd Annual Exhibition of this Academy.

We are not aware whether Messrs Durand-Ruel have yet conveyed this information to you but we suppose they will do so promptly. The picture entitled "The Caress" was selected by us through their courtesy for the exhibition and we are most happy that it should have received this award as denoting an honor paid to a distinguished artist who is also our townswoman.

We shall be ready to remit the amount of the Prize when we hear from you with the address to which it shall be sent and we also hope from indications at present pointing toward that event that we may be able to sell the picture before the close of the exhibition March 6th.

I beg to enclose herewith a circular of the exhibition which will give you the terms of the Walter Lippincott Prize and with much respect and sincere congratulations, I remain

<div style="text-align:right">Yours very truly<br>HARRISON S. MORRIS</div>

She declined the prize and sent a careful and courteous explanation of her unyielding stand:

<div style="text-align:right">PARIS March 2, 1904</div>

HARRISON S. MORRIS, ESQ.
*Managing Director of the Pennsylvania Academy of the Fine Arts*
~~~ MY DEAR MR. MORRIS,

I have received your very kind letter of Feb. 16th with the enclosed list of the different prizes awarded in the Exhibition. Of course it is very gratefying to know that a picture of mine was selected for a special honor and I hope the fact of my not accepting the award will not be misunderstood. I was not aware that Messrs Durand Ruel had sent a picture of mine to the Exhibition. The picture being their property they were at liberty to do as

they pleased with it. I, however, who belong to the founders of the Independent Exhibition must stick to my principles, our principles, which were, no jury, no medals, no awards. Our first exhibition was held in 1879 and was a protest against official exhibitions and not a grouping of artists with the same art tendencies. We have been since dubbed "Impressionists" a name which might apply to Monet but can have no meaning when attached to Degas' name.

Liberty is the first good in this world and to escape the tyranny of a jury is worth fighting for, surely no profession is so enslaved as ours. Gérôme who all his life was on the Jury of every official exhibition said only a short time before his death that if Millet were then alive, he, Gérôme would refuse his pictures, that the world has consecrated Millet's genius made no difference to him. I think this is a good comment on the system. I have no hopes of converting any one, I even failed in getting the women students club here to try the effect of freedom for one year, I mean of course the American Students Club. When I was at home a few years ago it was one of the things that disheartened me the most to see that we were slavishly copying all the evils of the French system, evils which they deplore and are trying to remove. I will say though that if awards are given it is more sensible and practical to give them in money than in medals and to young and struggling artists such help would often be welcome, and personally I should feel wicked in depriving any one of such help, as in the present case.

I hope you will excuse this long letter, but it was necessary for me to explain.

Thanking you again for your letter believe me, my dear Mr. Morris

Very sincerely yours
MARY CASSATT

Undaunted by her refusal of the prize, the Pennsylvania Academy again approached Mary Cassatt in the summer of 1904, this time asking her to serve as juror for their Hundredth Anniversary Exhibition. This, too, she turned down firmly:

August 29th [1904]

〜〜 MY DEAR MR. MORRIS,

I greatly regret that I cannot cable my acceptance of your very kind and flattering offer to serve on the Jury. That is entirely against my principles, I would never be able to forgive myself if through my means any pictures were refused. I know too well what that means to a young painter and then why should my judgement be taken? Or any one elses for that matter in the hasty way in which pictures are judged. One of the men who served oftenest in the Paris Jury, told me that after seeing a few pictures, some hundreds say, he was *abruti* and could not tell good from bad. I abominate the system and I think entire liberty the only way. I did allow my name to be used on the jury of the Carnegie Institute but it was only because Whistler suggested it and it was well understood I was never to serve, and I hoped I might be useful in urging the Institute to buy some really fine old Masters to create a standard. In this hope I was naturally disappointed. Please believe that if there were anything else I could do for the Academy I would be delighted to do it.

Begging you again to forgive me, and with many thanks for your very kind letter, believe me my dear Mr. Morris,

Most sincerely yours,
MARY CASSATT

She was included in the Art Institute of Chicago for the first time in their Seventeenth Annual Exhibition, being represented by four pictures, one of which was the "Caress," the recent prize winner in Philadelphia. The *Chicago Journal* for October 21, 1904, noted:

> Among the artists present were Ralph Clarkson, H. S. Hubbell, Julius Rolshoven of London and Florence and Miss Mary Cassatt, the latter of whom contributed a series of child studies to the collection.

Although the *Chicago Journal* seemed to indicate that Mary Cassatt was at the Chicago opening, they meant that she was represented in the exhibition. That she was not there in person

is made evident by a letter to her niece, Mrs. Robert Cassatt, November 11, 1904, in answer to a cable announcing the birth on November 5 of young Alexander Johnston Cassatt. "I had half a mind to go over this autumn for a month," she wrote:

〜〜〜 but the journey frightened me and I hope you will bring the baby over here before long. If you don't, I shall have to risk it and go over.

In the *Chicago Tribune,* October 22, 1904, Lena M. McCauley commented favorably:

> Miss Mary Cassatt sends a group of really extraordinary canvases. They are studies of babies and mothers, the children being very real, affectionately and tenderly considered. Pigment has been used with lavish brush, and the colors are pretty and contrasts clever indeed. Much ingenuity is shown in line, and accentuated points produce a decorative effect.

On November 13 the *Chicago Inter-Ocean* made further reference to Mary Cassatt's healthy children:

> Mary Cassatt, whom someone has styled "the painter of the modern Madonna," offers four honest, everyday home scenes. Her children are not fairies or urchins or even angels; they are simple, wholesome, unspoiled youngsters.

As the prizes were not announced until nearly a month after the opening of the exhibition, Mary Cassatt did not know until late November that her painting, the "Caress," had again been honored, this time being awarded the Norman Wait Harris Prize of $500. Mr. William M. French, brother of sculptor Daniel Chester French, was the director of the Art Institute at this time. In reply to his letter announcing the prize award Miss Cassatt wrote:

BEAUFRESNE
PAR FRESNEAUX-MONTCHEVREUIL (OISE)
Dec. 4th [1904]

〜〜〜 DEAR MR. FRENCH:

I have received your very kind letter of Nov. 19th telling me

of the honor that has been paid to me by the award of the N. W. Harris prize. Of course I am very much gratified that a picture by me should have been awarded this honor, but it has been given to me through a misunderstanding. The pictures belong to Messrs Durand-Ruel and were loaned by them under the proviso that they were not be in competitions for any awards. I was one of the original "Independents" who founded a society where there was to be no jury, no medals, no awards. This was in protest against the government salon, and amongst the artists were Monet, Degas, Pissarro, Mme. Morisot, Sisley and I. This was in 1879, and since then we none of us have sent to any official exhibitions and have stuck to the original tenets. You see therefore that it is impossible for me to accept what has been so flatteringly offered to me. In Philadelphia last year the same honor was offered me, but that also was on account of an error of the Durand-Ruels and I explained it to the Directors as I am doing now. Of course unless you had lived in Paris and seen the ill effects of official exhibitions you can hardly understand how strongly we felt about being "Independents." I think money prizes so much more sensible than medals, but not in case of painters practising their profession with a fair measure of success for long years. I think such prizes should be awarded to young artists or students.

I know in this you must agree with me, but the amateurs who so kindly instituted this prize no doubt did not think of that; I wish the money would go to some young artist to whom it might be of greatest use; or to some student in want of just such encouragement. I wish we could talk it over together, I feel sure we should agree about it, but it is difficult to explain just how badly I should feel in taking the prize unless I could say more than I have space for. Do believe though that I feel very highly honored and that I am very grateful for your kindness, first in writing to me about how my pictures were hung and now for your kind note of congratulation.

Believe me dear Mr. French most sincerely yours,

MARY CASSATT

Further reference to the prize appears in the Twenty-sixth Annual Report of the Art Institute (June 1, 1904–June 1, 1905, p. 19):

> The annual prize of $500, provided by the liberality of Mr. Norman W. Harris in the Annual Exhibition of American paintings, was awarded to Miss Mary Cassatt for a painting entitled "A Caress." Miss Cassatt, however, belongs to the Independents in Paris, who accept no prizes and exhibit in no exhibitions patronized by the government. She accordingly declined the prize and suggested that it be applied to the benefit of some American art student studying abroad, and this, with the assent of the donor, will be done.

Great interest was aroused regarding who the lucky student might be who would receive the $500. The answer is contained in Mary Cassatt's letter of March 17, 1905, to Mr. French:

<div style="text-align:right">

10, RUE DE MARIGNAN
PARIS

</div>

DEAR MR. FRENCH:

I have seen Mr. Philbrick; but first let me thank you for your letter; it was such a pleasure to know that you understood and appreciated my motives in declining the money prize; and your wish to associate me in the disposal of it to a young artist, to whom it will be useful gives me real satisfaction. Mr. Philbrick sent me your letter, and called on me this morning, we had a long talk; I am sure after what he said that you are right and that there is the making of an artist in him. I will be very happy if I can be of any use to him, I think I can give him some useful hints and perhaps facilitate his seeing pictures which are not open to the public; at any rate I am prepared to be helpful if I can, and am obliged to you for throwing a chance of being so in my way.

Believe me my dear Mr. French,

<div style="text-align:right">

Very sincerely yours
MARY CASSATT

</div>

Alan Philbrick was a student who had graduated *cum laude* from the School of the Art Institute in 1901, continued at the

school as part student, part instructor and, in 1903, won a travel-
ing fellowship and was in Paris at the time Mary Cassatt won the
Harris Prize. Mr. French selected him as a student worthy of
receiving the $500 prize money. Mr. Philbrick, except for this
period abroad, was continuously a teacher at the Art Institute
School until his retirement in the fall of 1953. He recalled that
with the incredibly inexpensive living conditions in France in
1905, the $500 enabled him to remain abroad more than a year
longer. He went to see Mary Cassatt at her apartment, 10, Rue de
Marignan, and found her, as he said, a "fiery and peppery lady, a
very vivid, determined personality, positive in her opinions. I
was scared to death of her." He remembered that the apartment
was "not formal but colorful, full of glitter with lots of Japanese
things around." He felt that he and Mary Cassatt were worlds
apart; she was so settled, he and his fellow art students were care-
free, living only for the day.

Toward the end of the year 1904, Mary Cassatt received the
most coveted honor of her career. She was made a *chevalier de la
légion d'honneur. The American Art News* for January 14, 1905
commented:

> Word has been received by Durand Ruel & Co. that Miss Mary
> Cassatt has received the Legion of Honor. This is not surprising
> in view of the fact that the Minister of Fine Arts, and the Direc-
> tor of Fine Arts, Mr. Marcel are both enthusiastic admirers of
> Miss Cassatt's work.

At an earlier date the Luxembourg had indicated that they
could get the ribbon for her if she would give them a picture, but
she did not like such an arrangement. Her own reaction to the
award is seen in a letter she wrote to her friend Carroll Tyson, the
Philadelphia painter, January 22, 1905:

Thank you very much for your kind letter. It was very
gratifying to get the ribbon for there had been difficulties and
my friends had some trouble, especially is it hard to get the honor
awarded to a woman. Perhaps it will help me to a little influence

with Museum Directors at home, to get them to acquire genuine old Masters and *educational* ones.

The letter goes on to mention a picture which has great significance in American collecting, but which is especially connected with the Art Institute of Chicago:

The Assumption (Greco) is now in Paris at Durand-Ruels. I wrote to Mr. Widener about it, unfortunately the Metropolitan in New York has bought another Greco[4] belonging to Manzi or rather Glaenzer, and passed by the Assumption, which really *is* a *great* museum picture. But I have had a letter from the Director of the Art Institute in Chicago who will be in Paris in February, and I have some hopes there. Otherwise the picture will surely go to Berlin. I do hope you young men are going to insist on a voice in the management of the Public Museums. It is your duty and your right.

About a year after this the "Assumption" arrived in New York and, after being shipped by mistake to Washington, went out to Chicago. As Mr. Hutchinson, the president of the board of trustees, was in Europe, the decision was delayed. He wrote Mr. French:

PAU, March 7, 1906

Ryerson and I ran down to Madrid and Toledo while at Biarritz to look up the Greco and see the Prado Gallery. How truly magnificent the "Salon Velasquez" is at Madrid with forty of the masters best pictures. We found the church at Toledo from which the Greco in Chicago was taken. In its place is a modern copy of it. We also found a lot of poor pictures by Greco both at Madrid and in Toledo. We saw no picture by him better than the one you have save possibly one in Toledo. It seems to me that the one in Chicago is a really great picture and a good example of the Italian School for while it is Spanish in name it is really in the Italian style, painted after Greco had been to Italy and was strongly influenced by Titian. I am anxious to see it again.

4 In 1905 the Metropolitan purchased El Greco's "Adoration of the Shepherds."

The arrival of the picture in Chicago created quite a furor, but the newspaper accounts were fantastic in their lack of knowledge and understanding of El Greco. On February 24, 1906, Durand-Ruel wrote Director French:

〰️ I duly received your letter of the 21st inst. and also the newspaper articles which you so kindly sent me.

I am surprised to see that the critic of the *Chicago Chronicle* should know so little about the history of Art. I notice he says that "Greco went to Spain with Velasquez, when the latter visited Italy in 1620." Greco was not a contemporary of Velasquez, having been born in 1548, and died in 1625, while Velasquez was born in 1599 and was therefore 26 years old when Greco died. Greco came to Spain before 1577 as all his important pictures which are now in Toledo are dated about that period.

Furthermore, I do not understand how the writer of the article could have written about "the lack of color in the Greco, ashy gray and unsympathetic browns prevailing," as he had not seen the picture when he wrote the article the painting not having arrived yet in Chicago.

<div align="right">Yours very truly,
GEO. DURAND-RUEL</div>

After several months of deliberation the Art Institute purchased the "Assumption" at a reputed price of nearly $40,000. Mrs. Albert Arnold Sprague ultimately gave the Art Institute a sum of money to offset the purchase price, so that the picture became her gift in memory of her husband. This was the second El Greco to enter an American museum, and it is regarded today as one of the greatest masterpieces in the country. Mary Cassatt deserves full credit for this since it was she who discovered the painting in Spain in 1901 and she who wrote to museum directors until she was able to arouse the favorable reaction which occurred in Chicago.

A new Pennsylvania state capitol building was completed at Harrisburg in 1905. Enormous sums were expended and nothing was spared to make everything the best and most up to date. A

mural competition was sponsored for which Mary Cassatt did two *tondo* compositions of mothers and children. Rumors reached her however, that graft was rampant in connection with the project, a high percentage of the vast sums of money being expended finding its way into the pockets of unsavory politicians and other interested persons. She withdrew from the competition and refused to have anything further to do with it. One of her two paintings intended for Harrisburg is owned by her niece, Mrs. Percy Madeira; the other is in the Whittemore Collection.

In September, 1906, she wrote to her niece, Minnie:

~~~~~ I am now painting with my models in the boat and I sitting on the edge of the water, and in the warm September days it is lovely; the trout leaping for flies and when we are still we can see them gliding along.

I am making some changes here. I contemplate a "garage" for autos—and I have now the telephone.

Several of her later paintings were done at her pool in Beaufresne, a major example being "The Bath" (Petit Palais, Paris) showing two young women in colorful flowing Paquin gowns and two babies—all posed in a boat. Although it is well organized as a composition, there is a coarsening of technique which characterized her later work when her eyesight began to fail.

At this period she felt the necessity of house-cleaning her studio and placing or disposing of her work, as is evident from her letter of February 26, 1907, to her niece:

~~~~~ I am glad you have my sister Lydia's portrait ["Lydia Knitting in the Garden," Mrs. Gardner Cassatt Collection] and I have a picture I think Rob may like to have, a portrait of his father [A. D. Cassatt] done at Marly and very like what he was in those days. The picture was never finished but the hair and shoulders are. Last summer a dealer came out and rummaged in the garret at Beaufresne carrying off a lot of canvases, and I burned the rest but kept this portrait, too good to destroy.

I had expected to join the Havemeyers in Spain in March but

Mr. Havemeyer is too busy repulsing the attacks on the Sugar Trust to leave home. I see much of Mrs. Sears and Helen, the latter is constantly talking of Frances [Minnie's sister].

During the early 1900's, several tragic events took place in Mary Cassatt's family. In 1901, Ed Cassatt and his wife were separated. His sister, Katherine, was married in 1903, only to be seized with an incurable illness which led to her death less than two years after her marriage. During the fall of 1906, Alexander Cassatt, then sixty-seven, was greatly exhausted from a serious case of whooping cough which he had contracted from his nieces. His condition grew worse, and on December 28 he died. His death was a severe blow to Mary Cassatt, for she and her brother Aleck had been very close since their childhood.

Almost a year later, December 4, 1907, Henry O. Havemeyer died. He was not only the husband of Mary Cassatt's closest friend, but he himself was devoted to her; each had great admiration for the other's intelligence and taste. Just the previous summer he had been in Europe for the last time and had gone briefly to Italy with Mary Cassatt. His daughter, Adaline, was also there with her newly married husband, Peter H. B. Frelinghuysen. When Mr. Havemeyer died, his widow was utterly distraught and did not notify anyone except Mary Cassatt.

In the deaths of her brother Alexander and her great friend Mr. Havemeyer, the sphere of Mary Cassatt's life was greatly constricted.

The Fading Years

IN 1906 MRS. HAVEMEYER bought Mary Cassatt a Renault landaulet which gave her great pleasure, for she was inordinately fond of motoring. She continued to use this car over a period of twenty years—up to the time of her death in 1926.

The entire Gardner Cassatt family went to Europe during the summer of 1907 and took their car, a White steamer, with them. They met Mary Cassatt in London, and together they toured England and Scotland. After this they went to France, where Mary Cassatt picked up her Renault with an English chauffeur and the family divided between the two cars and drove off to Nancy, Strasbourg, down the Rhine to Cologne, then to Brussels. There were many breakdowns and Gardner Cassatt's American chauffeur and his sister's English chauffeur fought incessantly.

In writing to her nephew Robert (October 3, 1907), she recalled the trip:

Your Uncle Gard's nerves have been rather unstrung by the eccentricities of the "White" and no wonder, *never* was there such a trip. Herbert, the chauffeur, lost pounds and my English boy had to go to the rescue twice. We never mention the machine now, but one thing is certain, it can't blow up, even when the boilers or rather the radiator cracked, this of course is a doubtful advantage.

The English "boy" was a young and extremely cocky lad, but a good mechanic whom Mary Cassatt employed temporarily to teach her old coachman Pierre Lefèbre how to care for and drive the Renault. Pierre hated him as he was always playing tricks, letting the air out of tires and making him late in bringing the car to the door at the time ordered. Pierre remained with Mary Cassatt until after World War I, and his brother Constant was for many years the butler of the Gardner Cassatts.

Beginning in 1907, Mary Cassatt rented from the Harjes family Villa Angeletto, at Grasse in the Alpes Maritimes, which she used as a winter residence up to within two years of her death. On December 13, 1907, she wrote to her niece Minnie:

➤ I feel I partly owe to you the getting this little place. It is small, just enough for me, and has been lately done over and added to, in fact is not yet finished but has the modern comforts and now all I need is the sun. The servants, dogs and auto are here and it feels now like home.

She mentions watching prices in the Rouart sale and hopes that Rob appreciates the value of the pictures his father left him, "$200,000. at least."

Mary Cassatt was devoted to her artist friends from Philadelphia, not only Carroll Tyson, but also Adolphe Borie, who married Edith Pettit in 1907 and went to spend a year in Paris. On May 4, 1908, Miss Cassatt wrote to Tyson:

➤ Are you in town? I went to see Mrs. Borie yesterday intending to give Mr. Borie the card for M. Rouart[1] to see his collection, but they were out. I have written to ask them to come here for a cup of tea on Wednesday next and meet some friends of mine, and at the same time I will give the card. I met M. Rouart's brother [Alexis] today and said I was going to introduce some of my compatriots. Come on Wednesday between half past

1 Henri Rouart (1833–1912), painter and great friend of Degas, whose son Ernest Rouart, painter, married the daughter of Berthe Morisot and Eugène Manet, brother of Édouard Manet.

four and five please, if you can, and I will arrange matters for you and Mr. Borie. Always yours cordially,

<div align="right">MARY CASSATT</div>

In the fall of 1908 she decided to come to America for a visit and spend Christmas in Philadelphia with her brother Gardner. She was so violently seasick on the way over that she had to be carried off the boat and was taken to Mrs. Havemeyer's where she spent weeks in bed recovering. She vowed then that she would never again attempt to come back for a visit, and she never did. One of her reasons for coming at this time was to be with Mrs. Havemeyer to console her on the anniversary of her husband's death. On this visit she urged the family not to give their paintings to the Metropolitan because she did not feel that the museum exercised good judgment and taste in its acquisitions.

On December 22 she wrote Carroll Tyson from Gardner Cassatt's house at 1418 Spruce Street:

DEAR MR. TYSON;

If I can possibly, I will with pleasure go to your studio while I am in Philadelphia. I greatly regretted not seeing you and your friends when you were in New York. We had an accident. The horses fell down and were with difficulty gotten on their feet again then we walked to a place some distance and sent for an auto-taxi, which broke down several times and had to be abandoned and we walked home; but you had left by that time. I fear the present storm which I would welcome were it in France will make the streets rather difficult. You may be sure however that I will do my best to get to your studio. Always most sincerely yours,

<div align="right">MARY CASSATT</div>

As one of her greatest desires had always been to meet an African big-game hunter, Gardner arranged a dinner party for his sister with the noted hunter, Percy Madeira, as the guest of honor. Mary Cassatt sat for hours spellbound, listening to tales of his exploits in Africa. No doubt Miss Cassatt would have enjoyed

the sport herself. She was so enthralled that she would not leave the table when the ladies retired to the drawing room, but insisted upon remaining with the men in order not to miss any of the adventurous talk.

At this time she had her only visit at the Gardner Cassatt's elaborate new fifty-three-room country house, Kelso, which was built in 1907 at Daylsford near Berwyn. The name was taken over from "old Kelso," a country house which they had had for years, a converted old stone farmhouse at Ithair near Radnor. The farmer's wife bawled her out for coming into the spring-house with her shoes on. Much as she seemed to enjoy visiting her family, she was obviously glad to be back in France, as we can see from her letter to Mr. Tyson, November 11, 1909:

I have written to Mrs. Havemeyer and she will be very glad to let you see her pictures at any time when she is in New York, and you are there too. She has added several fine things to her collection since you saw it, amongst others a very fine picture by Rubens. I am very glad to know that you have been working this summer and are interested in your work. It must be the best time at home to work. I confess I was so disappointed in the light in winter when I was there. I don't see that you are in the least better off than we are here. The houses too are so dark, it affected my spirits. I was so glad to get back to my *"cinquième"* where I have the sky to look at. I don't think we have made the best use of our material, and if I were obliged to live in America I would always live in the country. Fine pictures are going over fast and soon there will be little left in private collections on this side. I wish more of the pictures were for the Public, but that is the people's fault. They ought to insist on the galleries buying good things.

She felt that public museums in the United States were appallingly slow in acquiring major pictures. It was her hope that with J. P. Morgan, president of the Metropolitan Museum, there would be a change for the better. As she said, they did not lack money but *taste*.

On April 14, 1909, Mary Cassatt was elected an associate member of the National Academy of Design in New York. As her independent ideas would not permit affiliation with such an organization, she declined the offer. It was fitting that at the close of her artistic career in 1914, the Pennsylvania Academy should give her the Gold Medal of Honor "awarded for eminent services to the Academy." Since there was no money attached and the award was not to a painting but to her as an artist, she was willing to accept it. Two years previous to this she had given to the Academy "Unknown Lady" and "Mayor of Ornans," both by Courbet.

Although, by 1909, Mary Cassatt had reached the age of sixty-five, her energies had not yet begun to slacken. She wrote to Electra Havemeyer on January 15, "I am going to begin Spanish." Curiously enough in her several trips to Spain earlier in her life, she does not appear to have acquired much of a knowledge of the language. She had traveled a great deal in Italy, yet she never learned Italian. Clearly her ear for languages was not acute and even her French, though fluent, was never free of a strong American accent.

During the early 1900's she also became very much interested in spiritualism. As early as April 21, 1903, she wrote Theodate Pope, who was in Paris at the time, and sent her the name and address of a medium, Mme Ley Fontvielle, 26 Avenue d'Eylau:

If you think it would help matters to have me with you, I will go with pleasure. We owe it to the S.P.R. [Society for Psychical Research]. I long to know what your experience will be.

In October, Mary Cassatt wrote to thank Miss Pope for sending her Myers' books[2] and to say that she was overcome by the last chapter of the second volume, and recommended that the ". . . best results are from *non-professional* mediums. I wish I knew one."

In November she wrote Miss Pope of Camille Pissarro's death:

2 Frederick William Henry Myers (1843–1901), *Human Personality and its Survival of Bodily Death*, 1903.

"Poor Pissarro has just fallen victim to a mistaken diagnosis."
She also said:

~~~~ Your bereavement is a great shock. [Miss Pope had just
lost her fiancé, John Hillard] Oh! we must not lose faith, the
faith that life is going on though we cannot see it, you may some-
times have a convincing proof, just because he has gone before, I
mean this for both, I do so hope you may. What a consolation for
those who have had it.

Mary Cassatt, in writing to her niece, Mrs. Robert K. Cassatt
(February 2, 1906) said:

~~~~ I saw your sister Frances[3] and hope they will come to tea
tomorrow and meet Mrs. Montgomery Sears' daughter who is
here for the winter and knows no young girls.

She went on:

~~~~ Do you remember my telling you about "James Currie"
whose name turned up in a seance here in Paris and who was a
cousin of Mrs. Peters' mother, dead these thirty years (J. C.) and
lived in New Jersey? Well, Mr. Peters went to a medium in New
York and she gave him 25 names of dead friends with particulars
only known to him. It was my telling him of James Currie that
started him in that line. I assure you the reports of the Psychical
Society are worth reading.

Mary Cassatt had known Mrs. Montgomery Sears through Mrs.
Havemeyer and saw a great deal of her and her daughter Helen
when they were in Paris in 1906 and 1907. Every other Thursday
evening Mrs. Sears, also greatly interested in the occult, held a
séance at her apartment at 1 bis Place de l'Alma under the
direction of the famous medium, Mme de Thèbes, who wore
flowing garments and a black mantilla. Many notables came to
these evenings, Sir Oliver Lodge, Poultney Bigelow, the pianist
Ernest Schelling and his wife Lucy Draper, the Herbert Hasel-
tines, and William James.

[3] Frances Fell, who married first Antelo Devreux, then after a divorce, Radcliffe
Cheston.

On May 27, 1909, she wrote to Mrs. Havemeyer's daughter Electra, who had recently married J. Watson Webb, the son of Dr. Seward Webb:

✐ I dined with Mrs. Schelling Friday evening and did not get away before 12 o'clock although I was to start for Darmstadt the next day at 9, and all because of our weird experiences. The family who are experimenting were there and we sat around a table which rose four feet off the floor *twice*. Do you remember Mr. Stillman asking if there was a woman in Europe who could make that table rise off the ground? Well, it rose. They, the group, said that was nothing. They had seen a table more than once rise above their heads and hang suspended for *more than a minute in the air*. It was intensely interesting to hear of their experiences. They are relatives of a sister-in-law of my friend Mme. Mellon, my friend and country neighbor, and the things the mother told me were thrilling. They think the religion of the Egyptians and Greeks was founded on certain things of this kind and now we are rediscovering them through a scientific road. Oh! You young ones may see things we have never dreamed of. I tell you all this because I know you have a steady brain and would not allow yourself to be thrown off the track but will understand that we are on this planet to learn. I think it very stimulating to believe that here is only one step in our progress.

Aside from her interest in spiritualism, Mrs. J. Montgomery Sears also collected pictures and owned several paintings by Mary Cassatt, whose advice she sought in all art matters. Of even greater significance was Mary Cassatt's close connection with the banker James Stillman. His great mansion on the Parc Monceau in Paris afforded him ample space to indulge in his two great collecting passions. On the one hand he bought paintings and, at Mary Cassatt's insistence, acquired French Impressionists rather than Greuze, which would have been more to his own taste. Mr. Havemeyer told her she would never make a true collector out of him, and he, on the other hand, could not understand why Mr. Havemeyer thought it so important to bring up

his children with a fine appreciation of art. In his Newport and New York houses he had only paintings by the Barbizon men and such artists as Anton Mauve and Julian Rix. He also owned at least ten pictures by Mary Cassatt herself. He also collected women's dresses, which all the great Paris couturiers sent to be modeled in his house. Had he not been a banker, he would no doubt have been a fashion designer.

Mr. Stillman had been abroad in 1870 when he was a young man of twenty, but his great period of living in Europe came in the 1890's and early 1900's while he was president of the National City Bank and later chairman of the board. His houses in Paris, New York, and Cornwall on the Hudson were all run with the same perfection with which he ran the bank. As he objected to the way his wife managed their houses, he forced her to give way to a housekeeper who organized things the way he wanted them. At length in 1894, Mrs. Stillman left and went to live in Paris in an apartment not far from her former husband's house, although she never saw him again. Stillman lived like a recluse prince and, though distrusting most people, found in Mary Cassatt the kind of outspoken and forthright personality that he admired. He was impressed by her convictions in regard to art and ended by being greatly influenced by her, appreciating her elegance of bearing and her taste in dress. She wanted to paint his portrait, but he would not permit it. Outside of her male relatives and one or two older friends, Degas was the only other man whom she ever asked to paint. These were, one gathers, the only two men who had meant a great deal in her life. She and Degas were the best of friends, and if Degas was in love with her, and he well may have been, she could not reconcile herself to such a relationship, as his bohemian way of living was offensive to her strictly conventional manner of life. In later years a relative once asked her directly whether she had ever had an affair with Degas. She replied indignantly, "What, with that common little man; what a repulsive idea!" Apparently the idea itself did not bother her as much as the fact of his "commonness." Not even a Cassatt was in any position to call the aristocratic De Gas family "common," yet

it is true that the artist himself did not live in a manner commensurate with his upbringing. Degas was very conscious of Mary Cassatt's strong sense of propriety, a feeling which was also carried over into her paintings. He once said when looking at her "Boy Before the Mirror," "*C'est le petit Jesu avec sa gouvernante anglaise.*"

James Stillman's style of living made Mary Cassatt's ménage by comparison seem like a bourgeois French household. His dinners with a footman behind each chair were fabulous, but as Mary Cassatt's two brothers also lived in a style close to Stillman's, she was quite able to adapt herself to any degree of luxury. Stillman, it is believed, was more than anxious to have her share the amenities of his Parc Monceau house, but she being six years his senior and already in her fifties apparently felt that such a marriage was inappropriate. Mathilde commented tartly, "Surely Mademoiselle, you would not adopt the name Stillman in place of *Cassatt.*"

In 1911 his youngest son, Ernest Stillman, married Mildred Whitney, who gives some insight into the relationship between her father-in-law and Mary Cassatt in a delightful account she wrote of a visit to Beaufresne.[4]

Her old brick house had originally been a hunting lodge, belonging to some château—one of those delightful rambling buildings with more picturesqueness than convenience. I remember especially a sort of long, glassed room, like a sun porch, and the lovely pond with willows hanging into the very water, beside which many of her pictures were painted. As those who know her work know, Miss Cassatt usually painted out of doors in bright sunlight. Much of her best work was done at Beaufresne, where the models were neighboring peasant women and their children. Critics have sometimes objected to the homely faces of her women. But as Miss Cassatt wrote to me later when I sent her a photograph of my first baby: "Most mothers with nurses do not know how to hold their children." This great painter of maternity

4 Anna Robeson Burr, *Portrait of a Banker.*

wanted the rhythm of the constantly curving arm—the constantly bending back. She found it in those French women of the soil, stooping over their firm-bodied children.

Miss Cassatt herself was tall and gaunt, dressed in a shirt waist and black skirt. But her strong face and her rapid intelligent conversation gave me little time to notice externals. We had delicious curried chicken for lunch, a *specialité de la maison*, and looking forward to my first housekeeping I asked for the recipe.[5] Miss Cassatt expressed surprise that I was interested in cooking, and then I received one of the only two direct compliments my father-in-law ever gave me. After all it was chiefly negative, "She isn't a spoiled New York girl," he said. Miss Cassatt wished to paint Mr. Stillman's portrait and I wish that he had given her the opportunity. I do not know that she ever had painted a man, but she knew her old friend, and knew what expressions to watch for in

[5] These two receipes were furnished by Mrs. Cameron Bradley:
*Caramels au chocolat* (Recipe of Miss Cassatt, 1907, Paris)

> 125 gr: sucre en poudre
> 100 gr: miel
> 80 gr: chocolat rapé
> 40 gr: beurre fin
> 1 verre de crème douce

Mettez le tout dans une casserolle en cuivre, melangez bien ensemble. Remuez pendant tout le temps de la cuisson qui est assez rapide en employant un bon feu, mais pas trop vif. Je recommande de suivre cette cuisson avec beaucoup d'attention car c'est d'elle que depend la réussite. Dès que vous voyez que la melange epaissit et que la consistance devient assez grande, faites tomber quelques goutes de votre crème dans un bol d'eau froide. Si elle fond en petites boules, la cuisson est faite. Versez dans la moule à caramel. Puis ajoutez un peu de vanille.

*Truffets au chocolat*

Prenez du bon chocolat coupé finement 125 grammes que vous ferez fondre avec une cuillère à bouche de lait, sur un feu douce. Lorsque le chocolat est completement fondu ajoutez 70 grammes de sucre en poudre. Remuez avec une cuillère de bois jusqu' à ce qu'il soit fondu. Ajoutez 70 grammes de beurre fin. Remuez encore quelques instants pour bien opéré le melange, toujours sur feu douce. Prenez cette melange hors du feu, ajoutez 2 jaunes d'oeufs frais. Laissez refroidir cette crème pendant plusieurs heures ou même pendant la nuit. Divisez en boules la crème et roulez les petites boules dans du chocolat granulé. On peut les rouler dans des amandes ou noisettes hachées, melangées avec du chocolat.

As I copy these, it takes me back so, when I was allowed to go to the kitchen with Mathilde and watch her make them! You can see how fussy she was by the language, and eggs and butter *had* to come from Mesnil-Beaufresne!—Helen Sears Bradley

his often mask-like face. Kaulbach, who is said to have told the Kaiser that "he painted men, not buttons," did make a fairly good portrait of James Stillman the banker—but I think Miss Cassatt would have painted the father and the friend.

Miss Cassatt was heart and soul a modern. She abhorred the sentimental. She prevented Mr. Stillman from buying two small heads of Greuze, with their pastoral sweetness; and when I mentioned the beauty of Mme. Vigée le Brun, she dismissed her with this comment: "She painted herself."

Mr. Stillman's great recreation was touring. . . . In the cities, he would plan our sightseeing and then busy himself with his interminable cables. Late in the day he loved to stroll through the shops. No woman ever enjoyed shopping more than he. In Paris he picked out an opera coat for me which still hangs in my closet, after fifteen years, because though impossibly out of style now, the colors are so lovely, I have never been willing to part with it. He also bought us our table linen, considering the designs for the monograms as seriously as if they had been state papers.

Under tutelage of this friend, Stillman lost that timidity he had formerly experienced in the art galleries. Admiring Miss Cassatt's work as much as he did her vigorous opinions, he purchased several of her paintings. Before long he had annexed a collection of Gainsboroughs, Ingres, Murillos, Moronis, Rembrandts and Titians. As a connoisseur of painting, he practised the art with that thoroughness with which he went into every speculation. Thoroughly shocked at Morgan's manner of buying anything and everything that pleased him regardless of price, and fearful of the fate that other Americans of means had met in spending huge sums for practically valueless works, he calculated to a penny the worth of each picture in which he invested. A canvas would hang on his wall for days before he would decide to purchase it, meanwhile determining its value from a dozen or more "scouts" whose judgment he respected.

Nor in his artistic galavantings did the American banker neglect the couturiers. Afternoons often found him in a large chamber of his house, which he had transformed into a private fashion

salon. Here he would sit for hours, wrapt in contemplation of the latest creations of noted Parisian maisons. Worth was a favorite. Here the famous couturiers brought for his inspection hats, gowns, and lingerie by the gross. These were paraded before his eyes by beautiful selected mannikins. While Stillman's purchases were extensive, the couturiers admired, too, his subtle sense of color. He once sighed, dreamily, that he would like to have been a fashion designer.

In the fall of 1910 the Gardner Cassatts again went abroad and took Mary Cassatt with them for a winter trip. While they were all in Paris James Stillman took them out to Versailles and photographed them at the corner of the Grand Trianon. They went to Munich and Vienna, and then by the Orient Express through Budapest and Sofia to Constantinople. In Sofia Mary Cassatt heard that there was a nearby village where everyone lived to be 110. They took an arduous drive only to find that the one aged man in the village was away. They spent Christmas in Constantinople, took a very dreary boat to Cairo and went up the Nile in a dahabeah.

Some of these events are described in a letter to Miss Pope:

PERA PALACE HOTEL, CONSTANTINOPLE
Dec. 23rd [1910]

DEAR THEODATE, I need not ask you if you believe in telepathy, but it seemed to me an added proof when your letter reached me here. My family landed on Nov. 24th and ever since then, every day, we have talked of you and Mary Hillard and your joint efforts for the school [Westover School].

I wonder if you know this wonderful place. I don't believe you have been here, it is something to see. I am so glad we came, though quarantine regulations will prevent the three days trip in Asia Minor which we had hoped to take. We hope to be in Cairo by January 3rd and have two months in Egypt. My brother and his family are enjoying it all as much as I am. It seems so odd not to be working all day, but seeing sights and enjoying the young minds of my nieces.

I am glad you will be in New York and seeing Mrs. Havemeyer often, I hope. She has had hard times, just think how much better if women knew all about the men's work. At present men lead double lives. What we ought to fight for is equality it would lead to more happiness for both. Of course with that great big heart of yours you lean toward socialism. Up to the present time it don't work, then too I believe if we are to be led to that promised land of more equal rights, it will be by a silent leader. There has been far too much talking and Roosevelt has been the sinner. I am not hard, at least I hope I am not, but I am an individualist and I'm of Gissing's opinion. He said when he saw certain individuals he wondered the world did not move faster, but when he saw the crowd he wondered it ever moved at all. I am more interested to know if you don't intend to bestow that heart of yours on some individual than to know you are bestowing it on the suffering, the latter though do wring my heart, old and worn as it is. We can do so little for others except in the way of education. Did you ever read the "Benefactress"? It is by the author of "Elizabeth in her German Garden." May your poor little invalid recover. We were so interested in Sophia to hear of the great longevity. Our Doctor called in for a sore finger declared that individuals of ages varying from 140 to 150 were scattered over the country and he knew personally a man, Jew, still retaining all his faculties at 135 years. Of course most people would not care to go nearly as long as that, but it is interesting to know some cases.

I am quite sure Henry James is a fine man and he has improved since he first wrote, then he was inclined to be society, but superior people soon get over that.

Your affectionate friend

MARY CASSATT

Despite Mary Cassatt's diverse interest in art, she cared little about the ancient world and was bored stiff by Egypt. Miss Anna Ingersoll recalls meeting Mary Cassatt in Egypt in 1911:

She was with her brother Gardner, his wife, and daughters. We were traveling in plebeian fashion in a Cook boat and were

so glad we had *not* taken a private dahabeah as they had when we saw how everyone who had one got on each other's nerves and were bored. Mr. Cassatt was sickening towards his death which did not add to the cheer of their party. We met at Luxor and I remember our surprise that Miss C. seemed quite uninterested in the scenery, temples and "art" that we loved so and could only talk of the charming little boy who had driven her donkey.

Mary Cassatt herself wrote to Miss Pope from Shepheard's Hotel in Cairo on February 19, 1911:

The climate and even the country is a great disappointment and apart from some of the temples there is nothing to see. Temples and tombs, still one learns.

To her niece she wrote while going up the Nile on the dahabeah *Hope*:

Here we are going up the Nile in a most comfortable boat and you, I suppose, enjoying snowstorms in Philadelphia. Now I should like to see the boys. I never dared send them a Xmas present on account of the customs here, but would not they enjoy the camels and the donkeys! We have just passed a camel pumping or rather turning a crank with palm trees for a background. Of course you know all this, so I spare you a description, but if ever Rob wants a thorough rest and change bring him up the Nile, I cannot imagine anyone not benefiting by it, such air. Your Uncle Gard poor man has an attack of hives and is unfortunately in bed, but we got a little Egyptian doctor on board yesterday evening who prescribed and promises a cure for tomorrow. I hope he will soon be up here on deck, we are being towed to Luxor and Assouan. All the party are happy, your Aunt Jennie looking so well and Eugenia now reconciled to travels abroad, though looking forward to boarding school next winter.

We left Paris, or rather I did to join them in Munich, on the 10th and we stopped at Vann, Budapest, Sophia, and Constantinople, missed Athens on account of the quarantine, but mean to return that way. This is a great change for me. I can hardly believe

I am sitting on the deck of a dahabeah writing to you. When we were in Paris your brother John and his wife passed through coming from China.—We had a good deal of suffering on our way from Constantinople but I was not as seasick as usual, if only, as Mathilde says, we could cross to America this way!

Gardner Cassatt became very ill towards the end of the Egyptian trip, but they managed to get him back to Paris, where he died in the Hotel Crillon, April 5, 1911. At her brother's memorial service at the English church in Paris, Mary Cassatt became absolutely furious because the minister prayed for the King instead of for the President of the United States. She had never had much to do with churchgoing, although she had been baptized an Episcopalian. Her family's Episcopalianism was tempered by a certain amount of Presbyterianism, a combination which resulted in their interests in the church being slight.

On April 28, Mary Cassatt wrote to Emily Batchelder (the divorced wife of her nephew, Ed Cassatt, now remarried):

DEAR EMILY, I have been utterly unnerved by all I went through in Cairo and since. Now I am the only one left in my family! Who would have believed that both my brothers would go so near to each other. This one would have to have lived nearly a quarter of a century more to have attained my Father's age. Then the children are so young. There is no use looking back. I must try to get strong again and get to work, it is the only thing.—When I am in America I will certainly see you.

She felt very deeply her loneliness at this time and no doubt thought of returning to America to visit her nephews and nieces. She could not forget, however, the dreadful ordeal of seasickness she had undergone during her last trip; as a result she never attempted to cross the Atlantic again.

Much as she hoped to get back to painting, Mary Cassatt had now at sixty-seven all but completed her period of creativity. Although another fifteen years of life remained to her, she could no longer undertake the fine, delicate work required for dry

points, and her activities as a painter were greatly diminished and in another four or five years ceased altogether. This situation was caused by the fact that in 1912 she developed cataracts on both eyes. She had an operation which was unfortunately not very successful, and as a result, she was able to do less and less in the way of painting and her last works are coarse in technique and raw in color. Pastels of her two grandnephews, Alexander and Tony Cassatt, done in 1914, show the extent to which her work had deteriorated.

During the summer of 1914 several of Mary Cassatt's relatives visited her at Château de Beaufresne, and they were all there when the war broke out. Her nephew, Robert Cassatt, had come over with his two sons, and also her favorite niece, Ellen Mary Cassatt. Although the family went home, Mary Cassatt stayed there as long as the authorities would permit, but was finally forced to evacuate to her villa at Grasse where she spent much of the war. To her niece Minnie, she wrote hopefully on February 5, 1915:

It is thought that August will see the last of the fighting. I am here with my Swiss chambermaid who has been with me for more than three years and knows all the ways of the house, she and a cook from Grasse take care of me and the dog. Mathilde and her sister are across the frontier at Bordighera. Poor Mathilde has lost thirty pounds fretting over the separation. Pierre is "conducting" an auto for a Naval officer. My gardener is at the front since the first, the oldest aide, age 19, has also been called. I see much of Miss Harjes and her mother.

On June 8, 1915, she was still at Villa Angeletto and wrote Miss Pope:

I leave here for Paris by motor on Saturday providing my papers are properly signed. I intend going to Beaufresne later. The cannon is no longer heard there. Mathilde is in Switzerland with her sister[6] (Plates 2b and 2c).

[6] She worked in a glove factory in Roschat (Canton of St. Gall). After the war Mathilde returned to Miss Cassatt and brought her sister Julie as *femme de chambre*.

She has gone to pieces since the war. I got her safely to Italy. She did not have to go to camp, yet she lost thirty pounds and drove me nearly crazy. She showed no courage at all.—I have been so ill no one thought I would recover, but I did, then I overworked and when the war cloud burst, I broke down under my responsibilities and it has taken me all winter to get well again, and my sight is enfeebled.

During the summer of 1915 she was enabled to return to Beaufresne. From a letter to Harris Whittemore we learn of her problems with the authorities:

MESNIL-BEAUFRESNE
MESNIL-THÉRIBUS (OISE)
Thursday, July 8th [1915]

DEAR MR. WHITTEMORE: I have been long in answering your very kind letter which I received nearly two weeks ago. The reason is that I have been impressing on myself the absurdity of keeping a picture to leave a nephew or niece, who care nothing for art, and certainly not for my pictures. It is a great pleasure and gratification to me that you like and want to own that particular picture the "Tondo" for I have always thought it one of my best. Will you do me a favor? Take the Tondo, and keep it for sometime, if once you have it on your walls and continue to like it then I will sell it to you, the price is five thousand dollars.

I don't want the money now. Later when the period of destruction is over and reconstruction begins it may be useful. I came out here day before yesterday, it took me more than two weeks to get all the papers necessary to allow me to come here in my auto as this is in the Army Zone. To live here without horses and without an auto is to be a prisoner. I am hoping the General at Beauvais will give me a permission to use my auto in a strictly limited area, it is all I can ask. We are within fifty miles of the front and General Joffre's headquarters are at Chantilly I am told, that is thirty miles from here.

As you say the world is mad just now, when is it to end? The French as an English Admiral wrote to me, are fighting furiously, and we all of course are sure of the ultimate victory.

I saw much of Theodate in Paris, she is very calm, and seems none the worse for her terrible experience,[7] but nerves have long memories. She sails on the 24th. I envy her, and would love to accept your kind invitation to visit you all in that lovely mountain home, which I saw only in early Spring. I feel chained here, and have duties I must fulfill. With kindest regards to you and all the family believe me always,

Most sincerely yours,

MARY CASSATT

She comments on her eyes in a letter written to Minnie during the war.

DEC. 28, 1915, VILLA ANGELETTO

I have had a great deal of trouble with my eyes. Two years ago in October I might have been cured in a week had Landolt who has a great reputation seen what ought to have been so easy for him to see. I felt I was losing my sight and Dr. Borsch[8] operated. I think Rob may have known Dr. Borsch, he is a Philadelphian and knows all the family. He is making a great reputation in Paris. I am here to try and get as well as possible and let my eyes rest and in a couple of months to return to Paris and get spectacles. Dr. B. promises much but I remember my age and don't look forward but live from day to day.

In this sea of misery in which we live, an individual case seems of little account. There are ten thousand blind in France.—If only we could see the end of this war!

Another saddening event which took place in the third year of the war was the death of Degas on September 27, 1917. Mary Cassatt admired him more than any other artist in France, and, even though she did not see much of him in her last years, she felt the loss very deeply and it left her more lonely than ever. She managed to get to his funeral at Saint-Jean de Montmartre,

---

[7] Theodate Pope and her maid, Robinson, were on the *Lusitania* when it was sunk by a German submarine off Ireland May 7, 1915.

[8] Dr. Louis Borsch, an American doctor married to a French woman.

which must indeed have been a valiant effort on her part—all the more so, since she had been very much depressed by Degas' habit in later years of following funeral processions. It was she who urged his family to send a nurse to care for the painter when he was dying.

The day after his death Mary Cassatt wrote to George Biddle and expressed her great regret:

⟋⟋⟋ Degas died at midnight not knowing his state. His death is a deliverance but I am sad, he was my oldest friend here and the last great artist of the 19th century. I see no one to replace him.

In the spring of 1918, Mary Cassatt again had cataracts growing over both eyes, and, although she could still write, she could no longer read. That summer she stayed in Grasse as permission to go to Beaufresne came too late for her to bother to make the trip. As a result, she escaped the bombardments which took place during the last months of the war. In the meantime she waited forlornly and impatiently for the optimum time for another eye operation. Monet had also had cataracts (operated on in 1923), and Pissarro had eye trouble. Degas had curious spells of seeming blindness, eventually was blind in one eye, and had only dim vision in the other. It would appear that eye trouble was a malaise of painters of this period and makes one wonder whether there may also have been some underlying psychological fear which aggravated the situation.

Mary Cassatt's handwriting became more and more difficult to decipher as can be seen from a letter written in 1919 to Mrs. Jane Miller, the daughter of Dr. Louis Moinson, one of her doctors:

10, RUE DE MARIGNAN

⟋⟋⟋ MY DEAR YOUNG FRIEND, I have been wanting to write to you since many months but it is difficult with such sight as I have to write anything more than a very few letters except on necessary business.

I hear very often from Mrs. Havemeyer who has often given me news of you but she is immersed in politics which I greatly

regret, not that I am not strongly for suffrage[9] but there are limits. I don't think that they will hurry matters over here, there are other fish to fry and more pressing situations involved.

I have seen your Father very often and though he is over-worked he says he is well and his energy is as always remarkable. We are not in a good condition here, and there is no sense of security anywhere, but it is much the same everywhere.

There are many exhibitions but no Art. I think as to music you must be better off in New York. Of course you are like all the young people interested in the games. The papers say that Clemenceau attended at the college football match on a cold damp day. With a ball[10] in his back, he is certainly wonderful, but I hate his politics.

If you go to Philadelphia do see my family, my sister-in-law's address is 1418 Spruce St. and my nieces are great sportswomen and riders to hounds. They would be very glad to know you. The youngest is an enthusiastic farmer, her mother writes that she manages very well. I hope it is so, but I would rather that they were both married, but that is dreaming.

I hope I shall see you next summer if it is to be a summer visit to your Father. He always talks about you when we meet and I think of you so often.

[9] The Nineteenth Amendment, granting women's suffrage, was passed August 20, 1920. In April, 1915, Mary Cassatt and Degas had shown at the Knoedler Galleries for the benefit of women's suffrage, with $5.00 admission on opening day. Everything was lent by Mrs. Havemeyer, who had organized the exhibition.

[10] This refers to the fact that there was a shot lodged in his back as a result of a duel which he had fought in 1871.

CHAPTER XII

## Final Years of Bitterness

BY 1920 FRIENDS AND RELATIVES began going abroad again, but they found a much changed Mary Cassatt. By now she was past seventy-five, very nearly blind, and querulous and vindictive. Anna Ingersoll from Philadelphia went to study in Paris and made a friendly call at the Rue de Marignan. Mary Cassatt was bad tempered and ungracious, told Miss Ingersoll that she ought to go home, that her apartment on the Rue de Rennes was no place for a young lady to be living alone, and that she had no business in Paris anyway. She should study art in America, not in degenerate France. On hearing that Anna was copying Cézanne, Miss Cassatt showed little interest, but pulled out the copy of a Frans Hals which she herself had made in her youth. She felt that one learned more from studying the techniques of the old masters.

Although Mary Cassatt once owned a Cézanne, purchased for 100 francs, which she sold twenty-five years later for 8,000 francs to buy a Courbet, she never advanced beyond Cézanne in her taste for the modern. She considered that she was very progressive in her viewpoint in that she had done a great deal to further the Impressionist movement, but she had no use for the *avant-garde* of the early twentieth century and regarded Matisse and his circle as outrageous painters whose work could not possibly last. To her niece Brown (Mrs. Hare), she once commented that Matisse's

paintings were "extremely feeble in execution and very common-place in vision," and that any sound artist looked with scorn at Matisse and the Cubists. Even the late work of Monet disturbed her and once she wrote the dealer René Gimpel: "I don't care for the water lilies, they seem to me like glorified wall paper." She would have been horrified if she had ever learned that she was included in the famous Armory Show in 1913. Quite un-known to her, Durand-Ruel had lent a "Mother and Child," and John Quinn, the well-known collector of modern art, also lent a maternal subject.

She had the utmost disdain for Gertrude Stein and her brother Leo and considered that they were buying decadent art purely for the sake of sensationalism. Art dealers also engendered her wrath for encouraging this type of art, yet she had once said that to make a good collection one must have the "modern note."

Mrs. Sears, who enjoyed knowing people of a variety of in-terests, took Mary Cassatt in 1908 to one of Gertrude Stein's "evenings" on the Rue de Fleury, but had her car and chauffeur wait outside the door, not knowing how the evening would go off. Mary Cassatt was introduced to a number of people, looked about her at the dozens of early Picassos and Matisses, and finally went up to Mrs. Sears and said, "I have never in my life seen so many dreadful paintings in one place; I have never seen so many dreadful people gathered together and I want to be taken home at once." She regarded the experience as a nightmare.

Mary Cassatt not only had no interest in art activities after 1900, she also disdained some of her own contemporaries. She had no use for Sargent, little regard for Henry James, could not endure Cecilia Beaux, whom she had once cut dead on the steps of the Pennsylvania Academy, and loathed Edith Wharton, whom she thought no good as a writer and whose husband she regarded as a parvenu. She felt that they all were catering too much to "Society."

She once wrote to Cecilia Beaux (October 19, 1915) explaining why she had refused to be on a Pennsylvania Academy jury:

It is a matter of principle with me. I disapprove of the system which in France has always kept out of exhibitions the original painters. To mention only a few who were victims of the jury system: Corot, Courbet and Manet with their pictures constantly refused. The last two appealed to the public at one of the great exhibitions having at their own expense put up pavilions to show their work. I regret that we in America have copied the faults over here, here where they are beginning to remedy things too late for the great artists who suffered injustice all their lives. I hope in America another generation may inaugurate another system, freedom for all. You see I feel very strongly on this subject and could never bring myself to prevent even the humblest of painters from showing his work.

The only woman whom she really admired was Mrs. Havemeyer, who in general also disliked women. Although she adored children, her devotion was centered on the very young. Her niece remarked that "the Cassatts adored even the most repulsive children and babies." Once children were mature enough to stand up to her and talk back, she soon tired of them. Although she was nervous and irritable and could be easily upset, she very much needed companionship and felt lonely without it. This is indicated from her correspondence, which became much more prolific after her parents' deaths.

Before their deaths, her father and mother kept up much of the family correspondence, but even so Mary Cassatt was not an avid letter writer at this time, for her parents gave her the companionship she needed. As a lone woman she kept in constant touch not only with her brothers, nephews, and nieces, but also with Mrs. Havemeyer and her daughters, whom she regarded as practically a part of the family. Her valiant but almost illegible attempts at letter writing during her nearly blind years indicate a courageous spirit, but also show her compelling desire to maintain human contacts. Most people would simply have given up correspondence. She sometimes dictated letters in French to Mathilde, and during visits Mrs. Havemeyer occasionally wrote

letters for her, but generally she preferred the direct experience of putting pen to paper and, at the risk of illegibility, creating her own letters.

In 1921 there was a momentary hope for improvement in her sight. She dictated to Mrs. Havemeyer a letter to her grandniece, Lois Thayer, in September of that year:

Last May I had an operation upon my best eye. The operation was very successful and the oculist promised me I should paint again, but a hidden abcess in an apparently sound tooth caused a violent inflammation and I have not yet recovered from it. Nor has the sight of the eye returned.

And to Mrs. Montgomery Sears she wrote:

10, Rue de Marignan
Dec. 11th [1921]

Dear Mrs. Sears. I have had a very serious operation for cataract several weeks ago and have my eye still bandanged and can only see very indifferently with the other eye which is my poor eye. I shall not be able to use my eyes, nor be allowed glasses for several months to come, after that my oculist promises great results. I do not allow myself such sanguine hopes. You see why I have not written to you before. I was so glad to hear that you think of coming over in March to travel in southern Spain. As I will be I hope at Grasse until May I can look forward to seeing you. I hope you will come to see me in my little house there. Ah, this awful war, we seem more like insects with wings or legs pulled off. Science has usurped everything and what can it do to restore destruction. I sent you a cutting from one of the papers which gives a very candid account of what is going on here. We can get what we want if we can pay for it. Ellen House gives a very different account of things in England where street lines regulate consumption of food. My feeling is that fruitless wars are the Samson which will pull down our industrial civilization about our heads. We shall see worse things before the end.

I hope to leave for Grasse before Xmas, I don't look forward to

the journey with any pleasure but the winter here would be too hard on me and as my recovery of sight depends on general health I must go. I have no art news, speculation is the order of the day, one talks only of millions of people who have made great fortunes in the war. Must have something to spend their money on. You ought to get this near Xmas. A thousand good wishes to you and Helen and much love from

<div align="right">

Yours always
MARY CASSATT

</div>

George Biddle, Forbes Watson, and others visited Mary Cassatt, and all found her fascinating to listen to but at the same time difficult, unreasonable, and violently opinionated. Vollard had given her some small terra cottas, which she greatly enjoyed through tactile sense when her vision had failed. About the sculptor she seemed vague and disinterested; she believed him to be Clairette and showed no knowledge of the name when someone suggested that they looked like the work of Maillol. She was greatly interested in politics and held the lowest possible opinion of Woodrow Wilson, whom she called by an unprintable name. She said, "If I weren't a weak old woman I'd be a Socialist." By then she had given up eating lunch, told morning callers to "hurry out and get lunch and hurry back." In her last years she was under severe dietetic restrictions for diabetes. This was hard indeed for one who so enjoyed the excellence of French cooking.

A most unfortunate event took place in 1923 which embittered her during the remaining brief time of her life. Mathilde discovered some dry point plates in a closet and they were taken to Delâtre, the printer, to be examined. He pulled proofs of them and convinced Mary Cassatt that they were superb quality, and that the plates had not been printed before. She sent two sets of these prints to Mrs. Havemeyer and asked her to show them to William Ivins, the print curator of the Metropolitan Museum, saying that he might purchase a set for $2,000. Mr. Ivins realized at once that they were mostly proofs from worn-out plates and found that good proofs of most of them were already in the Metro-

politan collection. Mrs. Havemeyer conveyed this information to Mary Cassatt, telling her that she was being duped by either Mathilde or the printer and that no doubt her failing eyesight prevented her from realizing what the prints were. Mary Cassatt wrote a series of highly indignant letters to Mrs. Havemeyer and others, and would never admit being in the wrong. A great deal of unnecessary hard feeling was caused and, since Mrs. Havemeyer believed that Mr. Ivins was correct in his judgment, Mary Cassatt never forgave her and their friendship ended. Mrs. Havemeyer, however, bore her no malice and in 1928, after Mary Cassatt's death, went with her companion, Marthe Giannoni, the family *mademoiselle*, to place rambler roses on Mary Cassatt's grave.

Mary Cassatt's view of the controversy is aired in letters to Harris Whittemore and to Mr. Weitenkampf, print curator of The New York Public Library:

10, RUE DE MARIGNAN
May 12, 1924

MY DEAR MR. WHITTEMORE

I have been meaning to write to you for some time. You will easily know why, to thank you for your offer to buy several of the series of dry points which Mrs. Havemeyer offered for sale without the slightest authority from me and without telling me what she was doing. These plates representing states were found put away in the closet of my painting room—found there by Mathilde, were shown to an artist friend, an engraver, taken to Delâtre, son of Whistler's printer who was also mine and Degas.' The proofs were shown to artists and amateurs and generally admired. They were all dry points except two, one being an aquatint of my Mother; that one I knew had already been printed, the others had never been seen.

I sent two sets to Mrs. Havemeyer to show to Mr. Ivins with a request that he might exhibit them or rather one set and that if the Museum wished to buy a set the price was to be $2,000. I based the price on what my etchings are sold for here, at auction.

My surprise and anger were great when I was confronted with an accusation of fraud! Mrs. Havemeyer immediately sided with Ivins and advanced the excuse that my sight had so failed that no blame was to be attached to me, but to Mathilde using her as a scapegoat! She then wrote that "they," Ivins, herself, and a collector who boasts of having all my etchings, were so jealous of [my] reputation they were going to save me. I answered that I could take care of my reputation and she of hers. I at once cabled to send the etchings to George Durand-Ruel. She cabled that my etchings were in the hands of the Durand Ruels, but they were not, only one set had been sent as Joseph D-R. wrote to me. She had kept the other to show to you and others, to sell them! There are only six sets for sale, three I keep. As to the price Ivins most impertinently fixed and what you know and I was to sign every proof the date of 1923 frankly accepting the fact that these were a series of plates previously printed. They have sent me photos of my dry points to prove this. I took them to my printer and he said what does this prove? I know there may be one or even two proofs of them but I defy them to show a series.

I have no respect for the opinion of Mr. Ivins. I had a note from him a few years ago when he told me that Whistler's etchings looked as if spiders had been running over the plates! A most unbecoming attitude for the Director of Print Department of a great museum to sneer at Whistler indeed. Ivins cannot touch Whistler's fame. Mine is different. He has accused me of fraud and Mrs. Havemeyer has accepted the charge—of course all is over between us.

The etchings, not a full set, but twenty are in the Petit Palais. The Prefet de la Seine in his own name and in the name of the City of Paris has just written to thank me. One more word— there has never been a question of money. I am very indifferent to that as I have all the comforts I need and more money than I feel I ought to have. France is still the easiest and the cheapest place to live in.

How I wish I could have seen your sister and your daughter when they were here. My love to them and to Mrs. Whittemore.

I am afraid I shall never see them again unless they return to France and I can still hope I may see you and tell you how much I appreciate your kindness.

With kindest regards most sincerely yours

<div align="right">MARY CASSATT</div>

In case you should hear that I am a mad suffragette please don't believe it. I have allowed Mrs. Havemeyer to use my name far too freely but as soon as I knew what her party was about I withdrew my name.

Mr. Whittemore replied most tactfully:

<div align="right">May 26, 1924</div>

MY DEAR MISS CASSATT,

I was delighted to receive your good letter of May 12th and regret exceedingly that there has been any misunderstanding between you and Mr. Ivins and Mrs. Havemeyer regarding the two sets of prints which you sent over for exhibition and sale. I have only seen Mrs. Havemeyer once at her home and while I am the fortunate possessor of between fifty and sixty of your prints and lithographs I do not feel qualified to pass on the question involved. I felt very strongly at the time that there must be some mistake and that it would be impossible for any such thing to happen with your knowledge and consent. I further understood that all the prints were to be returned to Paris by Durand-Ruel and that I should hear further from Mrs. Havemeyer regarding your wishes in the matter. I have not heard anything from that day to this. Do I understand the matter correctly, that you propose to sell certain sets, every proof to be signed by you as of date 1923, with the understanding that trial proofs of some of these prints may have been previously printed? Under these conditions I should esteem it a great favor if you would let me have one set, you to fix your own price. In case you decide to do this you can send me the prints through Durand-Ruel and I will either remit direct to you or through them, as you may wish.

I wish it were possible for me to come to Paris and call on you but this seems an impossibility this summer although I do hope

to come at the earliest opportunity. I appreciate very much your thoughtfulness in writing me so fully in this matter and I shall say nothing to anyone about your letter or about purchasing the prints unless you wish me to.

With kind regards, Sincerely yours,

HARRIS WHITTEMORE

Mary Cassatt, more determined than ever at the age of eighty, continued to argue for her *cause célèbre*:

MESNIL-BAUFRESNE
MESNIL-THÉRIBUS (OISE)
[June 1924]

MY DEAR MR. WHITTEMORE

Your letter gave me the sincerest pleasure. I thank you for its kind appreciation of my feelings. I have been accused by Mr. Ivins of having knowingly sent these dry points to sell in the U.S. at a preposterous price knowing that they already [were] published, and Mrs. Havemeyer to save my reputation said that I could not see and that Mathilde had brought them to me and I without consulting anyone had accepted them. She wrote that they were so jealous of my reputation and I wrote I was quite able to take care of my reputation.

I think I have now sufficient evidence to prove the falseness of the accusation. When the two portfolios were returned to me I had to have an estimation made and pay the duty of 12% on the value, for nothing comes in nor goes out of France without paying. For this purpose Lair-Dubreuil[1] had to examine them, and of course he made an estimate as low as possible. He then told Joseph D R. that he had never seen these etchings, he had a vague memory of one or two of course the aquatint of my Mother, but I had explained that I knew that one had been seen. Mr. Lair-Dubreuil has sold at auction most of my etchings whenever there is a sale of modern etchings they are sure of some of mine being amongst them. I have a good many proofs of that kind—

---

1 F. Lair-Dubreuil, an auctioneer and appraiser at the Hotel Drouot, a Paris auction house.

more than enough to prove Mr. Ivins wrong. It is not for myself alone [I am] making this fight but for those who may be treated as I have been and who need the money and to whom it might bring suffering. I don't care for the money for I don't need it. I could not sign the proofs 1923 for that would be acknowledging that Ivins is right which of course I never would. Therefore I won't sell. When I have made Ivins acknowledge his error it will be time enough to think of that. All the same I am very very much obliged to you for thinking so kindly of me. I enclose a post card of this place and hope I surely see you here some day. With kindest regards

Most sincerely yours
MARY CASSATT

Mr. Whittemore replied on July 2 with a generous offer:

I have your recent letter and am disappointed that, apparently, I am not to have the pleasure of owning a set of your etchings until your controversy with Mr. Ivins has been settled. I trust that you will bear me in mind if at any time in the future you decide to allow any of this particular set to be disposed of. It will not make any difference to me whether each proof is signed and dated 1923 or whether they are simply signed without date. If this suggestion appeals to you I should be glad to have you send me a set through Durand-Ruel, at your own price.

Mary Cassatt's writing became ever more difficult to decipher and because of her near blindness was often repetitive and inaccurate. In a letter to Mr. Weitenkampf, she recounted more of the story of her prints:

MESNIL-BEAUFRESNE
MESNIL-THÉRIBUS (OISE)

MY DEAR MR. WEITENKAMPF

Your letter interests me greatly for reasons I must explain. It is connected with (what) a story which gave me much pain.

When I went to Paris from spending the summer here the last day of October 1923, my maid told me she had been arranging

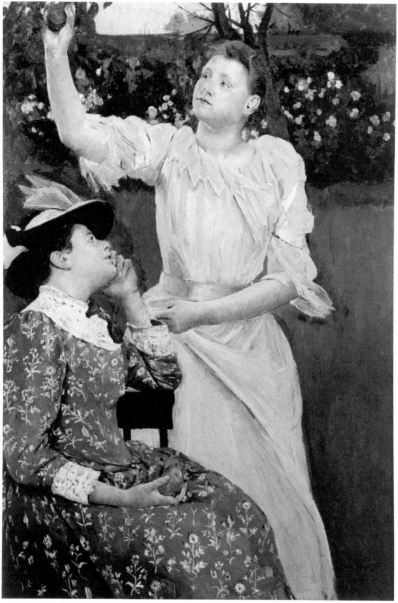

*Plate 17*  COURTESY MUSEUM OF ART, CARNEGIE INSTITUTE, PITTSBURGH

"Young Women Picking Fruit" (1891)
(oil—51½" high, 36" wide)

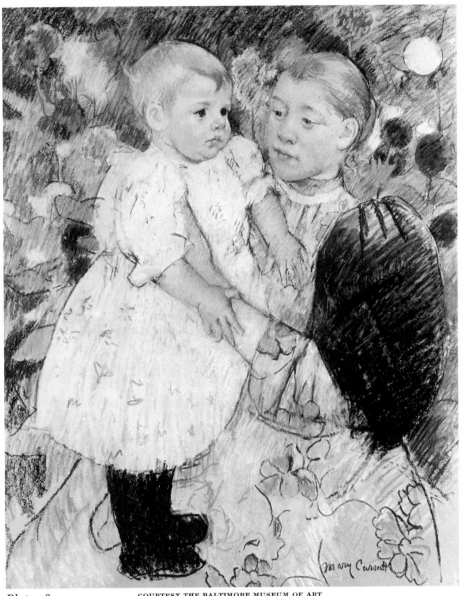

*Plate 18*

"In the Garden" (1893)
(pastel—28¾" high, 23⅝" wide)

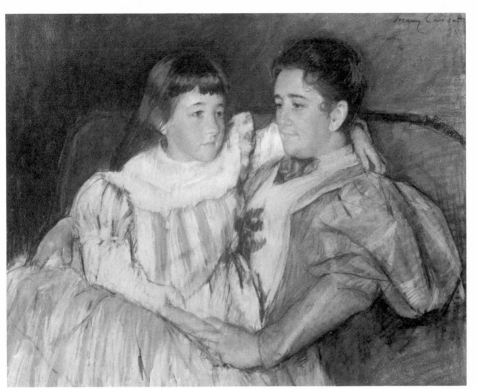

*Plate 19*

"Mrs. Havemeyer and Her Daughter Electra" (1895)
(pastel—24″ high, 30½″ wide)

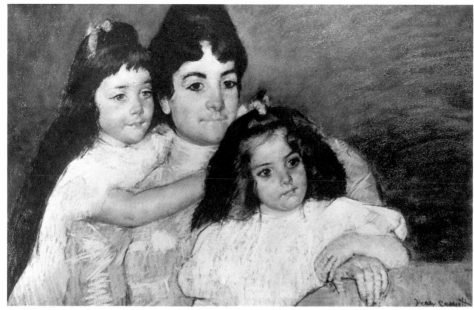

*Plate 20*

"Madame A. F. Aude and Her Two Daughters" (*ca.* 1899)
(pastel—21⅜" high, 31⅞" wide)

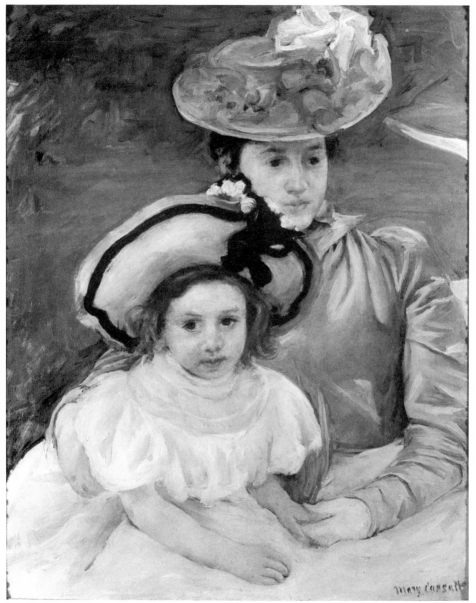

*Plate 21*

*"Fillette au Grand Chapeau"* (1901)
(oil—31¼″ high, 26″ wide)

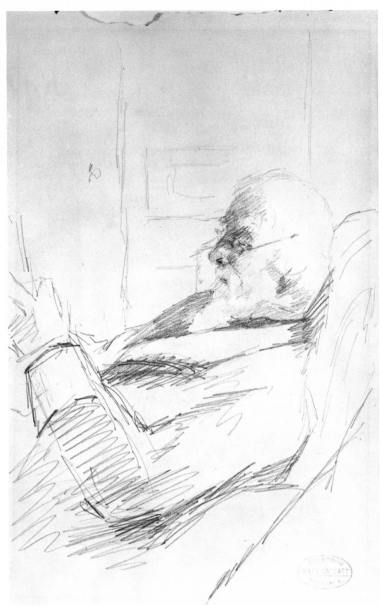

*Plate 22*

"Portrait of Her Father" (*ca.* 1880–85)
(pencil—8⅞″ high, 5½″ wide)

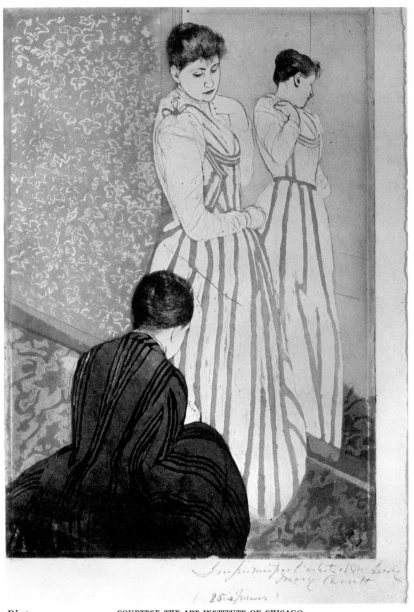

*Plate 23*

"The Fitting" (1891)
(aquatint, dry point, and soft ground—14⅞″ high, 10⅛″ wide)

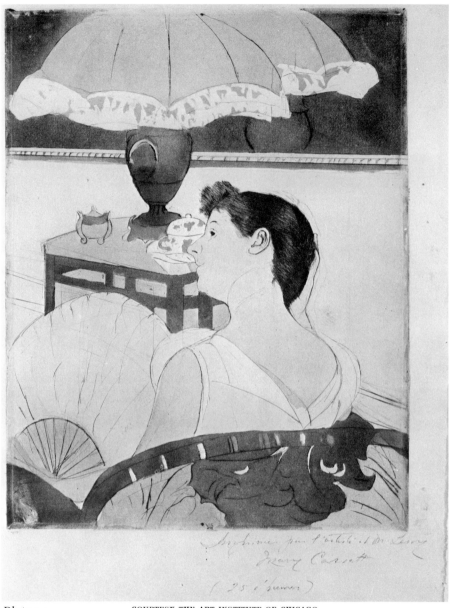

*Plate 24*

COURTESY THE ART INSTITUTE OF CHICAGO
(MARTIN A. RYERSON COLLECTION)

"The Lamp" (1891)
(aquatint, dry point, and soft ground—12¾″ high, 10″ wide)

the closet in my painting room and had found a pile of plates, some few not having been used, the majority having work on them. I was not able to distinguish the work on account of the reflection on the copper. That evening Mr. George Biddle came to see me and I showed him the plates. He told me that there was a great deal and advised me to have them printed for they had never been printed.

I took them to Delâtre whose Father printed all you have of my aquatints, soft ground etchings and some drypoints.

Delâtre who knows my work well was delighted with the work, especially with the lightness and the sketchy quality of the work. We found that there were 25 plates in the number, an aquatint of my Mother of which a few proofs had been printed. I explained this when [they] printed the set. I then sent two sets to New York and asked a friend to show them to Mr. Ivins and to tell him the circumstance. The most the plates would produce was nine,[2] the plates are not steeled. My astonishment was great when I was told that Mr. Ivins accused me of having already published these plates and that if these plates were sold I must not ask more than the originals were sold at Roger Marx sale in 1914. He accused my maid and friend of having brought these to me not having taken the trouble to verify.

I had already left for Grasse where I got this letter. The blow was indeed severe. In Paris the proofs had been seen by many amateurs and etchers. When I got back to Paris I saw Delâtre and showed him the seven photographs which Mr. Ivins had sent me to prove that all the 25 proofs were old prints. Delâtre said these photos prove nothing. There might be a whole set even but I don't think that. But there might be—one must make allowance for "des fautes." I printed all these plates and I know they are first states.

I sent to my friend to send back the two sets that were in New York at once and when they got to Paris they had to be seen by

[2] For supposedly unused plates to be able to produce only nine impressions seems almost an admission that they had already been printed from, as it was not at all unusual for Mary Cassatt to print editions of twenty-five.

an expert and a value fixed. When the expert M. Lois Pettanel [saw them] he said I have never seen these, I have a vague recollection of one or two sets (as that). Mr. Delteil is to write a letter to say what he thinks and then I consider that I have done all I can to protect my reputation. After all I am not under the jurisdiction of Mr. Ivins nor are the Museums of France under the jurisdiction of New York.

Now I must end this long letter which I hope has not tired too [much] to decipher. Not any of the plates have been kept, all have been destroyed but the set of the Petit Palais is not a full set. There are 20 of my prints. I should like to give you such a set.

I have always been so glad that my first work was left by Mr. Avery to the Library. As to names, I consider that my work was in studies of childhood and infancy, it could not have another name. Excuse my scribling with this long letter. I wish you were to be here this summer and would come to see me.

MARY CASSATT

In April, 1924, Mary Cassatt's niece Ellen Mary was married to Horace Hare, and they went abroad on their honeymoon. They visited her aunt at the Rue de Marignan and were superbly entertained along with the Adolph Bories from Philadelphia. At the end of May, Mary Cassatt left for Château de Beaufresne, and in June Horace Hare was taken to the American Hospital at Neuilly-sur-Seine for a mastoid operation. When he got well, they visited at Beaufresne, then returned home in September.

On September 20, 1924, Mary Cassatt wrote her niece Minnie from Beaufresne telling her of the illness and the visits of Horace Hare. She went on to say:

I have given up my villa at Grasse, when I got back from Grasse in the spring I found I had high pressure and one week out here reduced me to normal.

She wrote again in November that she would spend the winter in Paris, saying: "I have had electric light put in the apartment." Up to this time, only a year and a half before Mary Cassatt's

death, lamps and candles with a primitive gas arrangement had been used in the dining room.

Mary Cassatt's life went very much by routine, and she would allow for no change in her accustomed mode. Her chauffeur, Armand Delaporte (Plate 2d), recalls her motoring habits.

"Mademoiselle had only the one automobile from 1906–1926, a 20 horsepower Renault landau, license number of the car registered in Oise 702–1–3. She enjoyed and expected a daily drive, regardless of the weather as she was never cold. She insisted that the car be in a running order and would not allow a breakdown. She would not permit this despite the severe blindness with which she was afflicted. She was keenly aware of the places in which she was to the point that one day February, 1925, Miss Cassatt severely reproached me for having changed the route which we were accustomed to take to Saint Cloud."

Two letters to a cousin, Mary Gardner Smith, written within a year of Mary Cassatt's death in very coarse handwriting show that she was an embittered and sickly old woman:

MESNIL-BEAUFRESNE
MESNIL-THÉRIBUS (OISE) [1925]

MY DEAR MARY, Of course I had your letter but I never thought of answering it. If you knew what my life was you would not expect it ever. Ever since my mother's death thirty years ago I have been alone, carrying on this place and working here at my art.

Of course I have been better known as an artist in France than in the U.S.

If you would like to write to me anything (?) that you think I would [enjoy], I shall always be glad to know it but I am a very busy woman. Most of my correspondence is done in French through my maid who is French, she has been with us 43 years therefore is a member of the family.

In the meantime I send you my kindest regards and hope that next spring if I am well enough you will come out and see me. I had my three nephews and one niece here this last summer.

Ellen Mary has a daughter born Sept. 9th. Eugenia also is very happy married to Charles Davis.

<div align="right">Affectionately yours,<br>
MARY CASSATT</div>

MESNIL-BEAUFRESNE
MESNIL-THÉRIBUS (OISE) [1925]

~~~ MY DEAR MARY, I sent you a few lines which ended very abruptly. I had a sudden stoppage of circulation and could go no further. I am better now and send forth my excuses. Affectionate cousin, MARY CASSATT. Enclosed some violets from Beaufresne.

Eye operations had proved of only slight benefit to Mary Cassatt's sight and the favorable results so optimistically promised by the doctors only piled one disappointment upon another. In the spring of 1926, Mary Cassatt had her eighty-second birthday and was fearful of death, although she had every wish to live. Nearly blind, seriously ill, she became a crumpled old lady (Plate 6), embittered by loss of sight, outraged by the futility of the war, and disgusted by the political events which followed. Shortly before her death a young cousin of hers, Anna Newbold, came to see her, hoping to cheer her, but unfortunately Mary Cassatt's mind had begun to wander. To Anna's great confusion, Mary Cassatt took her for her Grandmother Scott, dead some twenty years. Although no other members of her family were abroad at the time, Mary Cassatt was well cared for by devoted servants during her last days.

At the time of her death, she still had the faithful Mathilde, with her forty-four years, also Hulda Surbeck as cook and Marthe Brune as chambermaid. She died at Château de Beaufresne resting on the arm of Armand Delaporte, her chauffeur, at eight o'clock in the evening on June 14, 1926.

M. Delaporte described her last days and her funeral. His letter in translation reads:

~~~ For a long time Miss Cassatt had diabetes which imposed on her a most severe regime which she observed rigorously. She

had a great desire to get well and to live. Mlle had given orders in case of her death, to open a vein. This was done by Dr. Gillet of Auneuil (Oise). Miss Cassatt was buried at Mesnil-Théribus in the family vault, the care of which I have taken upon myself, out of gratitude, during the time that I continue to live. In this tomb are placed her father, her mother, her brother, her sister of whom I shall add the names and dates. I have not spoken of the burial service but it may be useful for you to know about it. Miss Cassatt had a most imposing ceremony (of the protestant religion) with military honors in view of her Legion of Honor and accompanied by the Mesnil-Théribus band. She had a splendid turnout and quantities of lovely roses. The day of her burial the weather was sullen gray and raining but during the funeral procession there was a clearing.

The family vault has on it:

> Sepulture de la Famille Cassatt
> Native de Pennsylvanie
> Etats-Unis de l'Amerique

Louis Moinson, who had been one of her doctors, as well as a close friend, wrote of her:

C'était un grand peintre qui n'a vécu que pour son art. Les dernières années on été extrémement pénibles et doulour-euses car elle ne pouvait plus travailler, étant devenue presque complétement aveugle. Cette cruelle infirmité n'avait rien changé à son charactère resté doux et charitable jusqu'à son dernier jour.

Mary Cassatt's death was reported with varying inaccuracies. *The Philadelphia Inquirer* ran headlines: "Mary Cassatt Dies in Paris Home." The story continued:

Miss Mary Cassatt, considered by the critics of two continents one of the best women painters of all time, a member of the prominent Philadelphia family, died on Monday, in her chateau near Paris.

They gave her age as eighty-one. With greater accuracy the *Public Ledger* reported:

> Miss Mary Stevenson Cassatt, one of Pennsylvania's greatest artists and a sister of the late Alexander J. Cassatt, president of the Pennsylvania Railroad, is dead at Mesnil-Théribus, Department of Oise, France, friends here were informed yesterday. She was in her 83rd year.

Further details are full of errors such as the statement that "she had lived in Europe since 1875 after graduating from the Pennsylvania Academy of the Fine Arts." It was also stated that "in France she studied under Manet, and Degas and also with Renoir." The *Evening Bulletin* repeated much of the same and showed reliance for detail on Segard, Mary Cassatt's unreliable biographer.

More sound criticism was found in the editorial in the New York *Herald Tribune*:

> In 1874 Degas was walking through the Salon with his friend Tourny when the latter paused and asked him to look at a certain portrait. "That is genuine," was the master's comment. "There is one who does as I do." The portrait was painted by Mary Cassatt, the distinguished American artist whose death at an advanced age has just been reported in the dispatches. She was a remarkable woman, the comrade of those painters who under the banner of Impressionism achieved something like a revolution in modern art. The mot of Degas makes perhaps the best epitaph upon her whole career—"That is genuine." At the close of the famous exhibition of 1879 in which she and the others affirmed their independence there was a surplus in the treasury. With her share of it Miss Cassatt bought pictures by Degas and Monet. That, too, was like her. She lived utterly for art.
>
> She had the gift, the flair, but it took time before she found herself. Going abroad while she was still a young girl to be a painter, she strayed momentarily into the studio of Charles Chaplin, a graceful Salonier. Against his routine habit she promptly rebelled and sought instead the inspiration of the old masters. Rather coldly she found it first at Parma. This keen observer,

this practitioner of an essentially French and modern directness, whose tenderness never lured her away from the exact statement of fact, actually began her apprenticeship by long saturation in the melting Correggiosity of the Correggio. After Italy came Spain, but with a susceptibility to Rubens rather than to Velazquez in the stimulating pageant of the Prado, a susceptibility so ardent that it ultimately carried her to Antwerp and intense devotion to the works of the great Fleming. Yet these initiations were but preliminaries to the decisive development of her talent. That opened in Paris. The truth was her goal, and the newer French exemplars of it were her predestined counselors. She once told M. Segard, her biographer, what they meant to her. "I recognized my true masters," she said, "I admired Manet, Courbet and Degas. I hated conventional art. Now I began to live." The important point about this period in her life too, is that she "began to live" as an individuality. Her associations never submerged her originality. There was an organic energy in her art. Even on what was in a sense her real debut, in 1879, Gauguin could shrewdly say of her, "Miss Cassatt has much charm, but has more force." That force lifted her to high rank. It was as an equal that she foregathered with the Impressionist group. She and Degas were colleagues. It is an amusing paradox in her history that her force, her penetrating vision, her technical dexterity, were wreaked largely upon the most fragile of themes. She excelled in pictures of children and their mothers. But her sentiment couldn't have drifted into sentimentality. She had too lively a mind. She had too much taste. Apropos of her taste, it should be added that she was a most judicious connoisseur and had to do with the entrance of numerous fine pictures into divers American collections, private and public. Her judgment on a work of art was impeccable.

It is hard to think of her as gone from her French environment. For years she had seemed one of the permanent figures of an epoch. It is as such, indeed, that she will be long remembered.

An unidentified French paper published her obituary:

### Mary Cassatt est morte

La peintre Mary Cassatt vient de mourir dans son château de Mesnil-Beaufresne (Oise). Nous perdons une grande artiste en

même temps qu'une femme de haute distinction morale et intellectuelle.

Mary Cassatt appartenait à l'Amerique par sa naissance, mais elle appartenait à la France par son talent et la formation de son esprit.

Toute sa vie, depuis sa première jeunesse, elle l'a passée en France, à Paris. C'est auprès des maîtres tels que Manet, Degas, Raffaëlli, Bartholomé, qu'elle se forma. Aucune artiste n'a rendu comme elle l'âme de l'enfant et de la Mère.

Depuis six ans, elle ne peignait plus, ayant à peu près perdu la vue; mais sa vive intelligence était demeurée intacte.

Elle s'intéressait à tous les problèmes politiques et sociaux et en discutait avec ferveur.

Mary Cassatt, despite living abroad, was enabled to keep her legal residence in Philadelphia. On July 18, 1911, she made her will, in which she left most of her property to the three children of her brother Gardner. To Ellen Mary Cassatt (Mrs. Horace Binney Hare) she left Château de Beaufresne and all its contents. To Eugenia Cassatt (Mrs. Percy Madeira) and her brother Gardner she left the contents of her Paris apartment and all of her money—share and share alike. She left one picture[3] to her grand-nephew, Anthony Drexel Cassatt, a screen to Mrs. Havemeyer, and fifty dollars a month for life as well as a picture or article of jewelry to Mathilde.

Over the years Mary Cassatt had given various items such as pastels, oil sketches, and prints to Mathilde and often used to say, "Here, Taudy, you can have this; it's no good." Mathilde's rooms at Beaufresne and on the Rue de Marignan were covered with such things tacked to the walls and unframed. After Miss Cassatt's death, not wishing to be identified, Mathilde, under the name of "Mademoiselle X" held a sale on March 30, 1927, at the Hotel Drouot in Paris. There were ninety-one oils, pastels, and water colors, ten prints, and thirty-five crossed-out proofs taken from cancelled plates. All items had on them a blue stamp: "Vente/ Collection Mlle X/ 30 Mars 1927/ Mary Cassatt."

[3] He selected a fan painted by Camille Pissarro.

At a later date, probably in 1939, a second sale of things owned by Mathilde was held. As there was no catalogue, the details are not known except that each item was stamped "Collection/ Mary Cassatt/ Mathilde X . . . ."

Mrs. Horace B. Hare sold Mary Cassatt's collection of Japanese prints at auction at the Kende Galleries, New York, on April 18, 1950. In 1961, Mrs. Hare gave Château de Beaufresne to the Foyer de l'Enfance du Moulin Vert to be used as a children's home for the region of Mesnil-Théribus. The dedication ceremonies and an exhibition of Mary Cassatt's work took place June 12, 1965, with Mrs. Hare and other members of the Cassatt family present.

# Epilogue

MARY CASSATT'S VISION was directed toward the general rather than the particular and in this basic concept lay her strength. She avoided the topical, the particularizing, the specific qualities of one individual, and she thus escaped triviality or sentimentality. In declining to execute commissioned portraits, she was never in the position of having to compromise with a sitter. Those who posed for her were members of her family, friends, or paid models—all of whom were of necessity submissive to her feelings and her wishes concerning how a painting should be conceived. Her work is then always highly personal and is solely her interpretation of the subject at hand. Period settings and details of costume take a secondary place in her compositions where the basic spirit or mood predominates, with the result that her paintings are never slavish documents of a particular epoch. It is a tribute to her supreme artistic sense that a woman so forceful and dynamic could produce paintings so sensitive, so feminine, and so deeply felt. She had the ability of a truly well-disciplined person to direct her creative powers into the most perfectly modulated channels, where nothing was forced or overstated. As a person she was ruthlessly outspoken; as an artist she exercised perfect control. This pattern, not at all unusual among artists, musicians, or others with marked creative

ability, kept Mary Cassatt constantly intent on her work; the driving force of a strong temperament was the fuel of her creative power. Acutely discerning in her sense of quality in the paintings of others, she was able to be self-critical and, seldom completely satisfied, she strove constantly to improve. When a painting, such as the "Four Armchairs," purchased by Vollard, did seem to her entirely successful, she was deeply hurt when it was not favorably received by a jury.

Surrounded as she was in Paris by the keenest intellects of her day and by those who had the courage of independent action, she was constantly put on her mettle. Mary Cassatt thrived in this environment and was disdainful of small-minded people who followed a conventional course lacking in either imagination or creative force. Wholly dedicated to the cause of the Independents, she managed always to keep herself free from any of the restraining factors of officialdom. Untouched herself by the sterile traditions of academic painting, she in turn did not wish to impose her own personal viewpoint on anyone else, and she accepted no pupils and had no direct followers. Strong influences from Courbet, from Degas, and from Japanese prints appear in her work, but these were assimilated and reinterpreted in her own terms. No Latin herself, one could never mistake her work for that of a native of France. Her hot-blooded temperament was not Gallic emotionalism, but rather a forthright Scotch-Irish burst of temper. In fact, she regarded the French as overemotional, and would have thought of her own tirades as justifiable in taking a stand to defend her rights and opinions.

If Mary Cassatt's painting was in essence non-French, was it then truly American? She had very clearly those qualities of honesty, simplicity, and lack of pretentiousness which are considered to be American, but at the same time they are qualities bred in her from her stalwart forebears who were predominantly Dutch and Scotch-Irish. The fusion of these strains, fortuitously nurtured on American soil, produced qualities which, with the infusion of French taste, shaped her basic outlook. Other Ameri-

can artists studied in Paris in the nineteenth century, but none except Whistler had the innate creative urge which enabled Mary Cassatt to attain so eminent a place as an artist.

As a result of having matured slowly and in later life being restricted by blindness, her productive years, some thirty or so, were less in number than those of most artists who attained such an age, but, in spite of this, she has left a corpus of work—in oil, in pastel, and in various print mediums—which earns for her a position of distinction.

Mary Cassatt always showed a completely feminine touch, but she applied it with a masculine control. Never interested in landscape or still life, she was concerned entirely with people chosen from the contemporary world and always placed in a setting with which she was thoroughly familiar—an opera box, a garden, a living room, or a nursery. Her models are completely integrated with their setting and never emerge from it or assert themselves above it; thus she presents us, not with a specific personality, but with a vignette from life, people at one with their environment. They are never actors on a stage nor do they appear to be models posing—they are people at ease in the world to which they belong. Her women drinking tea reflect the friendly atmosphere of a well-bred home, and her maternal themes are convincing in their genuine tenderness. She was pleased by the fact that, despite being so non-French, she was greatly appreciated by the French; her lack of recognition at home was a source of great disappointment to her.

Most of Mary Cassatt's relatives had comparatively little interest in art and were not in the least proud of having an aunt who was an "artist." Although many of them owned paintings or prints by her, they regarded them as family mementos, and it has come as something of a surprise to them to learn that their Cassatts are worth more now than their works by Degas used to be.

If the Cassatt family were not enthusiastic over their artist-relative, they were merely reflecting the temper of their city. As early as 1878, Mrs. Robert Cassatt wrote from Paris complaining that Mary's pictures did not sell in Philadelphia despite finding

a ready market in New York. "A prophet is not without honor . . . ," she added dejectedly. Thomas Eakins kept doggedly at his painting in the old house on Mt. Vernon Street, but was scarcely recognized during his lifetime. John Sloan, George Luks, and others became known only after removal to New York. Sloan himself referred to Mary Cassatt as "a great figure in art," and he shared with her a love for Japanese prints.

Elizabeth Robins Pennel remarked in *Our Philadelphia*:

> Philadelphia, with its usual reticence and conscientiousness in preventing any Philadelphian from becoming a prophet in Philadelphia, had hidden its literary, with innumerable other lights, under a bushel.

Owen Wister had said that an "instinct of disparagement" was bred in the bones there.

Living abroad as she did, Mary Cassatt became something of a shadowy figure to those at home and was, in consequence, never fully appreciated. Logan Pearsall Smith made an apt summing up in his *Unforgotten Years*:

> It is after all fifty years since I left America, and during that period things have no doubt greatly changed. All I can say is that among my own contemporaries, those Americans who have made their home in Europe—Whistler and Henry James, Sargent and Mary Cassatt, and Mrs. Wharton—are, in my opinion, more likely to be remembered than those who stayed at home.

# Unpublished Letters

| Date | From | To | Owner |
|------|------|-----|-------|
| Nov. 17, 1860 | A. J. Cassatt | R. S. Cassatt | Mrs. J. B. Thayer |
| Dec. 21, 1861 | Eliza Haldeman | Her father | Pennsylvania Academy |
| Mar. 7, 1862 | " " | " " | " " |
| Oct. 23, 1867 | A. J. Cassatt | Lois Buchanan | Mrs. J. B. Thayer |
| Nov. 27, 1867 | " " " | " " | " " " " |
| Aug. 24, 1868 | " " " | " " | " " " " |
| Aug. 31, 1868 | Mrs. R. S. Cassatt | " " | " " " " |
| Aug. 1, 1869 | Mary Cassatt | Mrs. A. J. Cassatt | " " " " |
| Oct. 12, 1871 | A. J. Cassatt | " " " " | " " " " |
| undated [1873] | Mrs. B. R. Alden | J. Alden Weir | Mrs. G. P. Ely |
| Mar. 10, 1878 | Mary Cassatt | " " " | " " " " |
| Apr. 3, 1878 | R. S. Cassatt | E. B. Cassatt | Mrs. J. B. Thayer |
| July 2, 1878 | Mrs. R. S. Cassatt | Katherine K. Cassatt | " " " " |
| July, 1878 | " " " " | A. J. Cassatt | " " " " |
| Oct. 4, 1878 | R. S. Cassatt | " " " | " " " " |
| Nov. 22, 1878 | Mrs. R. S. Cassatt | " " " | " " " " |
| Dec. 13, 1878 | R. S. Cassatt | " " " | " " " " |
| May 21, 1879 | " " " | " " " | " " " " |
| May 26, 1879 | " " " | " " " | " " " " |
| Sept. 1, 1879 | " " " | " " " | " " " " |
| Oct. 15, 1879 | " " " | " " " | " " " " |
| Apr. 9, 1880 | Mrs. R. S. Cassatt | " " " | " " " " |
| July 10, 1880 | Mrs. A. J. Cassatt | Mrs. E. Buchanan | " " " " |
| Aug. 6, 1880 | " " " " | Harriet Buchanan | " " " " |
| Dec. 10, 1880 | Mrs. R. S. Cassatt | A. J. Cassatt | " " " " |
| Dec. 29, 1880 | " " " " | " " " | " " " " |
| Jan., 1881 | Mary Cassatt | E. B. Cassatt | " " " " |
| Apr. 18, 1881 | R. S. Cassatt | A. J. Cassatt | " " " " |
| Dec. 16, 1881 | Mrs. R. S. Cassatt | R. K. Cassatt | " " " " |
| Dec. 23, 1881 | " " " " | A. J. Cassatt | " " " " |
| Jan. 19, 1882 | R. S. Cassatt | " " " | " " " " |

| Date | From | To | Location |
|---|---|---|---|
| Feb. 5, 1882 | Mrs. R. S. Cassatt | A. J. Cassatt | Mrs. J. B. Thayer |
| Aug. 2, 1882 | R. S. Cassatt | " " " | " " " " |
| Dec. 26, 1882 | Mrs. A. J. Cassatt | Mrs. E. Buchanan | " " " " |
| May 13, 1883 | Mrs. R. S. Cassatt | Mrs. A. J. Cassatt | " " " " |
| May 16, 1883 | R. S. Cassatt | A. J. Cassatt | " " " " |
| May 25, 1883 | " " " | " " " | " " " " |
| June 1, 1883 | " " " | " " " | " " " " |
| June 15, 1883 | Mary Cassatt | Mrs. A. J. Cassatt | " " " " |
| June 22, 1883 | " " | A. J. Cassatt | " " " " |
| July 4, 1883 | Mrs. R. S. Cassatt | " " " | " " " " |
| July 16, 1883 | R. S. Cassatt | " " " | " " " " |
| July 18, 1883 | " " " | " " " | " " " " |
| July 19, 1883 | E. B. Cassatt | Mrs. A. J. Cassatt | " " " " |
| Aug. 17, 1883 | Mrs. J. G. Cassatt | " " " " | " " " " |
| Aug. 20, 1883 | R. S. Cassatt | A. J. Cassatt | " " " " |
| Oct. 14, 1883 | Mary Cassatt | " " " | " " " " |
| Nov. 18, 1883 | " " | " " " | " " " " |
| Nov. 30, 1883 | Mrs. R. S. Cassatt | " " " | " " " " |
| Jan. 5, 1884 | Mary Cassatt | " " " | " " " " |
| Feb. 15, 1884 | " " | " " " | " " " " |
| Mar. 6, 1884 | " " | " " " | " " " " |
| Apr. 17, 1884 | " " | " " " | " " " " |
| Apr. 27, 1884 | " " | " " " | " " " " |
| June 8, 1884 | R. S. Cassatt | " " " | " " " " |
| Dec. 3, 1884 | " " " | " " " | " " " " |
| Jan., 1885 | A. J. Cassatt | Mrs. A. J. Cassatt | " " " " |
| Jan., 1885 | R. K. Cassatt | " " " " | " " " " |
| Jan. 21, 1885 | Mrs. R. S. Cassatt | Katherine Cassatt | " " " " |
| Jan. 22, 1885 | A. J. Cassatt | Mrs. A. J. Cassatt | " " " " |
| Jan. 28, 1885 | Mary Cassatt | " " " " | " " " " |
| Mar. 1, 1885 | " " | " " " " | " " " " |
| July 6, 1885 | R. S. Cassatt | " " " " | " " " " |
| Sept. 21, 1885 | Mary Cassatt | A. J. Cassatt | " " " " |
| Apr. 14, 1886 | R. S. Cassatt | Mrs. A. J. Cassatt | " " " " |
| May 5, 1886 | " " " | A. J. Cassatt | " " " " |
| May 17, 1886 | Mary Cassatt | " " " | " " " " |
| Feb. 18, 1887 | R. S. Cassatt | " " " | " " " " |
| Mar. 14, 1887 | " " " | " " " | " " " " |
| undated [Fall 1888] | E. B. Cassatt | " " " | " " " " |
| undated [Fall 1888] | " " " | Mrs. A. J. Cassatt | " " " " |
| undated [ca. 1890] | Mary Cassatt | G. A. Lucas | Baltimore Museum |
| June 21, 1890 | R. S. Cassatt | A. J. Cassatt | Mrs. J. B. Thayer |
| Jan. 23, 1891 | Mrs. R. S. Cassatt | " " " | " " " " |
| July 23, 1891 | " " " " | " " " | " " " " |
| 1892 [Summer] | Mary Cassatt | Mrs. M. F. MacMonnies | Art Institute of Chicago |
| July, 1892 | " " | Sara Hallowell | " " " |
| Sept. 10, 1892 | " " | Mrs. Potter Palmer | " " " |
| 1892 [Fall] | Mrs. R. S. Cassatt | Mrs. A. J. Cassatt | Mrs. J. B. Thayer |
| Oct. 11, 1892 | Mary Cassatt | Mrs. Potter Palmer | Art Institute of Chicago |

| | | | |
|---|---|---|---|
| Dec. 1, 1892 | Mary Cassatt | Mrs. Potter Palmer | Art Institute of Chicago |
| Feb., 1894 | Sara Hallowell | " " | " " " |
| July 28, 1895 | Vernon Lee | C. Anstruther-Thomson | Miss I. C. Willis |
| Apr. 7, 1900 | Mary Cassatt | Mrs. A. A. Pope | Hill-Stead Museum, Farmington, Conn. |
| undated [*ca.* 1900?] | Mary Cassatt | Ambrose Vollard | Archives of American Art |
| Jan. 9, 1903 | " " | Samuel P. Avery | Brooklyn Museum |
| March, 1903 | " " | Mrs. A. A. Pope | Hill-Stead Museum |
| Apr. 21, 1903 | " " | Theodate Pope | " " " |
| Oct., 1903 | " " | " " | " " " |
| Nov., 1903 | " " | " " | " " " |
| Feb. 15, 1904 | Harrison Morris | Mary Cassatt | Pennsylvania Academy |
| Mar. 2, 1904 | Mary Cassatt | Harrison Morris | " " |
| Apr. 28, 1904 | " " | Carroll Tyson | Philadelphia Museum |
| July 11, 1904 | " " | " " | " " |
| July 14, 1904 | " " | Mrs. R. K. Cassatt | A. J. Cassatt |
| Aug. 29, 1904 | " " | Harrison Morris | Pennsylvania Academy |
| Nov. 11, 1904 | " " | Mrs. Robert Cassatt | A. J. Cassatt |
| Dec. 4, 1904 | " " | W. M. French | Art Institute of Chicago |
| Jan. 22, 1905 | " " | Carroll Tyson | Philadelphia Museum |
| Jan. 23, 1905 | " " | " " | " " |
| Mar. 17, 1905 | " " | W. M. French | Art Institute of Chicago |
| Feb. 2, 1906 | " " | Mrs. R. K. Cassatt | A. J. Cassatt |
| Feb. 24, 1906 | G. Durand-Ruel | W. M. French | Art Institute of Chicago |
| Mar. 7, 1906 | C. L. Hutchinson | " " " | " " " |
| May 18, 1906 | Mary Cassatt | F. Weitenkampf | N. Y. Public Library |
| Sept., 1906 | " " | Mrs. R. K. Cassatt | A. J. Cassatt |
| Feb. 26, 1907 | " " | " " " " | " " " |
| Oct. 3, 1907 | " " | R. K Cassatt | " " " |
| Dec. 13, 1907 | " " | Mrs. R. K. Cassatt | " " " |
| May 4, 1908 | " " | Carroll Tyson | Philadelphia Museum |
| Dec. 22, 1908 | " " | " " | " " |
| Jan. 15, 1909 | " " | Electra Havemeyer | Webb Estate |
| May 27, 1909 | " " | Mrs. J. W. Webb | " " |
| Nov. 11, 1909 | " " | Carroll Tyson | Philadelphia Museum |
| Dec. 23, 1910 | " " | Theodate Pope | Hill-Stead Museum |
| Feb. 19, 1911 | " " | " " | " " " |
| Apr. 28, 1911 | " " | Emily Batchelder | Mrs. J. B. Thayer |
| Feb. 5, 1915 | " " | Mrs. R. K. Cassatt | A. J. Cassatt |
| June 8, 1915 | " " | Theodate Pope | Hill-Stead Museum |
| July 8, 1915 | " " | H. Whittemore | H. Whittemore, Jr. |
| Oct. 19, 1915 | " " | Cecilia Beaux | F. A. Sweet |
| Dec. 28, 1915 | " " | Mrs. R. K. Cassatt | A. J. Cassatt |
| Sept. 28, 1917 | " " | George Biddle | George Biddle |

| | | | |
|---|---|---|---|
| undated [1919] | Mary Cassatt | Mrs. Jane Miller | Mrs. Jane Miller |
| Sept., 1921 | " " | Lois Thayer | Mrs. J. B. Thayer |
| Dec. 11, 1921 | " " | Mrs. J. M. Sears | Mrs. C. Bradley |
| May 12, 1924 | " " | H. Whittemore | H. Whittemore, Jr. |
| May 26, 1924 | H. Whittemore | Mary Cassatt | " " " |
| June, 1924 | Mary Cassatt | H. Whittemore | " " " |
| Sept. 20, 1924 | " " | Mrs. R. K. Cassatt | A. J. Cassatt |
| Nov. 27, 1925 | " " | F. Weitenkampf | N. Y. Public Library |
| undated [1925] | " " | M. G. Smith | Gilman's Old Books, Crompond, N. Y. |
| undated [1925] | " " | " " " | " " " |
| Aug. 17, 1952 | Armand Delaporte | F. A. Sweet | F. A. Sweet |
| Dec. 14, 1952 | Homer Saint-Gaudens | " " " | " " " |
| Oct. 11, 1954 | Anna Ingersoll | " " " | " " " |
| Nov. 16, 1955 | Paul L. Grigaut | " " " | " " " |

# Printed Sources

## BOOKS

Bazin, Germain. *L'Epoque Impressionniste*. Paris, 1947.

Biddle, George. *An American Artist's Story*. Boston, 1939.

Boggs, Jean Sutherland. *Portraits by Degas*. Berkeley and Los Angeles, 1962.

Breeskin, Adelyn D. *The Graphic Work of Mary Cassatt, a catalogue raisonné*. New York, 1948.

Breuning, Margaret. *Mary Cassatt*. New York [1944].

Burr, Anna Robeson. *Portrait of a Banker*. New York, 1927.

Cortissoz, Royal. *American Artists*. New York and London, 1923.

[Degas, Edgar.] *Degas Letters*. Translated by Marguerite Kay, edited by Marcel Guérin. Oxford [1947].

Degas, Edgar. *Huit Sonnets d'Edgar Degas*. [Paris, 1946.]

Delteil, Loys. *Le Peintre-Graveur Illustré, Edgar Degas*, Tome 9, Nos. 29 and 30. Paris, 1919.

Dewhurst, Wynford. *Impressionist Painting, Its Genesis and Development*. London, 1904, 75–77.

Elliott, Maud Howe (editor). *Art and Handicraft in the Woman's Building of the Worlds Columbian Exposition Chicago, 1893*. Paris and New York, 1893.

Gimpel, René. *Journal d'un collectionneur, Marchand de tableaux*. [Paris], 1963.

Halévy, Daniel. *My Friend Degas.* Translated and edited by Minna Curtiss. Middletown, Connecticut [1964].

Havemeyer, Louisine W. *An Address delivered by Mrs. H. O. Havemeyer at Loan Exhibition* [at M. Knoedler and Co.], Tuesday, April 6, 1915.

———. *Sixteen to Sixty, Memoirs of a Collector.* New York, 1930.

Huysmans, J. K. *L'Art Moderne.* Paris [1883].

Isham, Samuel. *The History of American Painting.* New edition with supplementary chapters by Royal Cortissoz. New York, 1927.

Jewell, Edward Alden, and Aimée Crane. *French Impressionists and Their Contemporaries Represented in American Collections.* New York [1940].

Lemoisne, Paul-André. *Degas et Son Oeuvre.* 4 vols. Paris [1946].

———. *Degas et Son Oeuvre.* Paris [1954].

Mauclair, Camille. *The French Impressionists (1860–1900).* Translated by P. G. Konody. London and New York [1903].

[Morisot, Berthe.] *Correspondance de Berthe Morisot.* Edited by Denis Rouart. Paris [1950].

[Pissarro, Camille.] *Camille Pissarro Letters to His Son Lucien.* Edited by John Rewald. New York, 1943.

Plowden, Helen Haseltine. *William Stanley Haseltine.* London [1947].

Rewald, John. *The History of Impressionism.* New York [1961].

Richardson, Edgar P. *Painting in America.* New York [1956], 280.

Saint-Gaudens, Homer. *The American Artist and his Times.* New York, 1941, 193–95.

Segard, Achille. *Un peintre des enfants et des mères, Mary Cassatt.* Paris, 1913.

Smith, Logan Pearsall. *Unforgotten Years.* Boston, 1939.

Valerio, Edith. *Mary Cassatt.* Paris, 1930.

Venturi, Lionello. *Les Archives de l'Impressionnisme.* Vol. 2. Paris and New York, 1939, 114–38.

Vollard, Ambroise. *Recollections of a Picture Dealer.* London [1936].

Walker, John. *French Paintings from the Chester Dale Collection.* Washington, 1953, 49–54.

Walton, William. *Art and Architecture, World's Columbian Exposition.* Philadelphia [1893–1895].

Watson, Forbes. *Mary Cassatt.* American Artists Series, Whitney Museum of American Art. New York [1932].

Wilenski, R. H. *Modern French Painters.* [London, 1944.]

## ARTICLES

Alexandre, Arsène. "Miss Mary Cassatt Aquafortiste," *La Renaissance,* Tome 7 (mars, 1924), 127–33.

———. "Portraits et Figures de Femmes—Ingres à Picasso," *La Renaissance,* Tome 11 (juillet, 1928), 258–308.

———. "La Collection Havemeyer et Miss Cassatt," *La Renaissance,* Tome 13 (fevrier, 1930), 51–56.

Biddle, George. "Some Memories of Mary Cassatt," *The Arts,* Vol. X (August, 1926), 107–11.

"A Big Baltimore Show Reviews Curious Case of Mary Cassatt," *Life,* Vol. XII (January 19, 1942), 54–57.

Brinton, Christian. "Concerning Miss Cassatt and Certain Etchings," *International Studio,* Vol. XXVII (February, 1906), *i–vii.*

Brownell, William C. "The Young Painters of America," Part III, *Scribner's Monthly,* Vol. XXII, No. 3 (July, 1881), 321–34.

Cary, Elisabeth Luther. "The Art of Mary Cassatt," *The Scrip,* Vol. I, No. 1 (October, 1905), 1–5.

Custer, A. "Archives of American Art," *Art Quarterly,* Vol. XVIII, No. 4 (1955), 391.

Denoinville, Georges. "Mary Cassatt Peintre des Enfants et Des Mères," *Byblis,* septième année (hiver, 1928), 121–23.

Duranty, Louis E. E. "La Chronique des Arts et de la Curiosité," *Supplement à la Gazette des Beaux-Arts,* No. 16 (19 avril, 1879), 126–28.

"Etchings given to Petit Palais," *Art News,* Vol. XXII (April 12, 1924), 4.

Grafly, Dorothy. "In Retrospect—Mary Cassatt," *American Magazine of Art*, Vol. XVIII (June, 1927), 305–12.

Havemeyer, Louisine W. "The Cassatt Exhibition," *The Pennsylvania Museum Bulletin*, Vol. XXII, No. 113 (May, 1927), 373–82.

Henrotin, Ellen M. "Outsider's View of the Woman's Exhibit," *The Cosmopolitan*, Vol. XV, No. 5 (September, 1893), 560.

Hess, Thomas B. "Degas-Cassatt Story," *Art News*, Vol. XLVI (November, 1947), 18–20ff.

Hoebner, Arthur. "Mary Cassatt," *Century*, Vol. LVII (March, 1899), 740–41.

Hyslop, F. E., Jr. "Berthe Morisot and Mary Cassatt," *College Art Journal*, Vol. XIII, No. 3 (Spring, 1954), 179–84.

Johnson, Una E. "Graphic Art of Mary Cassatt," *American Artist*, Vol. IX (November, 1945), 18–21.

Lafenestre, Georges. "Les Expositions d'Art," *Revue des Deux Mondes*, Tome 33, 2 ème Période (mai–juin, 1879), 478–85.

Leeper, John P. "Mary Cassatt and Her Parisian Friends," *Bulletin of the Pasadena Art Institute*, No. 2 (October, 1951), 1–9.

Lowe, Jeanette. "The Women Impressionist Masters: Important Unfamiliar Works by Morisot and Cassatt, Exhibition held at Durand-Ruel," *Art News*, Vol. XXXVIII (November 4, 1939), 9.

McChesney, Clara. "Mary Cassatt and Her Work," *Arts and Decoration*, Vol. III (June, 1913), 265–67.

"Mary Cassatt's Achievements: Its Value to the World of Art," *Craftsman*, Vol. XIX (March, 1911), 540–46.

"Mary Cassatt Dies in France," *Art News*, Vol. XXIV (June 19, 1926), 1.

Mauclair, Camille. "Un Peintre de l'Enfance, Miss Mary Cassatt," *L'Art Décoratif*, Tome 8, No. 47 (août, 1902), 177–85.

Mellerio, André. "Mary Cassatt," *L'Art et les Artistes*, Tome 12 (novembre, 1910), 69–75.

———. "Exposition Mary Cassatt, Gallery Durand-Ruel, Paris, November–December 1893," translated by Eleanor B. Caldwell, *Modern Art*, Vol. III, No. 1 (Winter, 1895), 4–5.

Pica, Vittorio. "Artisti Contemporanei—Berthe Morisot e Mary Cassatt," *Emporium*, Vol. XXVI, No. 3 (Gennario, 1907), 11–16.

RamBaud, Yveling. "Miss Cassatt," *L'Art dans les Deux Mondes*, Tome 1, No. 1 (22 novembre, 1890), 7.

Shapley, John (Editor-in-Chief). "Mary Cassatt—Painter and Graver, 1845–1926," *Index of 20th Century Artists*, Vol. II, No. 1 (October, 1934), 1–8.

————. "Mary Cassatt," *Index of 20th Century Artists*, Supplementary Issue, Vol. II, No. 12 (September, 1935), *i–ii*.

————. "Mary Cassatt," *Index of 20th Century Artists*, Supplementary Issue, Vol. III, Nos. 11–12 (August–September, 1936), *iv*.

Sweet, Frederick A. "A Château in the Country," *The Art Quarterly*, Vol. XXI, No. 2 (Summer, 1958), 202–15.

————. "America's Greatest Woman Painter: Mary Cassatt," *Vogue*, Vol. CXXIII, No. 3 (February 15, 1954), 102–103ff.

Tabarant, Adolphe. "Les Disparus—Miss Mary Cassatt," *Bulletin de la Vie Artistique*, 7ème année (juillet, 1926), 205–206.

Teall, Gardner. "Mother and Child, The Theme as Developed in the Art of Mary Cassatt," *Good Housekeeping Magazine*, Vol. L, No. 2 (February, 1910), 141.

"Une Rétrospective de Mary Cassatt," *Art et Décoration*, Tome 60, suppl. (juillet, 1931), 3–5.

Utrillo, M. V. "Exposición de Bellas Artes, celebrada en Barcelona," *Forma*, Vol. II, No. 20 (1907), 281–318.

————. "La Pintura. V. Exposición Internacional de arte de Barcelona," *Forma*, Vol. II, No. 21 (1907), 325–60.

Visson, A. "Exposition Galerie Wildenstein, New York," *Arts*, No. 141 (21 novembre, 1947), 8.

Walton, William. "Miss Mary Cassatt," *Scribner's Magazine*, Vol. XIX, No. 3 (March, 1896), 353–61.

Watson, Forbes. "Mary Cassatt," *The Arts*, Vol. X (July, 1926), 3.

————. "Philadelphia Pays Tribute to Mary Cassatt," *The Arts*, Vol. XI (June, 1927), 289–97.

Weitenkampf, Frank. "The Drypoints of Mary Cassatt," *Print Collector's Quarterly*, Vol. VI (December, 1916), 397–409.

———. "Some Women Etchers," *Scribner's Magazine*, Vol. XLVI, No. 6 (December, 1909), 731–39.

Welch, M. L. "Mary Cassatt," *American Society Legion of Honor Magazine* (Summer, 1954), 155–65.

Weller, A. S. "Expatriates Return," *Art Digest*, Vol. XXVIII (January 15, 1954), 6–7ff.

White, Frank Linstow. "Younger American Women in Art," *Frank Leslie's Popular Monthly*, Vol. XXXVI (November, 1893), 538–44.

## CATALOGUES

1891 Durand-Ruel, Paris. Exposition de Tableaux, Pastels et Gravures par Mlle Mary Cassatt, avril, 1891.

1893 Durand-Ruel, Paris. Exposition Mary Cassatt, novembre–decembre, 1893.

1895 Durand-Ruel, New York. Exposition of Paintings, Pastels and Etchings by Mary Cassatt, April 16–30, 1895.

1908 Durand-Ruel, Paris. Tableaux et Pastels par Mary Cassatt, 3–28 novembre, 1908.

1914 Durand-Ruel, Paris. Tableaux, Pastels, Dessins et Pointes-sèches par Mary Cassatt, 8 juin–27 juin, 1914.

1915 M. Knoedler and Company. Suffrage Loan Exhibition of Old Masters and Works by Degas and Cassatt, April 7–24, 1915.

1926–27 The Art Institute of Chicago. Memorial Collection of the Works of Mary Cassatt, December 21, 1926–January 24, 1927.

1928 Smith College Museum of Art. Memorial Exhibition of the Works of Mary Cassatt, January 4–25, 1928.

1928 Carnegie Institute, Pittsburgh. A Memorial Exhibition of the Work of Mary Cassatt, March 15–April 15, 1928.

1931 Galerie A.-M. Reitlinger, Paris. Dessins, Pastels, Peintures, Études par Mary Cassatt, 19 mai–30 juin, 1931.

1935 Durand-Ruel, New York. Exhibition of Paintings and Pastels by Mary Cassatt, February 11–March 2, 1935.

1936 Baltimore Museum of Art. An Exhibition of Pastels, water-colors, pencil drawings, soft-ground etchings, aquatints, color prints, dry-points, etc. by Mary Cassatt, January 7–February 10, 1936.

1941–42 Baltimore Museum of Art. Mary Cassatt, November 28, 1941–January 11, 1942.

1947 Wildenstein Gallery, New York. A Loan Exhibition of Mary Cassatt, October 29–December 6, 1947.

1953 Marlborough Fine Arts Ltd., London. Mary Cassatt, June–July, 1953.

1953 Munson-Williams-Proctor Institute, Utica. Expatriates–Whistler, Cassatt, Sargent, Bulletin, January 4–25, 1953, 1–4.

1954 Sweet, Frederick A. Sargent, Whistler and Mary Cassatt, The Art Institute of Chicago, January 14–February 25, 1954.
The Metropolitan Museum of Art, March 25–May 23, 1954.

1959–60 Centre Culturel Américain, Paris. Mary Cassatt, 25 novembre, 1959–10 janvier, 1960.

1964 The Renaissance Society at the University of Chicago. An Exhibition of Etchings by Edgar Degas with an introduction and notes by Paul Moses, May 4–June 12, 1964.

1965 Hommage à Mary Cassatt, Château de Beaufresne, Le Mesnil-Théribus (Oise), 12 juin, 1965.

1965 Musée Départemental de l'Oise, Palais Episcopal, Beauvais. juin–juillet, 1965.

1965 International Galleries, Chicago. Mary Cassatt, Retrospective Exhibition, November 20, 1965–December 21, 1965.

1966 The Knoedler Galleries, New York. Paintings of Mary Cassatt, February 1–26, 1966.

# Index

Adams, Henry: 118n.
Africa: 177
Aix-les-Bains, France: 22–23
Alba, Hotel d', Paris: 94
Albert, Prince Consort: 12
Alden, Captain Bradford Ripley: 28n.
Alden, Mrs. Bradford Ripley: 28
Alfort (veterinary school): 77
Algiers: *xiii*
Alicante, Spain: 86–88
Allegheny City, Pa.: 6–7
Allegheny River: 9, 19
Altoona, Pa.: 19–20, 23
Ambre, Mme Émilie: 105
America: *see* United States of America
American Art Association, New York: 104, 106
American Hospital, Paris: 206
American Students Club, Paris: 165
Angeletto, Villa, Grasse: 176, 190
Angleterre, Hotel d', Biarritz: 90
Anna (the Cassatt's cook): 78
Anstruther-Thomson, Clementina (Kit): 143
Antique Class, Pennsylvania Academy: 17
Antwerp, Belgium: 27, 80, 92, 211
Armand (Paris dressmaker): 96–98
Armory Show, New York: 106, 196
Arnolds (friends of Cassatts): 37
Arques-la-Bataille, France: 108

Art Academy, Parma, Italy: 25
Art Institute of Chicago: 137, 140, 159, 166, 169, 171
Art League of Paris: 160
*Assommoir* (by Zola): 34
Assouan, Egypt: 188
Athenaeum of Philadelphia: 8, 15, 20
Athens, Greece: 188
Avery, Samuel P.: 112–13, 120–21, 130

Bachivillers, Château: 123–24, 130
Bacon, Adele: *see* Peters, Mrs. Clinton
Bad Homburg, Germany: 153
Balloré, Captain: 113
Baltimore and Ohio Railroad: 6
Baltimore, Md.: 112, 141
Baltimore Museum of Art: 112, 139
Bancroft, John: 118n.
Barbizon painters: 105, 182
Barcelona, Spain: 87
Barentsen, Benjamin: 4
Bar Harbor, Me.: 163
Bartholdi, Frédéric Auguste: 92
Bartholomé, Mme Paul-Albert: 116
Bartholomé, Paul-Albert: 116, 122–23, 212
Batchelder, Mrs. Emily: 189
Bath Hotel, London: 70
Battie (Mary Cassatt's dog): 78, 86
Baudelaire, Charles: 115
Baudry, Paul: 126 & n., 132

229

Manzi, Mr. (collector): 171
Marcel, Mr. (French official): 170
*Mariana of the Moated Grange* (by Tennyson): 21
Marie Antoinette, Queen: 22
Marly-le-Roi, France: 53–55, 57, 59, 63, 74, 76, 173
Marseilles, France: 149
Marshall, Jonathan T.: 13
Martin (Cassatt's coachman): 89, 108
Massachusetts Charitable Mechanic Association, Boston: 47n.
Mathilde: *see* Vallet, Mathilde
Matisse, Henri: 195–96
Matsukata, Baron: 51
Mausoleum of Theodoric (Ravenna, Italy): 157
Mauve, Anton: 182
May, Ernest: 49
Mechanic's Building, Boston: 105
Mediterranean: 87
Meissonier, Ernest: 43
Mellario, André: 136
Mellon family (neighbors of Mary Cassatt): 148, 181
Mellon, Mr. and Mrs. Paul: 39
Meru, France: 163
Mesnil-Théribus, France: 11, 124, 143, 203, 207, 209–10, 213
Messina, Strait of: 156
Metropolitan Museum, N.Y.: 40, 63, 68, 85–86, 120–21, 139, 159, 171 & n., 177–78, 199
Meurice Hotel, Paris: 54, 153
Meyer, André: 51
Middle West: 24
Midy, Marcel: *xv*, 137
Milan, Italy: 45, 156
Millais, Everett: 61
———, work by: "Three Sisters," 61
Miller, Mrs. Jane: 193
Millet, Francis Davis: 128–29
Millet, Jean François: 165
Mino da Fiesole: 158
Mitchell, Mrs. (art dealer): 37, 47–48
Moinson, Dr. Louis: 193, 209
Monet, Claude: 29–30, 33, 41, 59, 82, 87, 90, 101, 104–105, 107, 109, 115, 120, 134, 159, 165, 168, 193, 196, 210
———, works by: "Impression: Sunrise," 32; "Stairs at Vétheuil," 84; "Springtime," 141

Mont Blanc: 23
Monticelli, Adolphe: 31
Montreal, Canada: 127
Moore, George: 143
Moran, Rev. (a minister in Paris): 72
Morgan, J. P.: 178, 185
Morisot, Berthe: 33, 41n., 51, 67, 82, 100, 103, 105, 116, 143, 146, 159, 168, 176
———, work by: "River Scene," 84
Morisot, Terbource: 82
Moroni, Giovanni Battista: 156, 185
Morris, Harrison S.: 164–66
Morrow, Paul: 5
Morse, Charles: 118
Moscow, Russia: 129n.
Moses, Paul: 50n.
Mt. Desert, Me.: 163
Munich, Germany: 186, 188
Murillo, Bartolomé Estéban: 185
Museum of Fine Arts, Boston: 18, 38, 48, 51, 137, 151 & n.
Myers, Frederic William Henry: 179 & n.

Nancy, France: 175
Naples, Italy: 156
Napoleon I: 79, 129n.
Napoleon III: 9, 11–12
Napoleon Bonaparte (a dog): 145
Napoleon, Imperial Prince: 12
National Academy of Design (N.Y.): 31, 47, 105–106, 179
National City Bank, N.Y.: 182
National Collection of Fine Arts: 163
National Gallery of Art, Washington, D.C.: 50, 102, 138
Naugatuck, Conn.: 151–52
Navaraoto, Italy: 45
Neuilly-sur-Seine: 206
New Amsterdam: 3
New Orleans and Pacific Railroad: 95
New York, N.Y.: 38, 48, 50, 62, 70, 92n., 94, 97, 104–105, 127, 130, 140, 177, 182, 194, 206
New York Public Library: 121, 200
Newbold, Anna: 208
Newmarket, England: 55
Newport, R.I.: 182
Nice, France: 83, 97
Nile River, Egypt: 150, 188
Nittis, Giuseppe de: 100n.
*Normandie* (ship): 99

*Miss Mary Cassatt* has been machine set in eleven-point Baskerville with two points of spacing between the lines. The type characters that you see are not merely an adaption, but a revival of John Baskerville's original, eighteenth-century type matrices for use on the Linotype.

The paper on which this book is printed bears the watermark of the University of Oklahoma Press and is designed for an effective life of at least three hundred years.

UNIVERSITY OF OKLAHOMA PRESS
*Norman*